Transparent Art

A SOMERSET STUDIO® PUBLICATION

Stampington & Company®

Laguna Hills, California
www.stampington.com

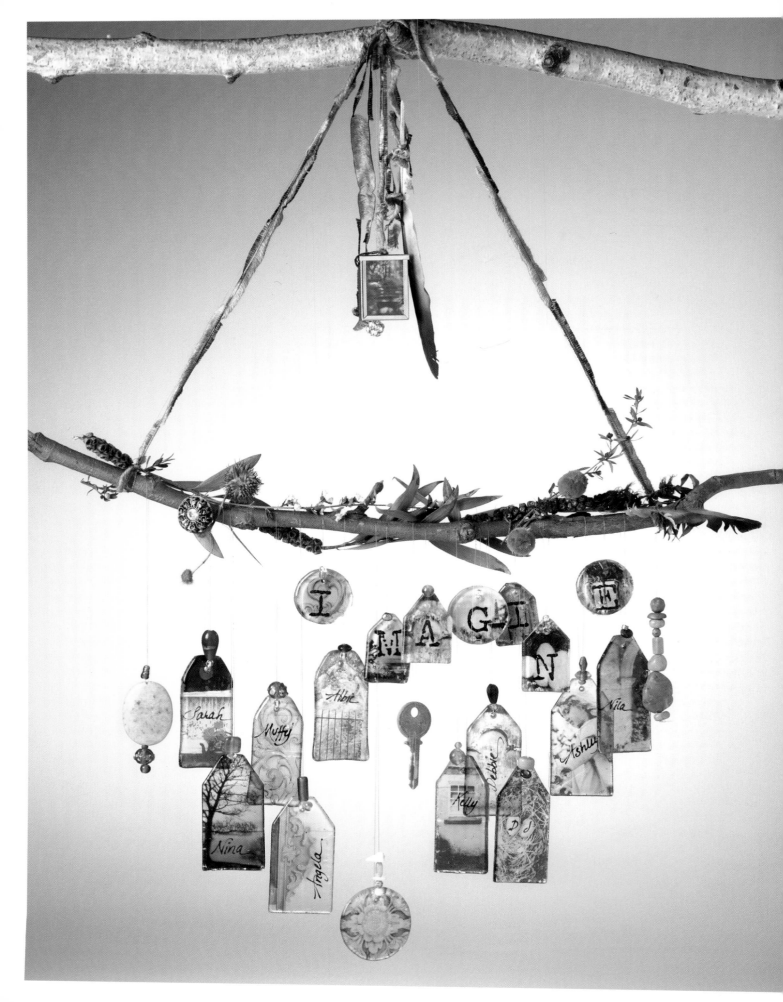

Imagining the Possibilities

by Angela Cartwright

There is something invigorating about art ... its endless possibilities and the inspiration we feel when developing our own style ... the freedom that comes with bringing to fruition something we are driven to create. But most of all, art is the part of us that uses our curiosity and our imagination.

Not long ago, I collaborated with Stampington & Company® to create a series of transparencies, vellums, and artist papers using my black and white hand-painted photographs. I was thrilled at the thought of my images becoming available in this way, for other artists to incorporate into their artwork.

I continued to research the use of transparencies in art, only to find very limited information available, which led me to approach publisher Kellene Giloff with the idea of creating a book about transparencies in art. Before I knew it, I was working with editor Jenny Doh on the book that is currently in your hands.

Soon after, I headed to the Art & Soul Retreat in Portland, Oregon, laden with several sets of the transparencies that Stampington & Company would be producing. It was here that I called upon my artist colleagues asking if they would be interested in incorporating this underutilized medium in their art.

> As you weave your way through the chapters, you will find yourself looking through a new window that opens to a whole new world.

The following artists that I approached wanted to participate and appreciated the freedom to follow their muse in creating projects for this book:

Nina Bagley is one of my favorite artists and whose work I have long admired. Though she usually uses her own found photographic images, she was instantly drawn to the "Bare Bones" image and was inspired to create an exquisite window hanging that calls for light to shine through it.

Muffy Alongi creates wonderful soldered jewelry to wear, and decorative jewelry for the home. After admiring a charm she was wearing around her neck that she had made, I asked if she would be interested in creating some jewelry with my transparencies. She was instantly motivated and that night she

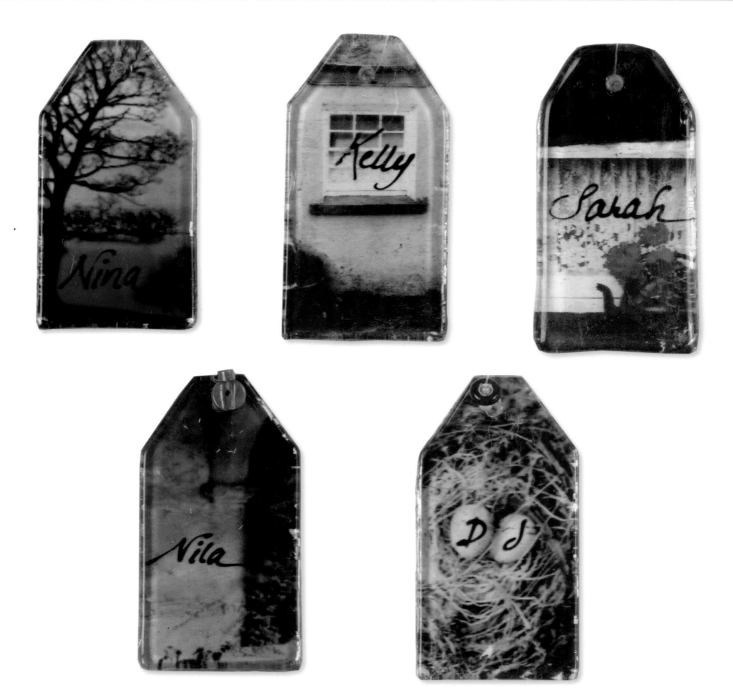

went home and produced some gorgeous jewelry pieces and brought them to me the next day. The art muse waits for no one when the artist hears the call.

Kelly Kilmer is someone who I've taken a few classes from. Her freedom with color and placement inspires me. For this book she created a piece overlaid with several transparencies and written copy – showing the depth that a transparency can bring to one's art.

Sarah Fishburn was introduced to me through Kelly as the "Queen of Transparencies." As such, Sarah is the author of "Transparencies 101" in this book's first chapter, and has used my transparencies in several projects throughout this book. Sarah is an artist who is thrilled to be creating, and I am inspired by her prolific creations and imaginative uses.

Nila Barja has been a friend for a long time. She creates with pastels and mixed-media on canvas to reveal the many layers of life. Nila had never used transparencies before but couldn't wait to work them into her art. She created a multi-layered piece incorporating my transparency.

DJ Pettitt chose a nest image from the "Cottage Garden" series and miraculously started formulating her delightful fabric purse right before my eyes.

Albie Smith, book creator extra-ordinaire, produced a charming cathedral-shaped book using an image of a portal that I photographed in Ireland.

Debbie Russell, owner of a decorative tile company, suspended her transparency onto a shrine that she built. The shrine is embellished with mini tile pieces she designs.

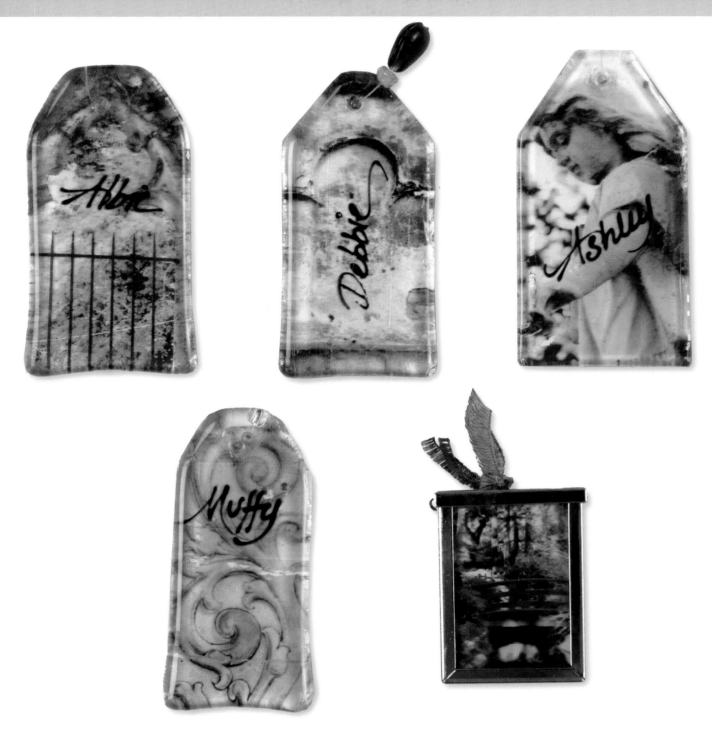

Ashley Sinclair, a graduating senior at NYU, was so excited about the project that she carved out time from her busy schedule to create a journal page using images from the "Casa Vista" collection.

I also took the challenge to see what I could do with these see-through images and ended up creating the wind chime shown here. It is a piece that celebrates all of the talented artists who so kindly and skillfully took up the challenge to participate in this book project. The wind chime utilizes the beautiful glass tags that are created by Stacy Dorr for Stampington & Company. To find the pieces by these artists that incorporate images from my collection of transparencies for Stampington & Company, look for this symbol (AC) in the Table of Contents.

Throughout the rest of this book, you will see creations by many artists who also answered the call to use acetate in their artwork, sharing generously of their techniques and ideas. *Transparent Art* is a book that will spark the freedom within us all. As you weave your way through the chapters, you will find yourself looking through a new window that opens to a whole new world.

It's a celebration of a new artistic possibility, which will inspire you to experiment and create with this new translucent medium. I hope you enjoy the result of this transparent journey as much as I have enjoyed imagining it.

Angela Cartwright lives in Studio City, CA. To learn more about her work, visit www.acartwrightstudio.com.

TRANSPARENT *Art*

PUBLISHER
Kellene Giloff

EDITOR-IN-CHIEF
Jenny Doh

CONTRIBUTING EDITOR
Kathryn Bold

ART DIRECTOR
Sonia Mara Adame

PHOTOGRAPHERS
Sylvia Bissonnette
Lorin Backe
Emily Arata

ART MANAGEMENT
COORDINATOR
Pamela Scruggs
pscruggs@stampington.com

Transparent Art™ is published by
Somerset Studio® a division of
Stampington & Company®

PRESIDENT
Kellene Giloff

VICE PRESIDENT,
CREATIVE DIVISION
Diane Michioka

PRINTING
Publishers Press
Lebanon Junction, Kentucky

Published in the United States
by Stampington & Company®
22992 Mill Creek, Suite B
Laguna Hills, CA 92653
Phone: (949) 380-7318
Or toll-free in the US: 877-STAMPER
www.stampington.com

ISBN 0-9717296-5-4

Dear Readers,

Innovation. That's something I hear repeatedly from art and crafters who seek products and techniques to take their artwork to "the next level." But what I have observed in reviewing the numerous submissions over the past several issues of *Somerset Studio* is that artists rarely find an art medium that is truly novel. Sure there are always new shades of paint and new patterns of paper being developed, but regardless of the new shades and patterns, paint is paint and paper is paper.

It could be argued that transparencies aren't really new either. After all, they have been around for many years – particularly in schools and offices where information is printed on clear acetate sheets to be viewed on overhead projectors.

However, the phenomenon of artists incorporating transparencies into artwork has only recently become so strongly visible. Rubber stampers, scrapbookers, quilters, collage and assemblage artists, lettering artists and more, are all discovering ways to add unique shimmer and depth with the use of transparencies.

It is my hope that through the projects presented in the following chapters, you will be inspired by the versatility and beauty that transparencies lend to a wide array of projects and ideas.

> It is my pleasure to help facilitate the showcasing of outstanding work – especially when the work collectively celebrates the discovery of an exciting and innovative medium.

In chapter one, you will learn extremely valuable basic methods of attaching transparencies. The chapter will also offer quick jump-start projects that are so inviting and achievable that really anyone can dive right in.

In the following chapters, you will observe that pretty much anything goes with transparencies. What you can do to paper, you can also do to transparencies – like paint, sew, burn, cut, adhere, collage, assemble and much, much more.

As is the tradition with readers of *Somerset Studio*, they always exceed our expectations in terms of the quality and volume of work that they submit. As a tribute to our readers, *Transparent Art* concludes with a gallery section in chapter ten, which shows numerous wonderful submissions with sample instructions.

It is my pleasure to help facilitate the showcasing of outstanding work – especially when the work collectively celebrates the discovery of an exciting and innovative medium. *Transparent Art* serves as clear evidence of the vibrant and pioneering nature of our art community – always relentless in its pursuit to create, share, and inspire.

Cheers,

Jenny Doh

Editor-in-Chief

TABLE OF CONTENTS

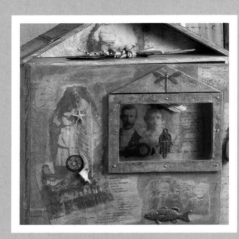

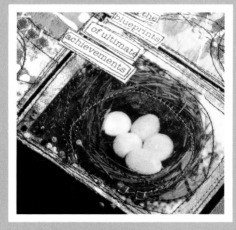

AC: Denotes artwork that uses transparencies by Angela Cartwright for Stampington & Company. The transparencies, with coordinating artist papers and vellums, are available for purchase at www.stampington.com.

PHOTO CREDITS:
Sylvia Bissonnette: Cover and pages 2, 11, 24, 47, 53, 61, 65, 67, 73, 87, 110, 123, and 139.

Lorin Backe: Pages 3-5, 12-23, 26-45, 48-51, 54-59, 62-64, 69-71, 74-85, 88-108, 112, 114-121, 124-137, and 140-175.

Emily Arata: Page 113.

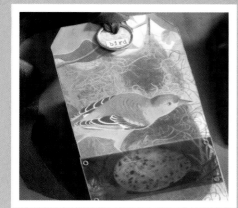

Transparencies can really

jazz up altered books,

art journal pages, collages,

fabric projects,

and oh so much more!

Think of them as an

additional layer in your art.

There are innumerable ways

to attach them…

SARAH FISHBURN

Getting Started

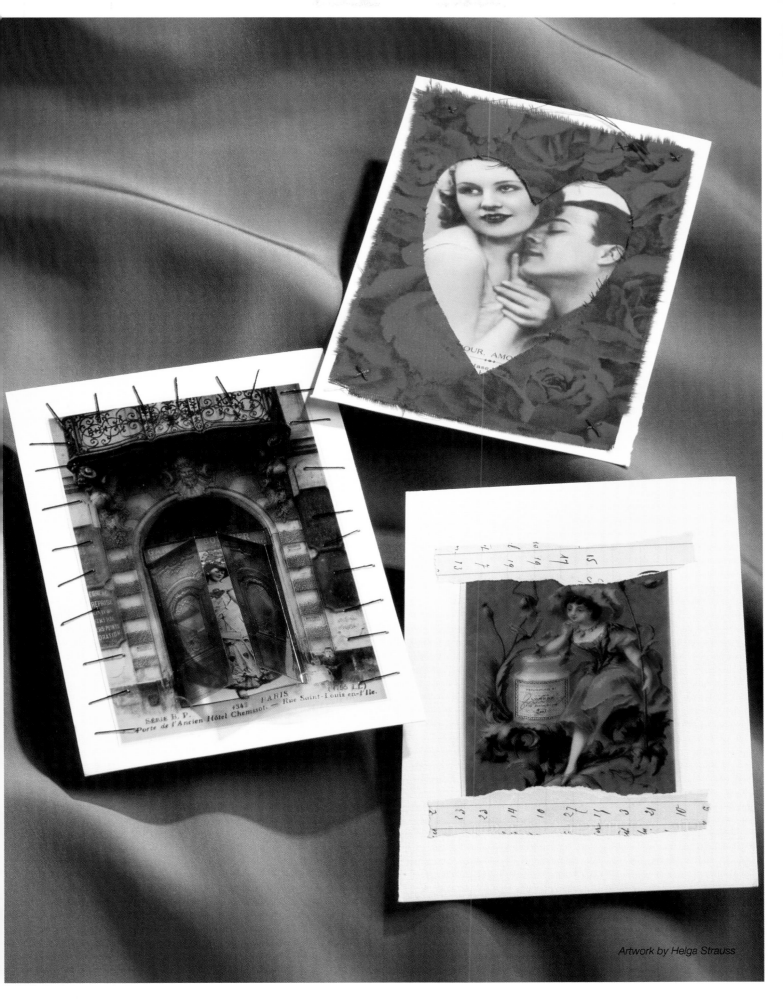

Artwork by Helga Strauss

Glue Stick

Terrifically Tacky Tape

Diamond Glaze on Mirrors

Xyron

Transparencies 101
ATTACHMENT TECHNIQUES

Artwork by Helga Strauss • Story by Sarah Fishburn

Transparencies can jazz up altered books, art journal pages, collages, fabric projects, and so much more! Think of them as an additional layer in your art. There are innumerable ways to attach them, and here are some of my favorites.

GLUES

First, experiment using your favorite glue, as you will discover its advantages and limitations. You can always branch out with different types of adhesives later on. Whichever glue you choose, be prepared for a less "clean" looking finish than when using other adhering techniques. It is an obvious characteristic of the transparency itself – that whatever is underneath will show through to some degree. If you adhere onto a printed area, the adhesive will generally show a tad less.

I don't recommend using glue sticks other than Coccoina, as most will likely not hold for the long haul. I find this to be particularly true with slicker elements, which of course is also the nature of a transparency. If you use a glue stick over the entire surface of the transparency, you may get a cloudy effect. This can be totally cool. That is, unless you seek a more transparent effect!

For those of you who use gel medium as your adhesive of choice, you have the option of spreading it all over the surface of the transparency, or just along the edges, or at any point you want it to be held. However, gel medium does not always dry clear — keep that in mind if you do want the transparency to shine through clearly.

If you have a Xyron machine, you're lucky because it's perfect for transparencies! Just run a transparency through a one-sided adhesive cartridge, and it'll turn into a sticker. If you don't have a Xryon machine, consider buying one – it's a great investment.

Diamond Glaze works in much the same fashion as gel medium. It works particularly well if you are trying to adhere a transparency to a surface other than paper, like metal, wood or glass.

If you decide to use any kind of glue just along the edges and do not want it to show, it can always be covered with one or more of the following: other collage elements, decorative tape such as masking tape, duct tape, stained glass metallic or graphic arts tape, ribbon, strips of cut or torn paper, strips of fabric, German scrap borders, and so on.

For gluing elements onto a transparency, I highly recommend Diamond Glaze, for both its relatively quick bond and its permanency. I don't recommend

using a hot-glue gun, as transparencies tend to melt when exposed to heat. But then again, if you're looking for a grunge look, that could be just about perfect.

Glue Stick

Silver Tape

Copper Foil Tape

TAPES

Tapes used underneath a transparency (e.g., double-sided (Terrifically Tacky Tape) and photo mounting tape) perform similarly to glues in that they also show through to some degree. If that's not the look you're looking for, but it is the adhesive you're going to use, you have all the same options to disguise the tape as you did with the glue by using ribbons, other tapes, etc. Basically, it's all just one big cover-up! To minimize the appearance of tape without covering it up, simply cut tiny squares of double-sided tape and put them in the corners under the transparency. You really won't be able to see them at all.

You might also consider using the tape directly on top of the transparency, extending over either of the side edges and/or the top and bottom. Or cut the tape into triangular shapes to give the appearance of photo corners. If you happen to have real photo corners, they're excellent too. Try traditional tapes, like masking tape in different colors or copper foil tape.

STITCHING, RIBBON AND FABRIC

Try stitching all around the edges of the transparency, layered on top of either paper or fabric. If you are using a machine, you may also have the option of a zigzag or other decorative stitches. If you sew by hand, you may want to just tack at the corners, or consider using larger, basting style stitches, or even more decorative stitches like cross-stitch or blanket stitches.

By the way, you could leave one side or the top open and insert a surprise — a snippet of fabric, or a love letter — let your imagination go wild! You can insert things and then stitch on all four sides (this is possible when adhered by any of the above methods as long as you haven't glued the middle down). Some examples include confetti, little plastic elements, beads, heishi, unattached additional paper, or cloth collage items.

Adhere transparencies by surrounding them with fabric or ribbon and allowing them to peek out of fabric "frames." Or, sew transparencies on top of your fabric pieces ... they look great this way too!

Black Masking Tape

Needle and Thread

Ribbon

Needle and Thread

Needle and Thread

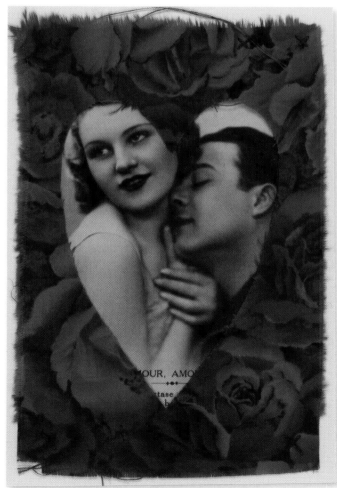

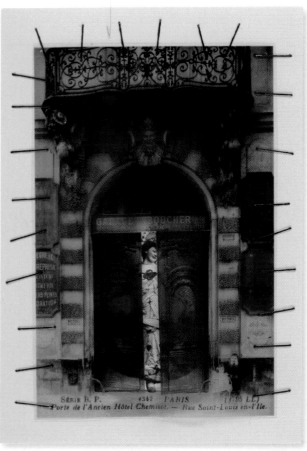

Staples

Paper Clips

Buttons

Mini Brads

BRADS, BUTTONS, EYELETS, SNAPS AND MORE

For a wonderful effect, try using brads, buttons, eyelets, grommets, or snaps to attach transparencies to almost any paper or fabric. Use them just at the corners, all along the edges, or any other place on the transparency.

To combine form and function, make the attachment a decoration. Attach the transparency using a heart shaped brad or button where you would really find a person's heart. Or use nailhead stars to both form a halo over someone's head and to hold the transparency in place.

If you use grommets or eyelets, you also have a perfect opportunity for threading some ribbon through to finish off borders in a really elegant or funky way. Try adding beads and charms to the ends of ribbons.

Don't forget to break out the paper clips, too! The nice round ones are perfect for adding a small frame or highlighting a special detail in the transparency.

Staples in bright colors are also make great, easy attachments.

Sarah Fishburn lives in Fort Collins, CO. To learn more about her work, visit www.sarahfishburn.com.

Helga Strauss lives in Victoria, BC, Canada. To learn more about her work and her company, visit www. artchixstudio.com.

Star Brads

Jump-Start Projects

by Jenny Doh

COMMERCIAL TRANSPARENCIES

Now that you've learned about the many different ways in which to attach transparencies, you're ready for some quick and easy project ideas. The great thing about transparencies is that they are readily available for purchase from different companies. As you will see throughout this book, many artists simply purchase transparent images, cut them up, and use them in their work.

Take this beautifully embellished tag from Sarah Fishburn, for example. The central image is a gorgeous transparency (Angela Cartwright for Stampington & Company) that doesn't need to be tinkered with very much as the image comes ready-made with stunning colors. By using ready-made transparencies, artists can hit the ground running by simply figuring out how to compose the rest of the design around it. Read the instructions on the opposite page to learn how Sarah made this tag.

Denise Lombardozzi enjoys experimenting with transparencies and finding new ways to treat them, color them, and layer them for effects that are like no other. Though her accordion slide mount frame project shown below looks complex, you will be surprised to learn that by following her instructions, you can achieve the similar results quickly and easily.

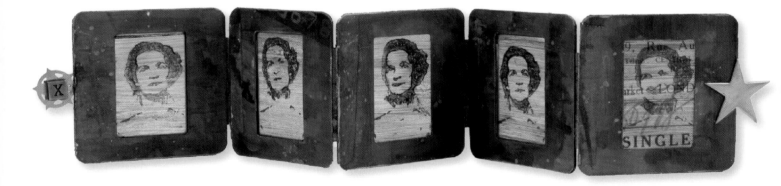

Denise Lombardozzi's Slide Mount Frame

Paint five slide mounts with Green Gold fluid acrylic (Golden) and drizzle Adirondack Eggplant Color Wash (Ranger) over them, followed by a spatter of Krylon pen. Repeat this on a strip of cloth book tape.

When dry, sand slightly over the slide mounts and then brush a thin layer of Interference Oxide Green fluid acrylic (Golden) over the top. Using a stamp image of a woman (American Art Stamp), stamp with black Staz-On onto vellum, then brush over the opposite side with the interference acrylic.

Place images between the slide mounts with a glue stick and then cut 1″ pieces of book tape to attach the slide mounts. Using the glue stick, adhere the mounts in place. Adhere a piece of pre-purchased and cut transparency with text over one of the slides. Embellish with the Krylon pen and add charms.

Denise Lombardozzi lives in St. Charles, MO.

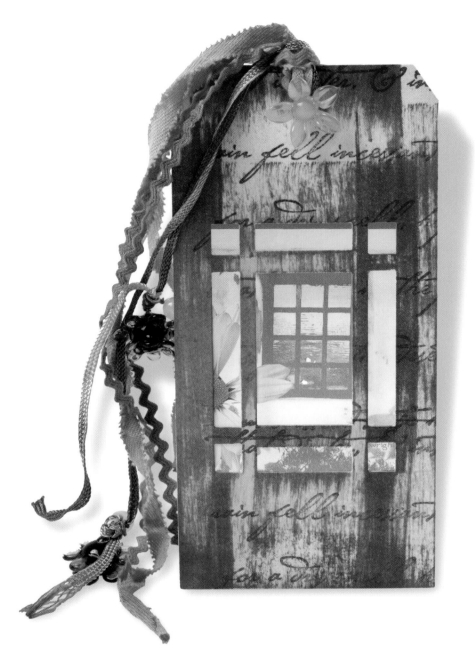

Sarah Fishburn's Echos Tag

Start with a Paper Reflections mosaic tag (DMD). Drag a Tuscan Earth Fresco Chalk-Finish Dye inkpad (Stampa Rosa) vertically down the tag and then a Vintage Photo Distress inkpad (Ranger) down over the yellow a couple of times. Use only light to medium pressure for a shabby chic style variation in consistency.

On top of that, using a Graphite Black Brilliance Pigment inkpad (Tsukineko), stamp repeatedly but fairly lightly, using any word stamp you love. Mine is a "poem segment" stamp that I wrote and designed for the original Uptown line. Behind a section of the "window" area, adhere a partial image of a pretty little flower, cut from a catalog, magazine or personal photo.

Adhere the transparency to the tag itself, behind the adhered flower. To make the back of the tag look tidy and nice, adhere a second mosaic tag, neatly positioned. Run a few color-coordinated fibers (Carma) through the tag hole. Attach a glass flower (Blue Moon Beads) to the fibers at the hole and add a few more glass flower charms and beads (Blue Moon Beads) for the perfect finishing touch.

Sarah Fishburn lives in Fort Collins, CO.

STAMPING ONTO TRANSPARENCIES

Many artists have also discovered the fun of purchasing plain sheets of transparencies (available in office supply stores) and stamping on them to achieve quick, easy, and tailored looks. Though there are many brands available, the overwhelming brand of choice named by most artists is 3M. Cynthia Shaffer made these adorably fresh bottles by first taking sheets of transparencies and stamping on them with acrylic paints. Read below to learn her quick and easy instructions.

Cynthia Shaffer's

Stamped Transparencies in Bottles

Before getting started, scout various sources to find glass bottles to your liking. You can find them at craft stores, online, flea markets, or other gadget supply stores. Once you've selected the bottles, select acrylic paints that will coordinate well with the bottles.

Take the assorted colors of acrylic paints and use a paintbrush to apply the paint onto art stamp images (Christine Adolph for Stampington & Company). Stamp directly onto a sheet of blank transparency (3M). After allowing the paint to dry thoroughly, place the bottle over the stamped transparency and trace around the bottle with a permanent black marker. Use the marking to then cut the transparency with scissors, approximately ¼˝ smaller all the way around the marking. Take the cut transparency and roll it tight enough for it to fit all the way through the opening of the bottle. Once it is placed through, the transparency will unfurl and open up to stand upright, within the bottle. Add additional embellishments as desired.

Cynthia Shaffer lives in Orange, CA.

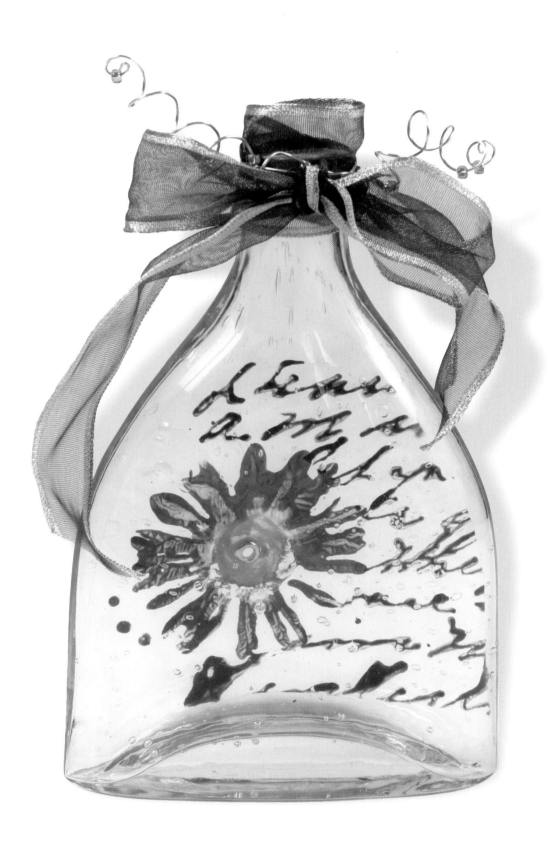

PRINTING

Aside from stamping onto transparencies, artists also frequently print directly onto them from their home computers. Although the idea of printing onto plastic may sound scary, artists have delighted in discovering that pretty much anything that gets printed onto paper can be printed onto transparencies. However, transparency sheets cost much more than paper. For this reason, artists recommend that before printing onto a transparency sheet, to run test prints onto sheets of paper.

Another important fact to note is that there are two different types of transparencies available, in varying thicknesses. The first type -- suited for laser printers – feels slick on both sides and produce images that are permanent and therefore able to withstand treatments with inks, paints and other liquids without becoming distorted. The second type – suited for inkjet printers – feels slick on one side and "rough" on the other side. When working with inkjet transparencies, they must be fed through the printer so that the image is printed on the "rough" side. Unlike laser images, inkjet images are not permanent, thus requiring great caution when combining with inks, paints or other liquids, so to prevent smudging.

For these cards, Kim Frantz used her computer to design sweet and simple sentiments to make a "thank you" card and a "happy birthday" card. With cardstock, rubber stamps and just a few other embellishments, her fresh and elegant cards can be whipped up in no time. Here's how she explains the process.

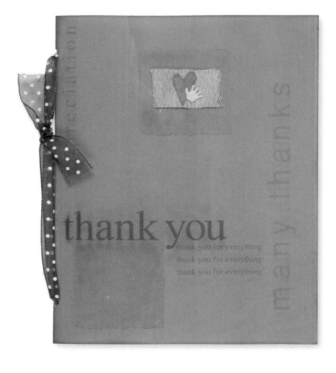 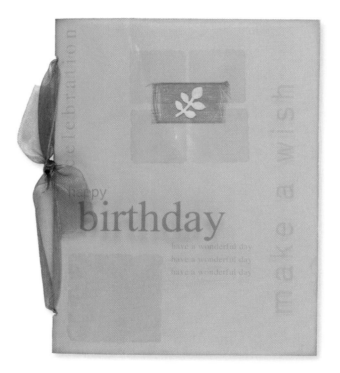

Kim Frantz' Transparency Cards

Use a computer to create a simple text design (in Photoshop or other program of choice) that can be generated onto an 8-1/2″x11″ sheet of paper. Next, print the design on a sheet of paper and make sure that once it is cut in half and then folded, that it will fit nicely onto a standard-sized greeting card.

Once you are happy with the test sheets, generate the design onto a transparency sheet on an inkjet printer. Use a sharp craft knife and a cutting mat to cut the transparency to size. Use a bone folder to then fold the transparency in half.

Cut cardstock the same size as the transparency. Use block stamps (Hero Arts) to stamp onto cardstock with coordinating inks. Punch shapes out with the same colored cardstock and layer the shapes with pieces of ribbon or fabric and adhere onto the card.

Place the cardstock inside of the folded transparency and then punch two holes along the fold. Thread a piece of ribbon through the holes and tie.

Kim Frantz lives in Oxford, PA.

TREATING

Aside from stamping or printing onto transparency sheets, artists continue to push the envelope by treating the transparency with added techniques to achieve very interesting results. Melody M. Nuñez loves how transparencies can be manipulated in various ways to add dimension and interest to her projects. The card project below is an example of how transparencies generated with text are cut and melted to achieve simple and unique design elements. When layered on top of Melody's crisp and colorful photographs, the cards take on unique depth and interest.

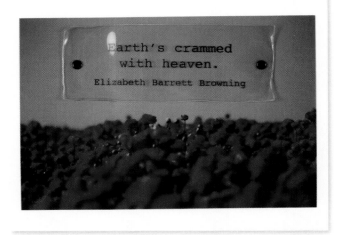

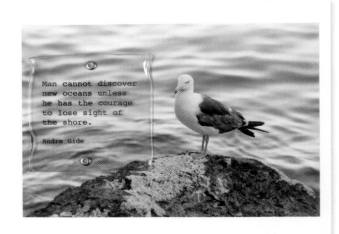

Melody M. Nuñez' Transparency Block Cards

Before assembling the cards, select photographs or other images that contain some "open space" where you can easily place the transparency block. Type a desired quote or greeting on the computer using a basic word processing program. Paste multiple versions of the text block onto the page and print the page onto multipurpose transparency film. Be sure to read the package instructions and feed the sheet correctly into the printer.

Trim each text block to size, leaving at least a blank ¼" on all sides. One by one, and working carefully over a sink, heat the edges of the transparency blocks with a fireplace lighter. This part takes some trial and error as too much exposure to the flame will catch the edge on fire or buckle the piece. Ideally, the edge should melt slightly, giving a nice finished edge that is light brown in color.

When all four sides of the transparency block have been heated and finished, attach it to the photo or image with eyelets. Finish by mounting the photo onto a card.

Melody lives in southern California.

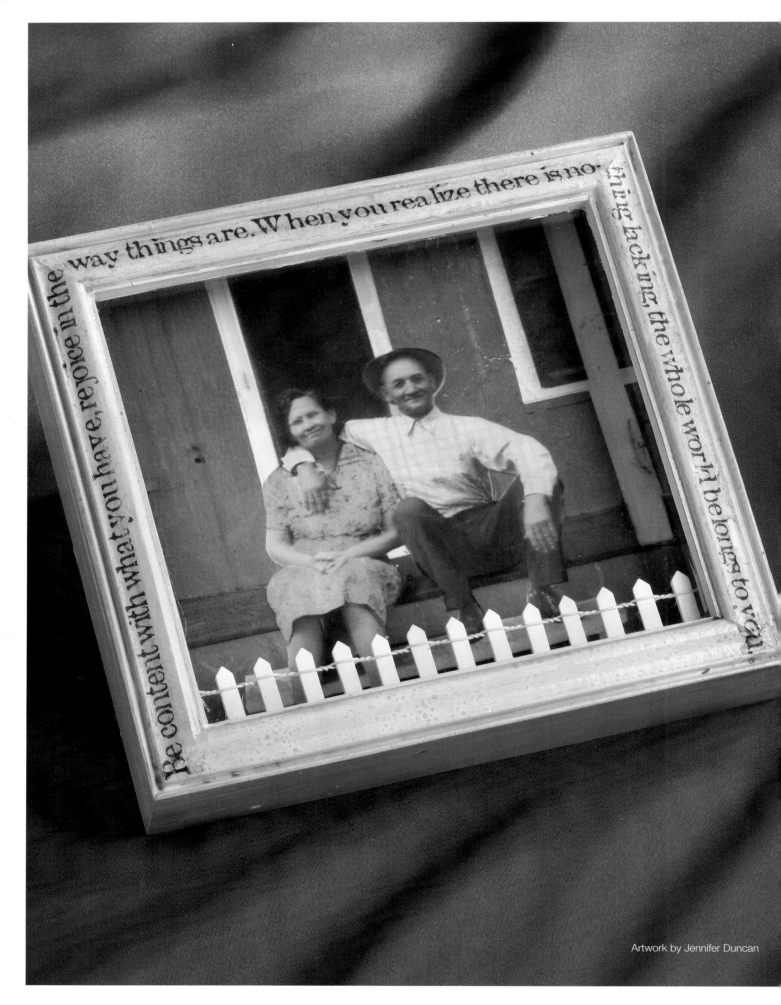

Artwork by Jennifer Duncan

The beauty of this technique
is that you can make mistakes
and just keep wiping the paint
off over and over again
with a wet rag and start again.
JENNIFER DUNCAN

Colors & Treatments

love

1953

Adding New Life to Old Photos

by Jennifer Duncan

While recently working on a collage that featured an old black and white photo, I had the strongest urge to make the sky a bright and cheerful blue. It's taken me all of my 46 years to even consider calling myself an "artist" because I don't draw or paint. I thought maybe I could do something fancy with the trusty pack of water-soluble oil pastels so I pulled them out and basically made a mess of it.

Frustrated but not ready to give up, I glanced over at my pile of decorative scrap papers and saw the perfect blue! Yes, that was what I was going for! A light bulb went off and since then, I have been very excited about giving new life to old photos. I've gotten so much inspiration from the contributors to *Somerset Studio* over the past few years that I thought it was only right to share my newfound technique with other readers through this special publication.

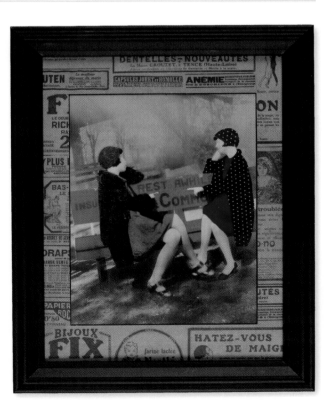

TOOLS & MATERIALS

- Small scissors
- Decorative paper scraps
- Image printed on transparency
- Xyron machine (with adhesive cartridge)
- Temporary (removable) adhesive tape
- Transparency image printed on sheets of copy paper

best friends

Technique

ADDING COLOR WITH PAPER

Study the selected photo and decide which sections need to be colored and which colors would work best together. I typically end up adding color to the sky, the foreground, and the clothes of the people in the photo.

For the sky, take one of the copy paper prints and use it as a pattern piece by roughly cutting the sky out and leaving a ½″ border. Attach it face-up to the right side of the decorative scrap paper using temporary adhesive tape. Precisely cut the shape of the sky. Remove and discard the copy paper pattern and the tape. Run the resultant piece of sky paper through the Xyron machine (with the adhesive

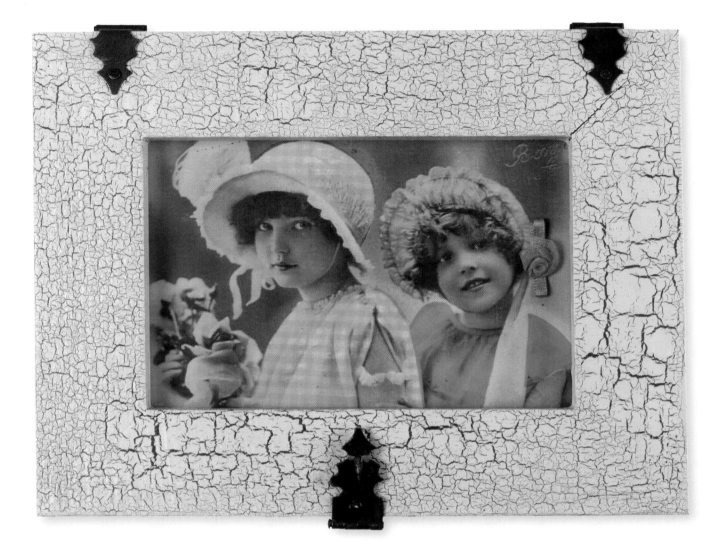

cartridge) so that the right side will become sticky. Flip the transparency to the backside and place the sky on it so that it shows through correctly on the front side.

Repeat this technique to add color to other portions of the photo. Keep doing this until all the fields of choice are "colored in."

The final step is what really makes the piece "pop." I pick a flesh-tone paper and cut it to the size of the transparency collage. Run this through the Xyron machine (with the adhesive cartridge) so that the right side will become sticky and cover the entire back of the transparency with it. This is how the people's faces, arms and legs will become colorized, and it also serves to finish off the backside nicely. Now you can go on to incorporate this newly created art piece into frames or collages.

ADDING COLOR WITH PAPER & PAINT

There are some photos with such intricate details that they just don't lend themselves solely to the paper layering technique. This is when you can combine the paper technique with a little bit of paint, even if you (like me) believe that you "can't paint."

To incorporate paints with papers, have a supply of liquid acrylics (any brand) nearby. Study the photo and ascertain the layers of the elements. Also decide which elements will be painted and which will be layered with paper. Work your way from the foreground of the picture back. Remember that you're always working on the backside of the transparency.

Typically, I'll start painting the skin first. I find that a very soft baby pink, with just a couple dots of soft yellow

mixed in, combine to make a perfect flesh tone. A small round brush works best. Complete all the painted elements first. Lighter paints work best. If your paint is too dark it will obliterate slight details in the print such as flower petals, hair color variations, tree bark, etc. When you come to an element that just isn't working well with any color, I find Golden's Titan Buff acrylic works well to cover it realistically.

The beauty of this technique is that you can make mistakes over and over and just keep wiping it off with a wet rag and start again. Once all painted elements are dry, start adding the papers as described above. You'll notice that in some instances you won't have to cut paper pieces exactly to size because everything around that element is painted. This is especially true for the final layers of foreground and sky, and often for clothing, too.

Step 1: Original black and white photo.

Step 2: Photo reproduced onto a laser transparency with some details painted in.

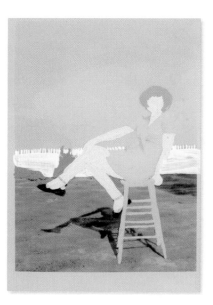

Step 3: Red dress colored in with paper layering technique.

Step 4: Completed transparency with additional papers layered for sky and ground.

- Go as realistic or as whimsical as you like. For instance, how much better might old buttoned up Aunt Martha look if she had on a dress of bright orange stars?
- Wear a short sleeve shirt when doing this project. More than once, I've cut out a fairly small piece, got it sticky and ready to apply to the transparency, only to reach for the ringing phone and never finding the piece until much later, stuck to the sleeve of my sweater!
- I use laser printed transparencies, which are smooth on both sides. If you only have access to ink-jet transparencies, print your photo on the rough side as usual but remember to flip it or set it in mirror image. With ink-jet transparencies, the image is just imbedded in the rough coating. If you were to paint on the rough side and make a mistake, you would wipe off the

image itself just by trying to wipe off the paint. You always want to paint on the smooth side.

- Expect to paint two coats on everything. When you use a nice flowing paint you will get smooth outlines to your elements, but the first coat will almost always be streaky and require filling in with a second coat. Feel free to hurry drying times with a heat gun but do be careful not to melt the transparency.
- Permanent markers are very useful in some cases. Silver for chrome accents, black for certain shoes or belts, etc.

Jennifer Duncan is a frequent contributor to Stampington & Company publications. More of her work can be seen at www.jkduncanoriginals.com.

Happy Accident

by Jill Haddaway

I've long been a fan of Lesley Riley's ink-jet transfer method (*Somerset Studio*, Nov/Dec 2002), but was never sure what to do with the leftover transparency pieces after the process. One day, I did a transfer that didn't quite work so I started playing around with the "leftover" film. I noticed there was a pleasing rough pattern of gel versus ink around the edges. I thought maybe I could layer the transparency on top of the transfer … perhaps with a circle to highlight the face. I picked up a black pen and started to draw the circle, but oddly, it turned white. I realized that that portion of the ink-jet image was being left behind on the scrap paper. Very pleasing effect!

"I have a darling kitty,"

the comrade heart

laughing lightly at Dame Despair

And drinking deeply of life

Technique

TOOLS & MATERIALS
- Foam brush
- Scrap paper
- Circle template
- Watercolor paper
- Matte gel medium
- Permanent black marker (fine point)
- Xyron machine (with adhesive cartridge)
- Image printed onto ink-jet transparency sheet
- Background paper (vintage text, scrapbook paper, etc.)

With a foam brush, spread an even layer of gel medium onto a piece of watercolor paper. Transfer the image by firmly rubbing the transparency with a bone folder or other burnishing tool. After burnishing, you can lift the transparency to see the inks from the image transferred onto the paper.

While the medium on the transparency is still moist, lay it (ink-side-down) on a piece of scrap paper. Use the circle template and permanent black marker to trace a circle. Lift the transparency up off of the scrap paper and let dry overnight.

Once dry, run the transparency through a Xyron machine (with the adhesive cartridge) and then attach it to a vintage text or other decorative paper. Trim and mount to a watercolor paper base, journal page etc. Paint a border, add more text, or whatever you like. After I've completed my collage, I like to cover it with a layer of matte medium, avoiding the area inside the circle for a shiny contrast.

Jill Haddaway lives in Seattle, WA. To learn more about her work, visit www.weeladstudio.com.

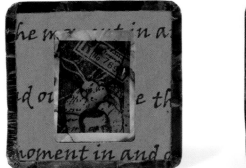
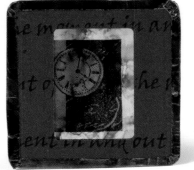
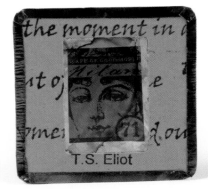

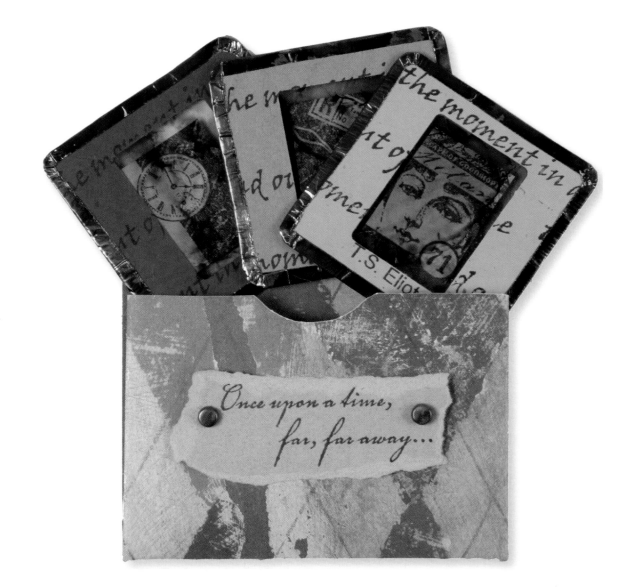

Sheer Fusion

by Nancy Curry

I am drawn to create techniques that allow for momentary minglings of color that are hard to duplicate, making the outcome unique and surprising every time. Acetate is a great choice to use for this type of exploration since its slick nature allows for maximum movement of the inks before they dry. Alcohol inks work well because of their transparent nature, quick dry time, and inherent color variegation. Their properties also allow the artist to keep adding and diluting the ink until the look and mood of the piece come together.

To get the most visual depth, I decided to float the artwork between two pieces of colored acetate for these projects. This technique works especially well for projects that are free-standing such as trading cards, slide mounts, windows in altered books, or acrylic framed pieces. This is because both sides of the artwork look finished. The effect is also great for those who do not like stamping on a slick surface since the stamp composition occurs separately on cardstock.

The finished products have some elements that I love in stained glass, yet exploit what can happen with random mixes of colors in a given moment, giving each one a unique presentation.

TOOLS & MATERIALS
- Brads
- Cardstock
- Art stamps
- Bone folder
- Plastic wrap
- Leafing pen
- Epoxy stickers
- Acetate (heavy duty)
- Perfect Paper Adhesive
- Jet Black archival ink (Ranger)
- Copper metal foil tape (1/4˝-thick)
- Slide mount punch (Emaginations)
- Wood applicator with Velcro & felt
- Blender liquid (Adirondack by Ranger)
- Alcohol-based re-inkers (Adirondack by Ranger)

Technique

ADDING COLOR
I usually tear off about a foot-long piece of plastic wrap that I lay out flat to serve as my plastic wrap palette. There are always some natural ridges that occur, which is fine for this technique. Drizzle a few drops of alcohol-based re-inkers in two or three coordinating colors onto the plastic wrap palette. Add a couple of drops of clear blender liquid. Press the precut acetate into the plastic wrap and pull up. Repeat if pattern is not pleasing or add more ink to add contrasted areas. Repeat with other piece of acetate. Set aside to dry.

STAMPING & MOUNTING
It is a personal choice whether you organize your composition on precut paper or slightly larger paper. I usually use larger paper and then cut it after the composition is done. Stamp composition on white or light-colored cardstock with black or dark-colored ink. Place the cardstock between the two sheets of acetate. Add very thin lines of double stick tape to hold edges together if desired. This will make the next step easier.

FUSING

Cut a length of foil tape that will fit around the perimeter of the project. Color tape with coordinating alcohol inks using a homemade felt applicator, which can be made by attaching a piece of felt with Velcro to a piece of wood. Set aside for a few minutes to dry. The tape will be easier to work with if you only pull part of the liner off to begin with. Lay the tape down flat and center the acetate on top. Start near the short side corner, lay acetate on top so the front and back borders will be equal. Once tape is around all sides, begin squeezing the edges of the tape together, working from the middle but stopping before reaching the corners. Repeat with the other sides. Use a bone folder to burnish the corners and then the sides.

VARIATIONS

After fusing the layers for the ATCs shown here, the copper tape was spot-colored with the re-inkers. Clear epoxy stickers were added and also stamped. Stamps used: Hero Arts, Rubbermoon, Great Impressions, Stampington & Company.

The slide mounts were made by punching out rectangles on pieces of cardstock and then stamping onto the punched cardstock in black ink. Small fused layers with acetate and cardstock were then adhered between layers of the punched cardstock and fused together with copper tape that was also spot-colored with re-inkers. Stamps used: Impression Obsessions, Treasure Cay, and Acey Deucy.

After fusing the layers for the framed piece, the copper tape was spot-colored with re-inkers. Before encasing the fused layers into a glass float frame, the bottom layer of the float frame was spot-colored with a felt applicator. Stamps used: Tin Can Mail for Inkadinkadoo.

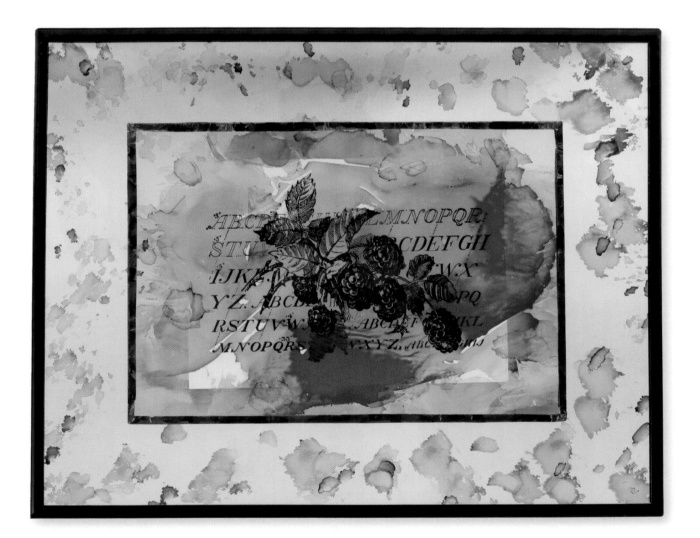

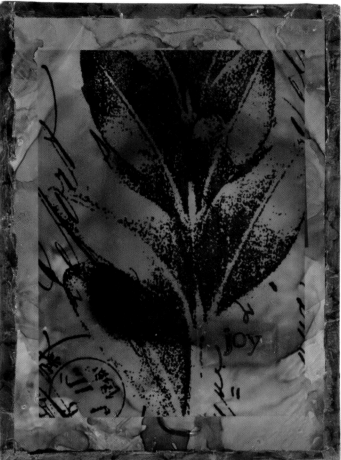

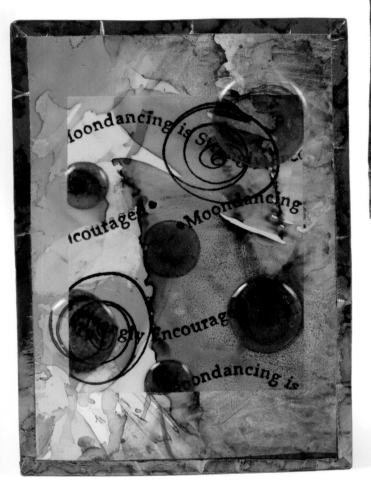

- Leave "white" area. Negative space is important for technique not to look overdone.
- Look for larger images to cut down.
- Look at your old stamps in a new way.
- The backs are as decorative as the fronts.

- Try various pale cardstocks for different looks between the acetate pieces.
- If some of the coloration is too dark once the artwork is between the layers, add some blender to the plastic wrap palette and press the acetate in again to separate the darker areas

Nancy Curry resides in Mason, OH. Her book, Texture Effects for Rubber Stamping by North Light Books is available for purchase at www.stampington.com.

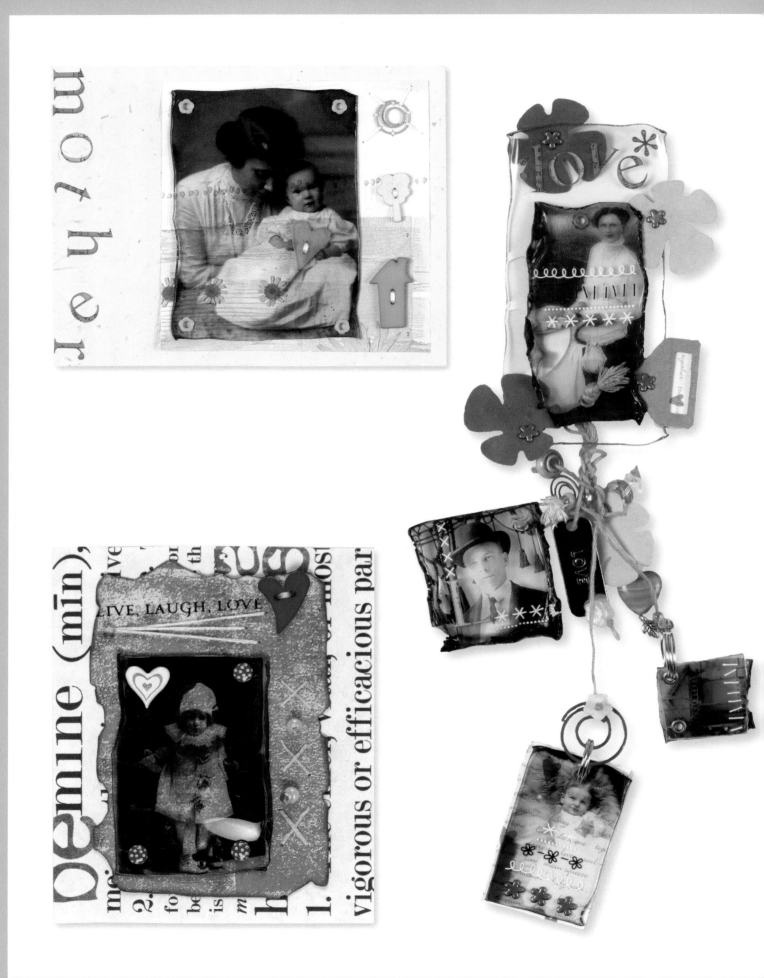

Flamed to Perfection

by Jen Osborn

When I first started using transparencies, I simply scanned my vintage photographs, printed them onto the transparency and stitched them over white paper or light colored fabrics. Since I'm always looking to learn new techniques and evolve my style, I sought to find a way to have my transparencies take on a new look. Specifically, I was searching for the soft, whimsical look of ripped fabric that I had grown to love while experimenting with paper and fabric quilting. However, the nature of transparency sheets made them nearly impossible not to tear into the images or have them look too jagged.

One day, I remembered a lesson my father had taught me as a young girl to seal up the ends of frayed plastic roping. He showed me how if you held a match or lighter gently to the end, it would curl together and melt the fray, keeping the rope from unraveling.

I wondered if I could use this technique on the transparencies to age them and give them that same whimsical look that was emerging in my fabric art. So I started cutting up transparencies and experimenting with fire. What a joy to discover the smoky, burnt uniqueness I could create with each image by melting the transparency in different ways! Everyday images could now be transformed into little windows of magic with just a touch of flame.

Technique

TOOLS & MATERIALS
FOR THE BURNING TECHNIQUE
- Scissors
- Hole punch (optional)
- Damp rag (to control the burn)
- Images printed on ink-jet transparencies
- Matches & candle (or a metal lighter)

FOR THE BOOK OR OTHER TRANSPARENCY PROJECTS
- Needles
- Art fibers
- Assorted fabrics
- Embellishments
- Assorted papers
- Sewing machine
- Embroidery floss
- Eyelets & setting tools
- Rub-ons (letters, words or images)

NOTE ON SAFETY

Work in a well-ventilated room and have a damp rag on hand to help control the burn and extinguish any small fires you start unintentionally. Wear short sleeves and tie your hair back or wear a bandana. Work on a fire-safe surface like glass or wood.

PREPARING TRANSPARENCIES

If you inspect an unprinted transparency sheet, you will notice that it has a shiny (front) side and a rough side, which is the side that gets printed on. Don't forget to reverse the image – especially if it includes text so that it looks correct when the shiny side is facing up. You also need to let the printed ink-jet transparency dry completely (preferably overnight) before you handle them to avoid smudging.

BURNING TRANSPARENCIES

You can use a lighter, but if you're melting more than one image or going for a distressed look, I recommend using a candle to avoid burning or fatiguing your fingers.

Take the edge of a transparency image and pass it along the tip of a flame. The faster you pass it through, the cleaner the melted edge will be. The plastic continues to melt for a second after it is out of the flame so work a little bit at a time. You can vary the look by leaving a wider, unprinted border. The wider the border, the more grungy and aged the image will become. If you want a clean melted line, trim the image right up to the printed area and pass it along the flame quickly once or twice.

The transparency can catch and hold fire so don't leave it in the flame too long.

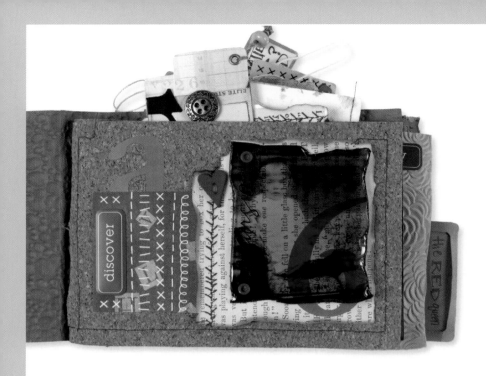

work with a monochromatic palette when using lots of layers. This gives me more freedom with the colors of other embellishments without making my piece look too busy.

The treated transparencies can be attached to the pages through all the attachment mechanisms outlined in the Transparency 101 article in the first chapter of this book. When adding hand-stitching or embellishments to the top of the transparency, make sure to anchor them through at least one or more layers of paper or fabric to prevent the thread from tearing up through the image. Try adding mother-of-pearl buttons, glass beads or small metal elements to liven up an image. You can also sandwich small objects between the transparency and closest layer.

You can use this to your advantage and create holes along the edges to add character. Transparencies also have a tendency to curl up as they melt. Allow each edge to cool before moving to the next side or the hot plastic will stick to your fingers and burn. Don't be afraid to blow out the fire and to burn it multiple times.

CONSTRUCTING THE PAGES

I like to layer paper and fabric with my transparency images to soften the feel and make my pieces more whimsical. Generally, I use an inexpensive white fabric like muslin or a pale-colored felt behind my transparencies so you can see all the details of the image. I like to

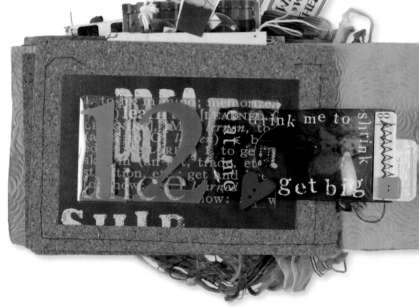

To add even more interest, create pockets and insert additional items of interest such as embellished tags with pull-tabs. For this project, I pre-stitched cork paper on three sides with a sewing machine to create the pockets.

CONSTRUCTING THE BOOK

Binding is one of the more difficult tasks when making books and is best learned from one of the many classes or books available. I taught myself using books by Shareen LaPlantz and highly recommend them to anyone interested in learning how to properly bind books and journals.

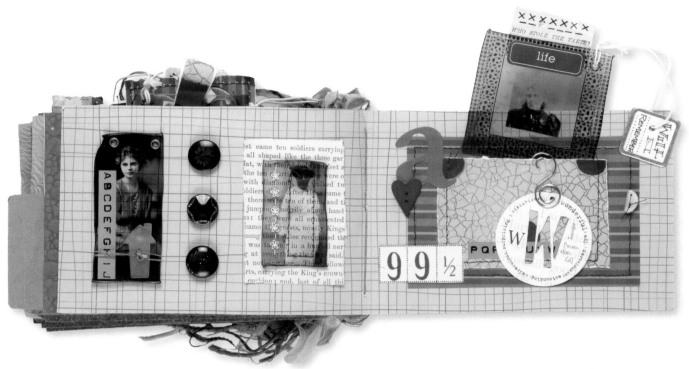

USING EYELETS & OTHER SUPPLIES

Eyelets can be really frustrating when you are first learning to use them, but with patience and practice, you can master the technique. Remember to set eyelets on a hard, flat surface with a firm hammer blow. They are a great way to dangle or attach things to transparency images. If you print an image out in black and white, you can use colored eyelets to add spots of color. Try dangling things off the edges of the transparency image through eyelets by using a ball chain or colorful yarn.

Rub-on words, letters, and images are fantastic for adding on top of transparencies. They stick beautifully to the smooth and shiny finish of the transparency's top. It's best to add these before the melting process, while the transparency is still flat. Pull up the transfer slowly to make sure that you've completely rubbed all parts of the word onto the transparency.

- Lighter shaded images or ones with bold contrast work best when printing on transparencies.
- Punching holes in the transparency prior to melting allows you to create holes with a unique effect.
- Try adding a layer of unprinted, melted transparency behind the top transparency image for a floating effect.

Jen Osborn is a mixed-media artist from Mason, MI. To see more of her work, visit www.identityseven.com.

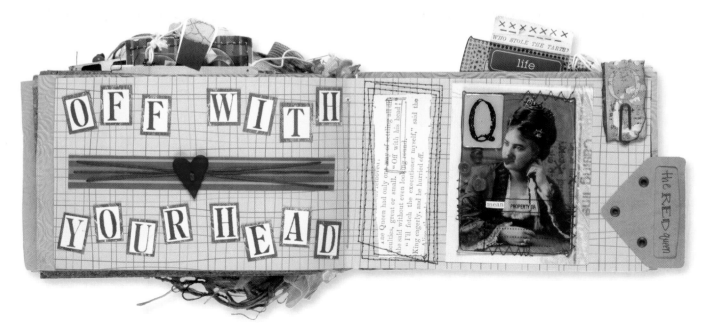

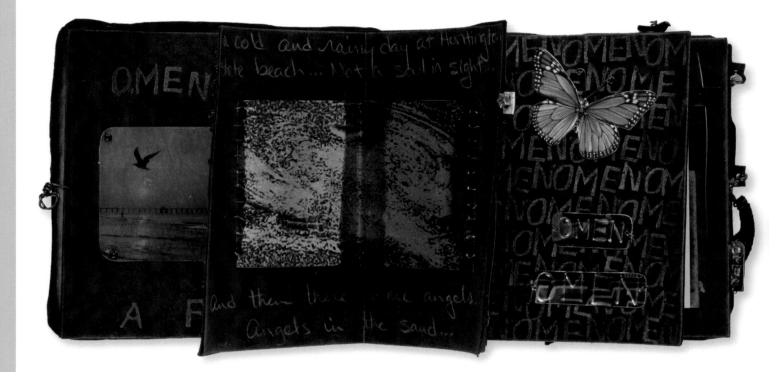

Beneath the Layers

by Tracy Tatro

Art is my therapy. Layers of emotions, memories, and events spill into my journals and books. This book is filled with omens that have been haunting me this past year as my husband has struggled to fight lung cancer. I tend to see sad things...scary things...omens...but find that when they are transformed into art, another dimension or meaning begins to show through.

I've always liked the look and feeling of layers in my art, because that's the way I think and feel. That's who I am. Windows in journal covers give a peek at the feelings inside, transfers and transparencies layered over text or photos add depth and emotion. Inspiration can come from many things ... a song or conversation, a found feather or cat whisker, a lonely walk at the beach.

The omen book began with the creation of the sand angel last December, a particularly sad time in my life. The fact that I can take feelings of sadness and transform them into art is definitely a good omen.

For both the book and the ATCs shown here, I have layered transparencies with treated soda can segments or pieces of mylar. The process of burning the soda can is therapeutic and a bit unpredictable. Layered beneath transparencies, the burned metal adds color, and to me, signifies surviving a struggle and taking something "usual" and transforming it into something unusual. When attached to the metal, the transparencies take on the look and feel of old tintypes. The reflective quality of the mylar picks up colors and light from the surroundings, and viewers often become part of the art, adding their own color and movement to the images

SODA CAN & MYLAR

Carefully remove the center (flat) section of soda can with a sharp craft knife or scissors to yield one flat piece of metal. Use caution when handling, as edges will be sharp! Burn the metal with a propane torch or other gas flame. Be sure to work outdoors during this process, with plenty of ventilation. This process produces smelly smoke, so take all precautions not to breathe it. The metal will be HOT, so hold it with rubber-coated pliers.

Print black and white photos onto adhesive-backed inkjet window decal transparency sheets. Cut out image and decide which part of the burned metal complements the image when layered. There should be a variety

TOOLS & MATERIALS

To achieve the layered look with soda cans or mylar, you will need:
- Inkjet printer
- Sharp scissors
- Sharp craft knife
- Empty soda cans
- Rubber-coated pliers
- Serrated edge scissors
- Silver mylar (gift wrap)
- Packing tape (optional)
- Black & white photocopies of images
- Small propane torch (or other outdoor gas flame)
- Self-adhesive inkjet window decals (by Mirage available at www.mcgpaper.com)

To construct the book, you will also need:
- White glue
- Silver pencil
- Embellishments
- Double-stick tape
- Metallic inkpad (Colorbox)
- Window screen (for spacers)
- Covers cut from old library book
- Tool marking ABC set (Pittsburgh)
- Black construction paper (for pages)
- A book with instructions for star-format book (I recommend *Cover to Cover* by Shereen LaPlantz)

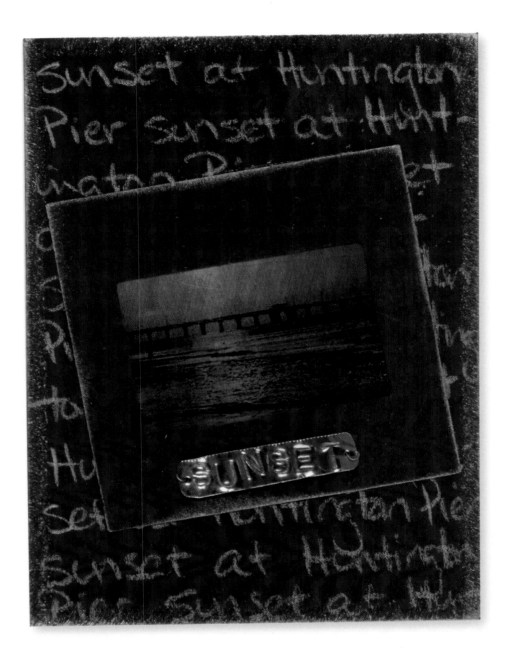

of color on the backside of the metal, as well as the printed side. Remove backing from transparency and press it in place on the metal. Use serrated edge scissors to cut around image, rounding corners to reduce sharpness. This will result in a metallic-looking image.

If a reflective quality is preferred, place transparency on a piece of mylar and cut around edge of image with sharp (non-serrated) scissors. I usually prefer high contrast black and white images, but it can be fun to experiment with color ink-jet photos layered over mylar and soda can.

Another alternative to making transparencies is to use clear packing tape. Photocopy black and white images. Cut out the images, cover with a piece of packing tape, and burnish with fingers. Submerge in water for a few minutes and carefully rub off paper. The image will be transferred to the tape. Stick the tape image onto the burned metal or mylar.

THE BOOK, ATCs & BEYOND

For the book, use black construction paper pages and window screen spacers to create an eight-signature star book base by following directions found in a book by Shereen LaPlantz titled *Cover to Cover*, or other comparable book-making publication.

Hand write text with silver pencil or stamp background words with metallic Colorbox inks. Burn edges of existing book cover and stamp title with tool marking ABC set (Pittsburgh). Attach prepared transparencies layered with treated soda can or mylar to the pages and embellish. Glue base to covers and top pages to base.

In like fashion, incorporate the transparencies with treated soda can or mylar to ATCs or any other art project that you choose.

Tracy Tatro lives in Fountain Valley, CA and can be contacted via e-mail at aspenswhiskers@aol.com.

I first encountered transparencies
in a workshop, several years ago.
One of the students was
using them in her work,
and I just about jumped up
and clicked my heels with excitement.
It was one of those "a-ha" moments,
when you discover something so simple,
yet full of possibilities.
CAROL OWEN

Assemblages & Hangings

Spirit Houses

by Carol Owen

I first encountered transparencies in a workshop, several years ago. One of the students was using them in her work, and I just about jumped up and clicked my heels with excitement. It was one of those "a-ha" moments, when you discover something so simple, yet full of possibilities. I have been using them ever since. They fit in perfectly with the stories I tell in my Spirit Houses.

Transparencies can serve as windows that invite the viewer to step inside and take a closer look, or they can be used as a layering element, with a transparency placed over a paper photocopy. A picture of a person showing through a different figure on top implies a visual memory of the past -- a compelling and somewhat mysterious connection between the two. It asks questions of the viewer about the relationship between these figures.

Nowadays, you can conveniently buy transparencies pre-printed with images. You can also make your own. I like to do both. When I make my own, I use overhead transparency sheets found at office supply stores. I get the kind meant for ink-jet printers, since that's what I have in my studio.

When making transparency copies of photographs, those with a lot of open space work best. After all, you want what is underneath to show through. If you use a photograph with a lot of dark areas, it defeats the purpose.

When you layer the transparency on top of your work, you might have to move the elements around a bit so that the faces, or whatever you want to show, are not obscured by what's underneath. And remember, the transparency will show up best on a light background.

I use textile glue with my paper

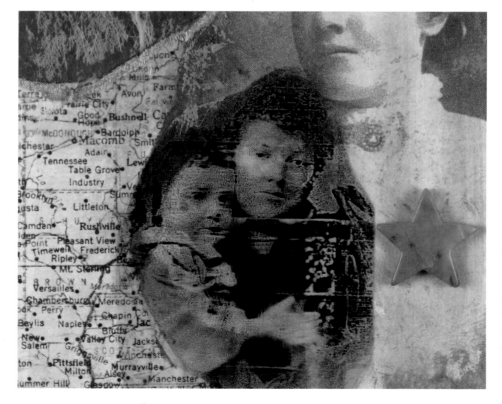

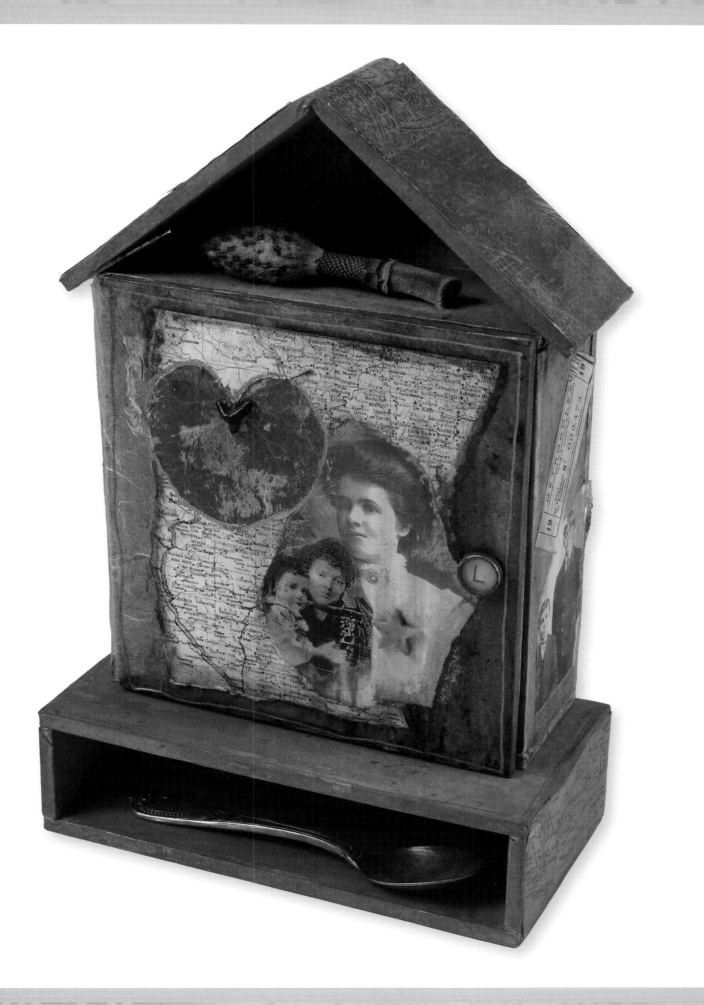

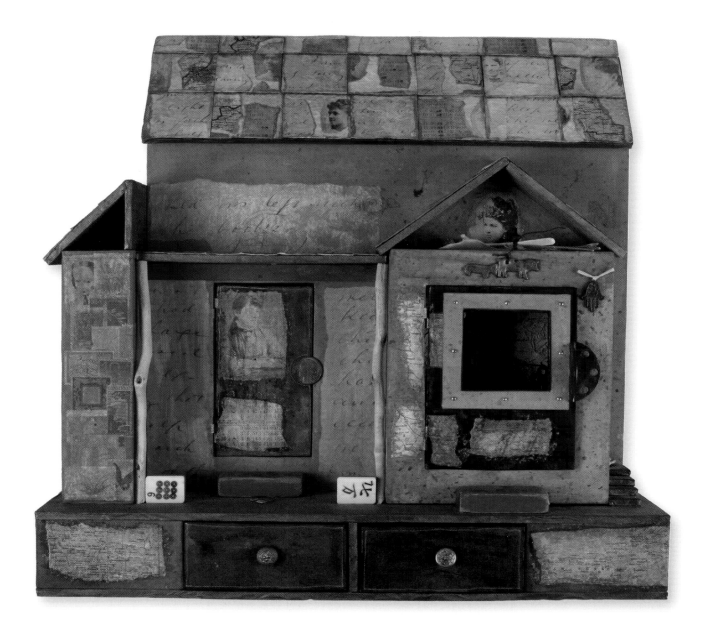

collages, and the same glue works with transparencies. If I am using a picture of a person, I cut around the edge of the figure or the face, eliminating extraneous background material. Then, to layer it over another image, I'll use a little of the textile glue, just on the edges of the transparency. The glue dries clear and isn't visible.

Often, I create a window in one of my Spirit Houses, by cutting an opening in the door and fastening the transparency in the opening. If the door is glued in place, and the backside won't show, the transparency can be adhered underneath the opening without worrying about the edges. But if the door can be opened, and both sides will be visible, I want the back to look neat, so I may cover the glued edges with collage or ribbon or decorative paper.

Working with transparencies is seductive. I love the effect and I don't think I've exhausted the possibilities

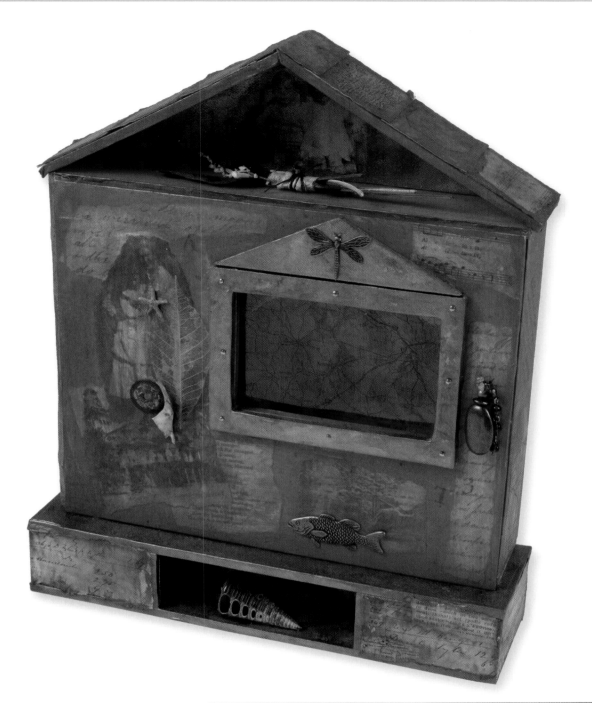

yet. Sometimes, I have to remind myself that I shouldn't use them all the time on everything! I hope you will give transparencies a try. It's a very satisfying way to get a big effect with very little effort.

Carol Owen resides in Pittsboro, NC. She is the author of a book titled Crafting Personal Shrines by Lark Books. To learn more about her work, visit www.carolowenart.com.

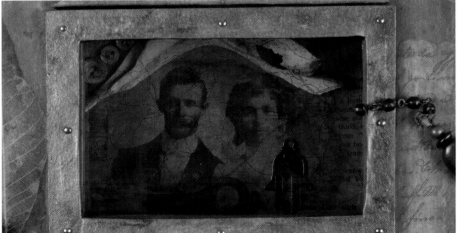

The Promise of Spring

by Nina Bagley

Some time early in March, deep in the heart of a never-ending freeze, I received a slender cardboard envelope from workshop student and friend Angela Cartwright. It was yet another grey day, bone-cold, and the walk back up the hill to my house led me underneath branches bare with the lingering emptiness of a stubborn mountain winter. Peeling back the seal, I tilted the open envelope and out slid a transparency faintly flushed with color. Held up to the sky, I could see the familiar image – that of a grand old tree, alive but naked, its own branches as bare as the ones flanking my drive, and I was instantly moved by the notion that this tree, held between careful fingers, was reaching for the sun, for warmth, for the promise of spring.

Angela had written me, asking if I would like to design a piece of artwork using an image from her line of transparency designs, and from there we planned on getting our heads together at the upcoming Art & Soul retreat in Portland, Oregon. Over dinner one evening, Angela spread an array of breathtaking images before me – nests, windows, gateway entrances that led to further mysteries down a winding road. How to choose just one?! I've always been drawn to the use of natural findings in my work – rocks shaped like hearts, twisted twigs, abandoned nests – and with Angela's suggestion that I construct a window hanging using the same, I instinctively reached for the tree and the design began, "naturally" to fall into place.

First-time visitors to my studio stand in the doorway with mouths agape as they visibly struggle to take in the stacks of vintage photographs, jars overflowing with ribbon, thin slabs of mica towering atop my worktable, small bundles of branches in corners, bowl after bowl of rocks and dried vines encroaching floor and table space like summertime kudzu. I shrug, grin, and ask, "What can I say?"

Most of my treasures do miraculously make their way eventually into pieces of artwork, in the form of jewelry, artist books, or assemblage, and I've grown accustomed to the flotsam that consumes my workspace with quirky character and grace. I find myself shrugging as I write this just now. Really – what can I say?! It's art. Or it will be, soon enough. And easy reaching access to these assorted findings lends great flair to what I consider spontaneous creation.

Look, with me, at the window hanging I designed for Angela's bare tree. Note the lovely gnarled twig from which the vintage photo album page is suspended: I've held onto that particular small section of a burl oak tree ever since I taught at Valley Ridge Art Studio in the countryside of Wisconsin last August. The ribbon? Some of it velvet, dunked in holiday orange spiced tea, and some of it French haberdashery silk trim, dyed in a huge pot of simple black tea and afterward stuffed haphazardly into a house-shaped cardboard box at my elbow.

The wooden egg was a gift from a student; fabric snippets were infinitesimally small bits of coveted barkcloth (pun very much intended) that I kept with other tiny flyaway scraps of fabric and ribbon within a huge zip-locked bag. And under the words at the bottom of the window hanging, some treasured paper-thin strips of birch bark peelings, a tidy roll of which was sent to me by a dear friend from Pennsylvania.

See how the light captures the tree? Doesn't the image make you, too, pine for spring? For light, for warmth, for whispers of longer days to come? Thank you, Angela; my winter day, that day, was made pleasant and warm, and whenever I see this tree again, I'll thank you for spurring my creativity on into the anxiously awaited greenness of spring.

Nina Bagley lives in Whittier, NC. To learn more about her work, please visit www.ninabagley.com.

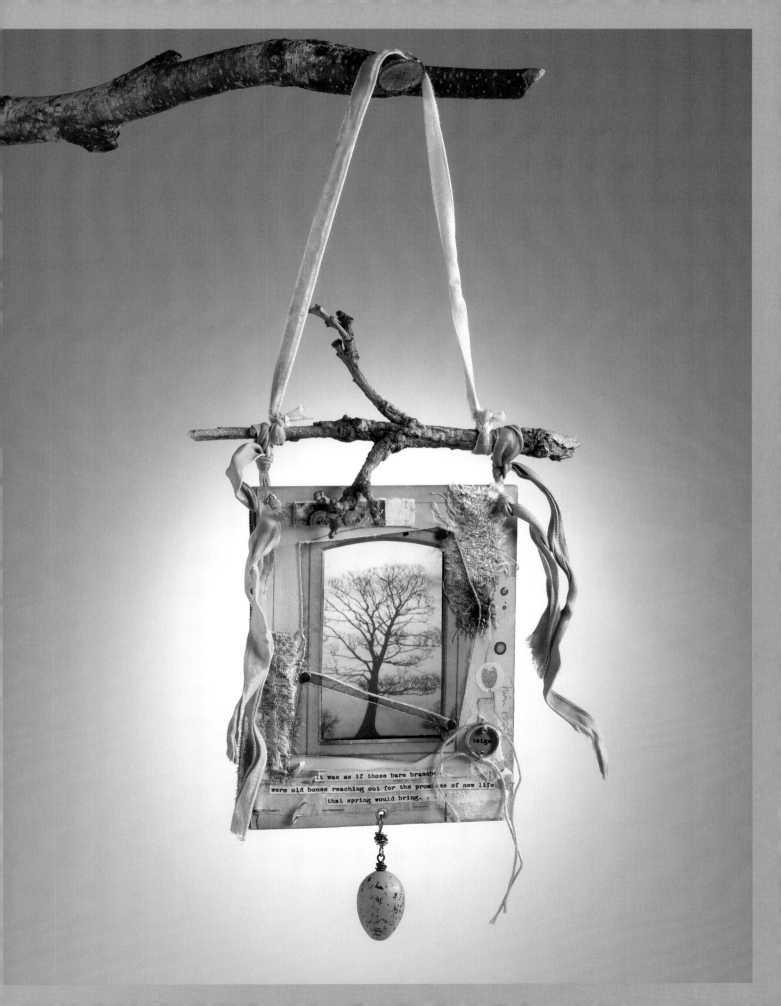

It was as if those bare branches
were old bones reaching out for the promises of new life
that spring would bring. . .

Visual Haiku

by Kim Tedrow

As a poet and a mixed-media artist, I often translate ideas from one discipline to the other. Once in a writers' workshop, we learned about "haiku," which is a form of Japanese poetry with 17 syllables in three unrhymed lines of seven, and five syllables. The workshop challenged us to think about haiku as if it were a photographic slide and to visualize what was outside of the frame, what happened before, and what happened after.

Prompted by ARTchix Studio transparency sheets, and inspired by a box of glass slides and the ideas in the haiku exercise, I made these miniature altered board books. Like the poetic version of haiku, these miniature "scenes" capture a moment, and invite the viewer to imagine the context as well as the moments before and after. The transparencies further invite the viewer to open the book and fully reveal its contents.

Technique

Using a sharp craft knife, cut a 2-1/4″x2-1/4″ niche through all but the back cover of the board book. Create a background on the inside back cover. I used scrap lace, acrylic paint, and small craft mirrors. Using Diamond Glaze, glue all pages together except the front cover. Clamp or weight down the pages until dry. To assemble the "scene" within, use images, art stamps, small objects and ephemera.

Separate the front and back panes of the slide mount. Place the transparency in between the two panes and snap them back together. Alternately, the transparency can be adhered to the front or back of a single pane with a thin strip of Diamond Glaze.

For the closure, drill two small holes on the right side of the book, and one corresponding hole on the cover. With needle and thread, attach a button using the small holes on the side, and then attach fiber through the hole in the cover.

Decorate the "frame" of the slide mount in any number of ways (or leave it as is). I've used polymer clay strips and ARTchix Studio metallic borders. Adhere the slide mount to the board book using a thin strip of Diamond Glaze around the niche, and gently weight it until dry.

TOOLS & MATERIALS
- Scissors
- Art fibers
- Art stamps
- Gel medium
- Paintbrushes
- Acrylic paints
- Diamond Glaze
- Needle & thread
- Sharp craft knife
- Rotary tool & drill
- Assorted embellishments
- Transparencies (ARTchix Studio)
- Polymer clay for a frame (optional)
- 60x60 mm glass slide mounts (Gepe)
- Children's board books (2-3/4″x 2-3/4″)

Tips

- Keep in mind the objects in the niche show through the cover so select objects and images that work with the transparency.
- Using a sharp craft knife to cut the niche takes a long time. I used my rotary tool with the cutting wheel attachment, then finished the corners with a craft knife. Wear a mask when you do this!
- The "linguine" feature of a pasta machine makes strips of clay exactly the right width for the slide frames. After making the strips, I texturized the clay with rubber stamps, baked it, and adhered it to the frame with Diamond Glaze.

Kim Tedrow lives in Lincoln, Nebraska, and can be reached by e-mail at kimtedrow@aol.com.

Her Eyes

by Gloria Page

I collect interesting wood boxes from thrift and antique stores and selected one for this project. It had a back piece and I needed to open it up, so I removed it. Fortunately I was able to slide the internal shelf unit out and with a scroll saw, cut several pieces to free up even more space.

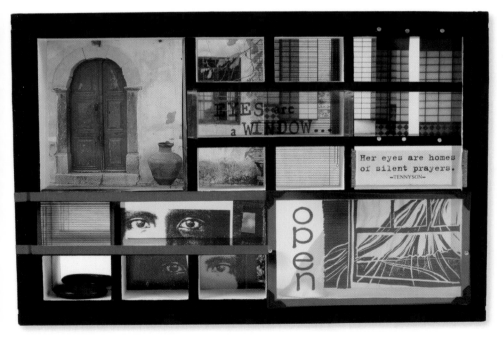

The design elements all came together to center around the photography of Edward S. Curtis that I found in an old calendar. I love the eyes of one of the young Native American women he photographed and started from there. I wanted to incorporate places I love and contrast the images with

each other. From another calendar photo – this one of Greece – I came up with the wonderful red door and turquoise walls. New Mexican windows and an art stamp of a window shade added more layers.

Next, on to Japan, especially since the wood frame took on the look of a shoji screen, especially after it was painted black. The black and white Japanese images are from a set of postcards. I used ivory paint on the inside surfaces to lighten the tones and give more depth. The Tennyson quote fit. I wanted any words printed to say a little and then let the viewer add his or her own story to it.

Words, black and white images, color, printed and stamped (JudiKins, stampcraft), I wanted to try it all. The elements were laid out on two 8½″x11″ sheets, scanned, and then printed onto two sheets of transparencies (Hammermill), and cut from there. The open window image is a transparency stamped with StazOn ink. I carved that piece based on a photo of a painting by Andrew Wyeth. It was great fun to make the "curtain" with sheer fabric and to add the shell.

Once all the transparent elements were prepared, it was a matter of assembling and adding dimensions. The mirror in the corner with a black stone invites you to look into the mirror and interact with the piece: now you see "my eyes."

Adhering all the pieces was a trick, and I decided to use different art supplies, from tiny nails to copper foil tape, photo corners, narrow masking tape, and assorted glues and glue sticks: whatever seemed to add texture and interest and not be in the way visually.

Gloria Page is an artist and author of the self-published art memoir Holy Moly Mackeroly. Her second book, Art Stamping Workshop by North Light Books, will focus on creating hand-carved stamps and incorporating them into art projects. The book will be available at the end of 2005. To learn more about her work, visit www. impressionsart.com.

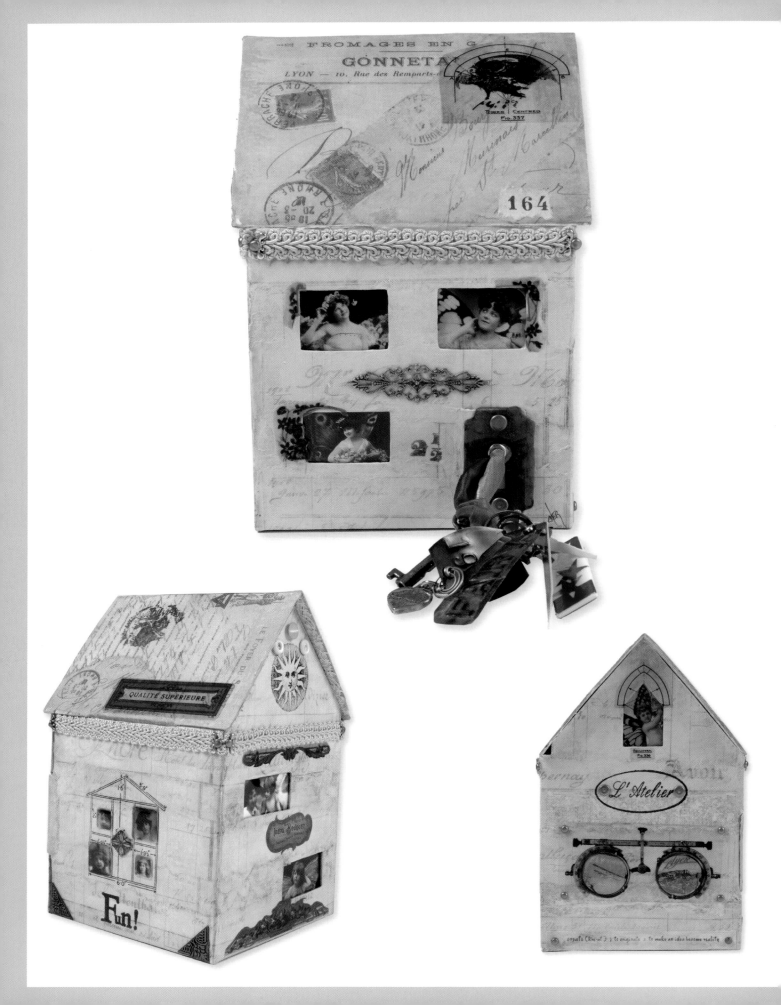

To Build a Cottage

by Cher B. Lashley

My home is a structure where I can look out upon the world around me from a cozy shelter surrounded by belongings that reflect my creativity, as well as, collections acquired on the road of my personal journey. However, like everyone else, there are secret dream places that only reside in my imagination.

This wonderful little house kit, along with images evoking that dream-like quality achieved through the process of printing them on acetate, allowed me to explore one of the structures in my imagination. With these innovative artist's tools I was able to create my secret French cottage without leaving my studio. The more I manipulated these transparent images, the more my creative process went into overdrive and before I knew it, this secret dream became a diminutive reality that makes me smile every time I look at it. And honestly, there is no better "reality" in my life's journey than that!

TOOLS & MATERIALS

- Walnut ink
- Acrylic paints
- Embellishments
- Sharp craft knife
- Glazing medium
- StazOn black ink
- Mini brads & tacks
- Clear epoxy stickers
- Vintage postage stamps
- Pickling White wood stain gel
- Copies of vintage French envelopes
- Copies of vintage French ledger paper
- Chipboard house kit (ARTchix Studio)
- Vintage wallpaper (sanded and torn into strips)
- Transparency images (ARTchix Studio, Red Letter Art)
- Adhesives (Crafter's Pick Ultimate, Uhu glue stick, Glue dots)
- Art stamps (Green Pepper Press, Limited Edition, Stamper's Anonymous, Great Impressions)

Technique

Using craft glue thinned with water, the house portion of the kit was covered with strips of vintage French ledger papers and alternated on every other panel with strips of wallpaper. A glaze mix made with walnut ink and acrylic paints was applied over the dried strips with a final coat of a mix made with glazing medium and Pickling White wood stain gel added to soften the look. The roof was covered with vintage envelopes and glazed with a mixture of glazing medium and acrylic paint.

Window transparencies were cut larger than the openings and affixed from the inside, using a glue stick around the edges. Embellishment transparencies were elements cut from French label images and adhered with a glue stick, including the cut matte postage circles behind the optician lenses. All stamping over the glazing was done with black StazOn ink. Most three-dimensional embellishments were held in place by craft glue. The metal corners and epoxy squares were adhered with glue dots. Mini brads and tacks were used for reinforcement and design element on the heavier pieces. Custom epoxy squares were created by affixing the square over faces of various transparency images or stamped vellum, then trimmed to the edges.

The front door was overlaid with a key plate transparency with a hole punched and eyelet set to accommodate the wired ribbon that secures the vintage key and other embellishments. After assembling the house according to the kit's instructions, craft glue was used at all joineries to ensure stability.

Cher B. Lashley lives in St. Augustine, FL.

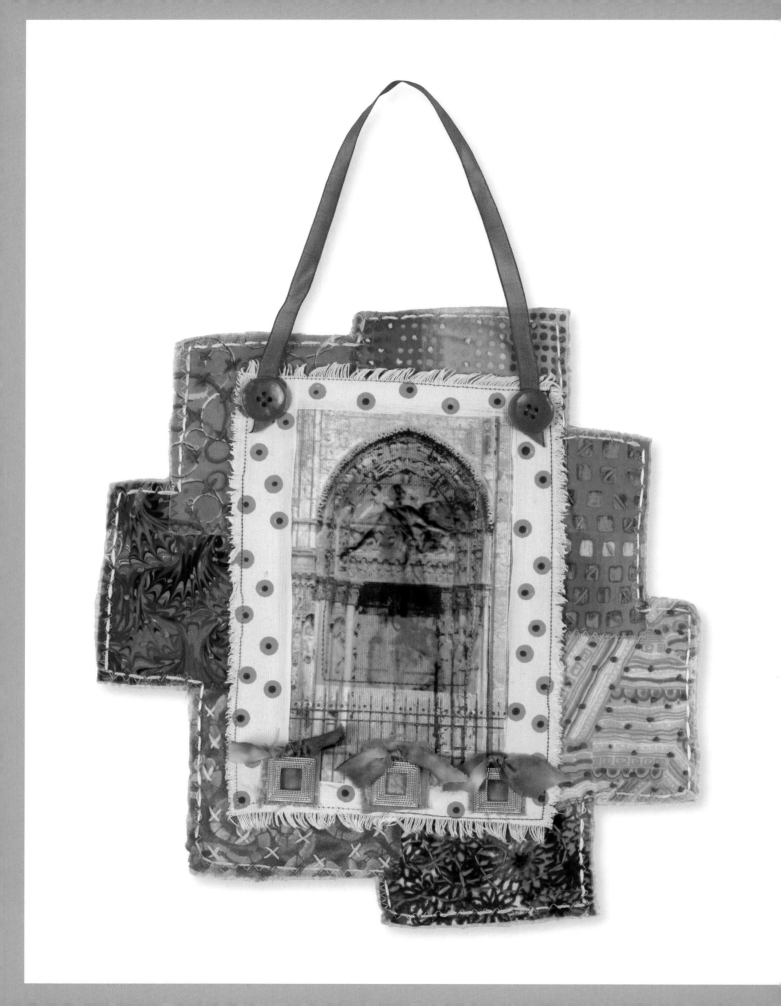

Layer It On

TRANSPARENCY WALL ART

by Chrissy Howes

The beauty of transparencies, or acetate sheets, is the depth they add to art in one simple step. By building layers of mixed media elements within a piece, one is adding dimension and meaning. The pieces I created for this article are truly mixed-media. They involve fabric, acrylic paint, paper, transparencies and a tranfer to unstretched canvas.

I began by selecting images from the files on my computer that I thought would mesh together. I opened each photo in my Adobe Elements program and proceeded to change the hue, saturation and contrast. I wanted the images to be bold, bright and colorful. When I was finished digitally altering the images, I printed them onto transparencies and Avery Inkjet T-shirt transfer sheets. This is when the real fun begins!

To transfer the images to unstretched canvas, I began by cutting a piece of unstretched canvas (this is sometimes called duck cloth at your fabric store). Following the instructions on the package, I ironed the transfer onto the canvas. After the transfer had cooled, I then began adding layers of paper and acrylic paint to the unstretched canvas. To add even more depth, I selected a transparent image and using my sewing machine, I attached the transparency over a portion of the canvas piece. Paper and fabric finished up the layers underneath the canvas collage.

Transparencies have to be one of the most versatile elements to date. They can be transferred, sewn, cut and stapled back together, but the true beauty lies in the mysterious, ethereal depth that they create.

"Gloria" (shown on the opposite page) is one of my all-time favorite creations. The same techniques were used to transfer the image to unstretched canvas. I added acrylic paint and then utilized my sewing machine to layer the angel transparency. Using 4″ squares of coordinating fabric, I created a base for the collage with unusual visual interest. The unstretched collage was sewn to the base, with embroidery stitches added for detail. I added a silk ribbon to hang this piece.

"Dreams" is actually two collages that I decided to combine. I have an unusual infatuation with old, broken-down buildings. They seem to hold secrets ... untold stories. Using wire and beads, I connected the two collages through large eyelets. I added a sleeve at the top of the piece to insert a small dowel. I attached various fibers and vintage beaded costume jewelry to hang the finished piece.

Chrissy Howes is a mixed-media artist living in northern Minnesota. She is the publisher of a mixed-media art zine, ARTISTA ZINE. To view more of her work, visit www.itsmysite.com/ tigerlilycreations.

Once the transparency is in the vessel,

you can take it out

to make adjustments,

but only do this a few times.

Every time the transparency

comes out of the ball or bottle,

the glass leaves small scratches

that will be visible.

CYNTHIA SHAFFER

Glass

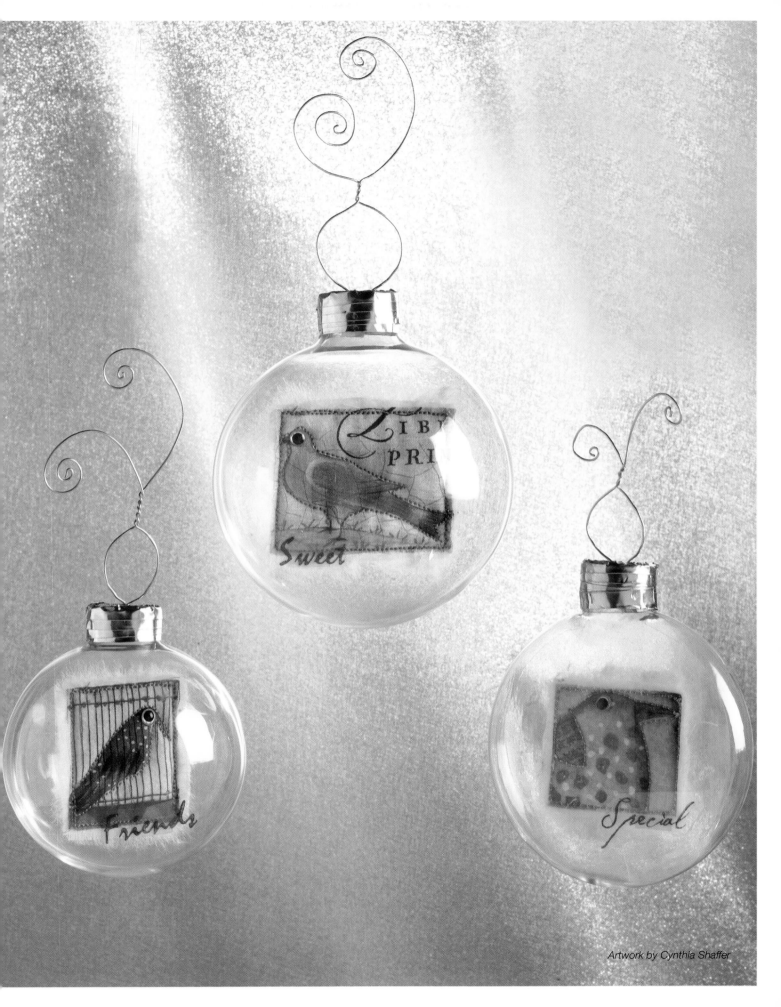

Artwork by Cynthia Shaffer

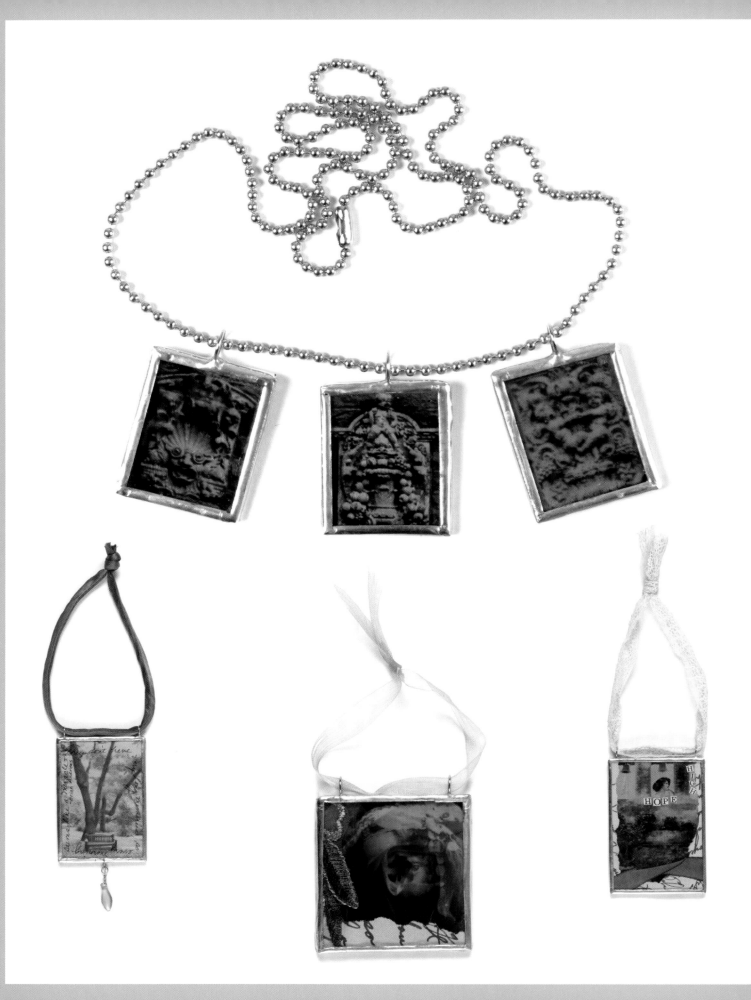

All Things Little

by Muffy Alongi

had been obsessively gathering and collecting found objects and papers for many years with absolutely no idea why, other than the fact that I wanted to use them in a creative manner. I had also been totally fascinated by all things miniature, and had also been amassing all things little.

When I discovered collage and altered art, I realized that I could finally recycle my collected treasures in the manner for which they were intended. It was a natural progression for my art to evolve into something small and wearable. When I started seeing soldered pieces in different publications, I fell in love with them and knew that was something I needed to teach myself how to do.

In my acquiring of "things," I had been drawn to collect transparent images. I wasn't sure what to do with them, but at least I had them, for when I figured it all out. When I met Angela Cartwright in an art class, she commented on a soldered pendant that I was wearing. I offered to make something for her out of her transparent photos, as I knew that if I had created those photographs, I would want to wear them, or at least to experience them in some other venue than a wall. I went home and made the triptych series of pendants for her.

This experience inspired me to consider my own stash of transparencies and how I might use them in the pendants and ornaments I was making. This opened my eyes to a whole new way of layering images in this tiny format. In working with Angela and her transparencies, I have come up with a process that optimizes the use of transparent images in soldered glass art to create jewelry to wear or to use as adornments for the home.

TOOLS & MATERIALS
- Flux
- Cutting mat
- Copper tape
- Soldering iron
- Transparencies
- Diamond Glaze
- Lead-free solder
- 7mm jump rings
- Microscope slide glass
- Found papers & objects
- Rotary type glass cutter (optional)

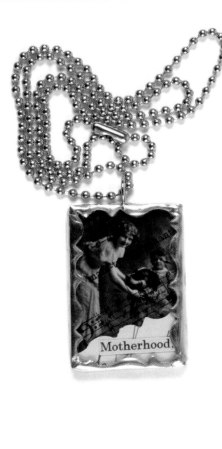

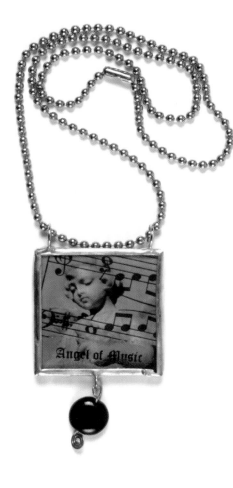

Technique

Microscope slide glass can be purchased in standard pre-cut sizes. If you like the size they come in, you can simply create a design that fits within the pre-cut size. For me, I like to cut the slides into even smaller sizes by using a rotary-type glass cutter. Because the pre-cut slides are already small to begin with, the process of cutting them is not too cumbersome. Simply place the glass on a self-healing cutting mat with a measurement grid and use the cutter to score and cut the glass. After some practice, you will be able to cut glass into miniature sizes to suit small-scale designs.

After you select a transparency image, cut two pieces of glass to fit the transparency. Trace the glass over the transparency and cut the transparency with scissors. Adhere the transparency to one piece of glass with Diamond Glaze. Allow to dry for at least 24 hours. Compose a collage behind and/or in the front of the transparent image. Sandwich the collage with another piece of glass and tape the edges together with copper tape. Burnish the tape as smooth as possible and apply flux to all the taped areas. Solder all four sides, being careful to work quickly with the soldering iron. Excess heat will cause the Diamond Glaze to react and become distorted. Solder a jump ring to the top so that it can be hung or worn.

Muffy Alongi lives in Vancouver, WA and can be contacted via e-mail at malongi@comcast.com.

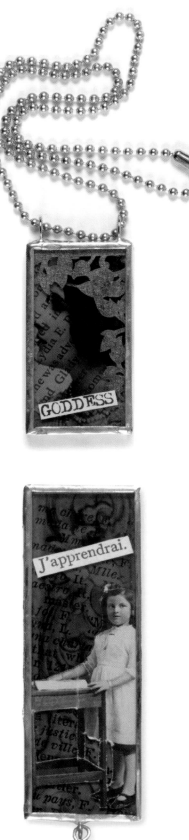

Mini Art Quilts in Vessels

by Cynthia Shaffer

I love all things mini. And I have found that the more I become skilled in learning a craft, the more I start scaling that craft down into miniature form. Mini is about details. Mini is about fun. Mini is about magic.

When I was 7 years old, I took formal oil painting lessons and was required to paint on large canvases to learn composition, color theory, and basic painting techniques. As my skills and knowledge increased, I began to paint still life scenes on miniature canvases -- some as small as 1˝x4˝. I was in my glory.

My love for sewing sprouted only one year prior to my painting lessons, and to this day, continues to be my life passion. A few years ago, when I found

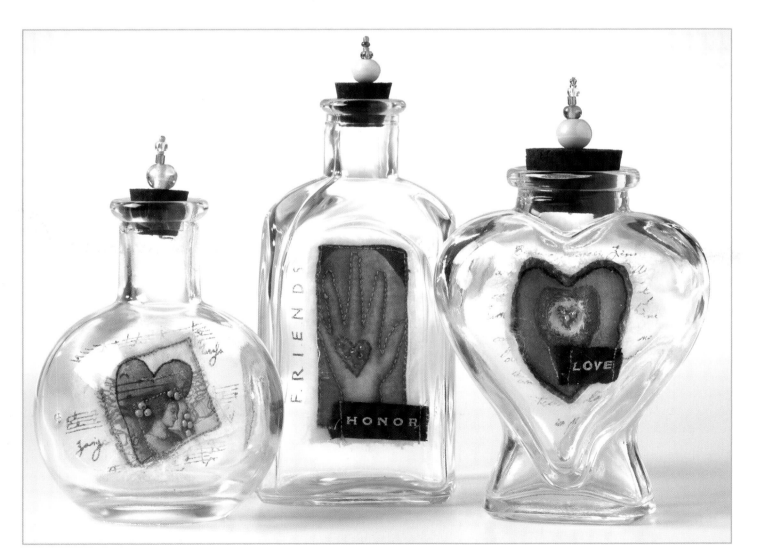

myself at home as a "stay-at-home" mom, I began to quilt. Each day, as I faced the challenge of changing diapers and cleaning bottles, I motivated myself by stealing moments here and there and completing one quilt square by each day's end. In no time, all the squares were done and the quilt top was ready to be assembled. Just like the oil paintings, my first quilts were very large – large enough to cover king size beds or to hang on large walls. Again, as my skills and knowledge increased, my quilt projects became smaller, and

today, what I enjoy most is making miniature quilts with very tiny details.

Recently, I attended a rubber stamp convention and of course I had to visit Tracy and Teesha Moore's Zettiology booth. There, I discovered a small piece of muslin with several of their images printed on it with all their miniature and terrifically quirky details. My mind was spinning at the thought of making a series of mini art quilts stitched to transparencies, rolled up and slipped into a glass ball or bottle. The technique is simple and the results are stunning.

TOOLS & MATERIALS
- Batting
- Silver tape
- Art stamps
- Transparencies
- Sewing machine
- Scraps of muslin
- Black StazOn ink
- Black permanent marker
- Glass vessels (balls or bottles)
- Small images printed on muslin (Zettiology)
- Embellishments (beads, eyes, wire, words on ribbon)

Technique

Cut out the image you are going to quilt leaving a ¼" border on all four sides. Cut out batting and muslin slightly larger than the size of the image. Sandwich the batting between the image and the muslin backing and stitch together around outer edge. Fray the edges of the image and the batting. Leave some of the threads still attached. Stitch or quilt around the details of the image to help them pop out. Embellish the miniature quilt with beads, eyelets and other findings. Scrap pieces of transparencies can be rubber stamped with words or letters

and then cut and sewn onto the mini quilt as well.

Lay the glass ball or bottle down on a transparency and trace around the shape using a permanent maker. Be sure to include the "neck" portion of the vessel that you are tracing. With scissors, cut the transparency slightly smaller than the traced shape. Roll up the transparency shape and slip it into the vessel to check the fit. The unfurled shaped should only slightly touch the sides of the vessel. The "neck" helps to spin the image around and keep the transparency in its place.

Curl the "neck" up and pull the transparency out and make any adjustments needed by trimming the transparency with scissors. At this point, you can use black StazOn ink to stamp a script image at the center of transparencies, if desired. Center the miniature quilt on the transparency and stitch in place. Roll up the transparency as tight as possible and slip it back into the vessel. Top the bottles with black corks and beads, and wrap the tops of the glass ball with silver tape and add silver wire for hanging.

Tips

- When preparing the transparencies, use colored cardstock to make a template first. Roll this up and slip it into the ball or bottle. As it unfurls, you will be able to see exactly where you need to trim away (or add to the transparencies) to get a great fit.
- Use double-sided tape to adhere the miniature quilt to the transparencies to avoid shifting while stitching.

- Once the transparency is in the vessel, you can take it out to make adjustments, but only do this a few times. Every time the transparency comes out of the ball or bottle, the glass leaves small scratches that will be visible.
- Once the transparency is in place, put a small piece of double-stick on the inside of the neck, and press the

transparency to the tape. This will keep the image from moving when you add the tops.
- If the transparency does not unfurl completely, use the eraser end of a pencil to position the image.

Cynthia Shaffer lives in Orange, CA and can be contacted via e-mail at shaffy@pacbell.net.

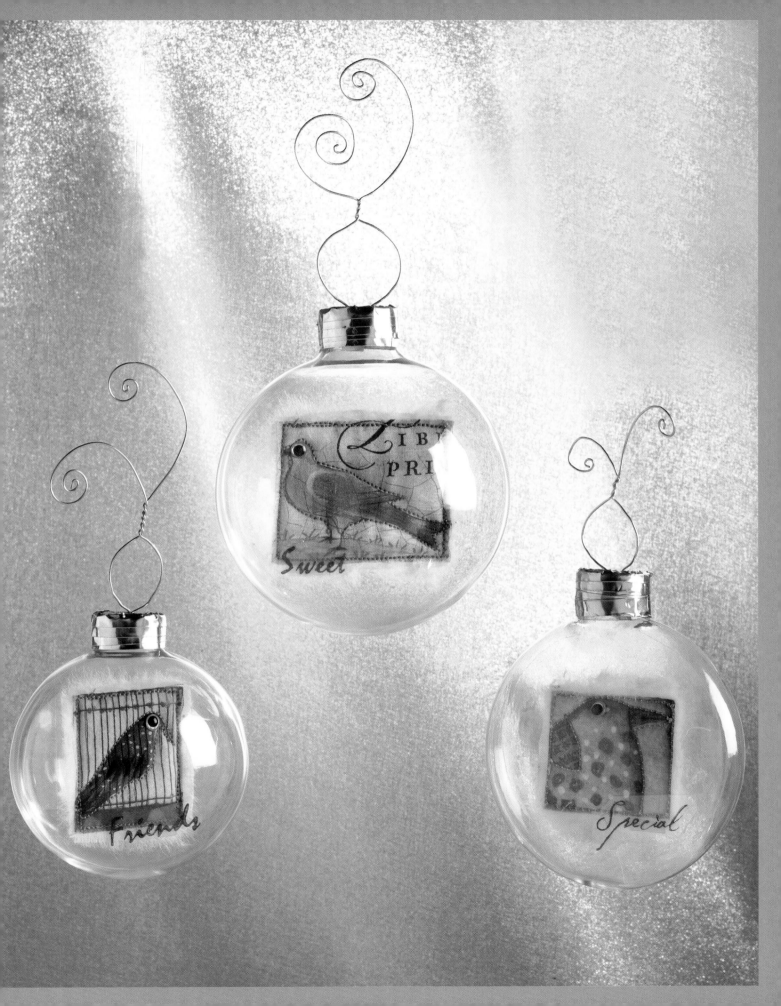

Adorable Ornaments

by Lisa Cook

It's fun to look at art materials in a new light, so as I held a transparency image in my hand, I did some word associations: transparency – transparent – glass – light. Instead of placing the transparency on an opaque surface, why not use it for a soldered ornament that can hang like stained glass on a window? That idea excited me as I held up different images and quotes to the light. A new variation on my soldered ornaments was born.

Technique

DESIGNING & SANDWICHING

Hold the transparency images up to a window and move microscope slide glass over them until you frame in a result that you like. Trace around edges with the marker and cut out with scissors. Repeat with word and quote transparencies to create layers. Cut strips of old ledger paper with scallop-edged scissors to create edging papers and punch tiny holes in the circular areas.

Clean off two microscope slides and sandwich the two transparencies and any edge papers between them. Cut a piece of copper tape long enough to fit around the glass, plus an additional ¼″. Peel off about 2″ of the backing paper, place it up on your work surface and press the glass sandwich down the center. Turn the glass and keep pushing the edges to the tape as you peel the backing off. Overlap the ends. Fold and press the tape to the glass surface over each side and carefully miter the corners. Burnish the tape on all surfaces with the bone folder.

SOLDERING

Please note that the flux should not get on your skin or into your eyes or mouth. A well-ventilated work area is always recommended for the soldering process. Find a heat resistant surface to work on and plug in the soldering gun. Brush flux along the copper tape. Lay the ornament face up on your surface. Hold the spool of solder in one hand with about 4″ of solder protruding. Hold the gun in your other hand over the area where you want to start. Heat up the solder using the solder tip and when it starts to melt, spread it along the copper tape edge. Continue around the front edges and complete the back the same way.

Place the ornament in the mini-vise. Use the gun to smooth the excess solder along each edge. Add new solder as needed. Hold the jump ring with pliers; dip it into the flux, and hold the joint end of the ring to the top of the ornament. Touch the tip of the gun to some solder and place it on the bottom area of the jump ring to adhere it to the ornament. Add a ribbon to the ring and you're done!

TOOLS & MATERIALS

- Liquid flux
- Bone folder
- Small brush
- Sharp scissors
- Transparencies
- Lead-free solder
- 7mm jump rings
- ¼″ copper tape
- 1/8″ soldering tip
- 1/16″ hole punch
- Needle nose pliers
- Soldering gun stand
- Mini-vise (Volcano Arts)
- Fine point permanent marker
- Mini scallop-edged scissors (Fiskars)
- Temperature controlled soldering gun
- Glass microscope slides (1″x3″ or 2″-square)

Lisa Cook lives in Amherst, WI and can be contacted via e-mail at cookster@wi-net.com. To see more of her work, visit www.picturetrail.com/lisacook.

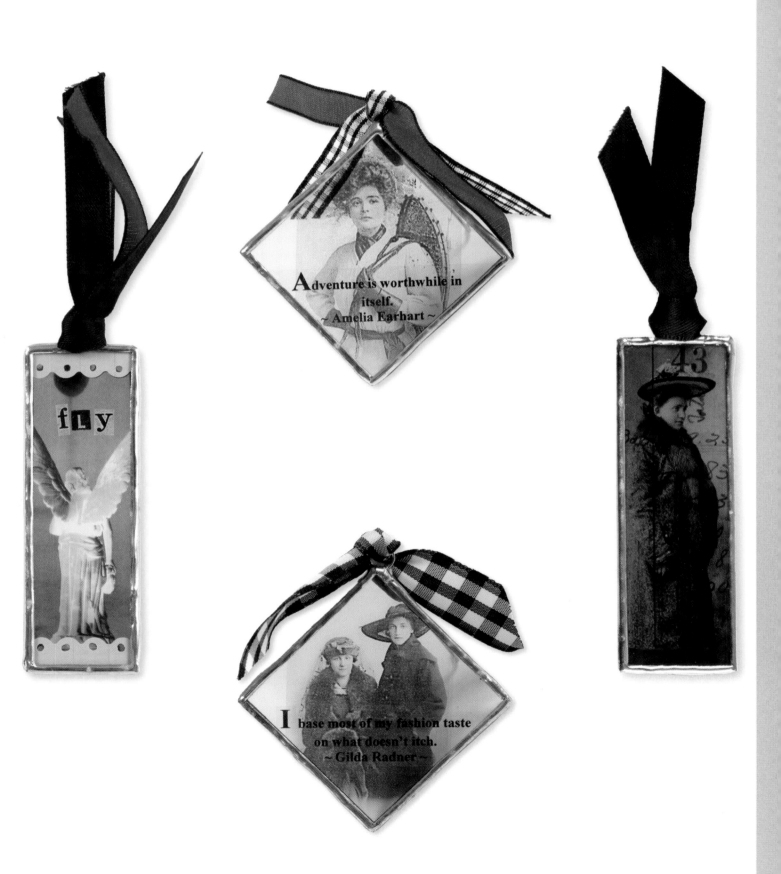

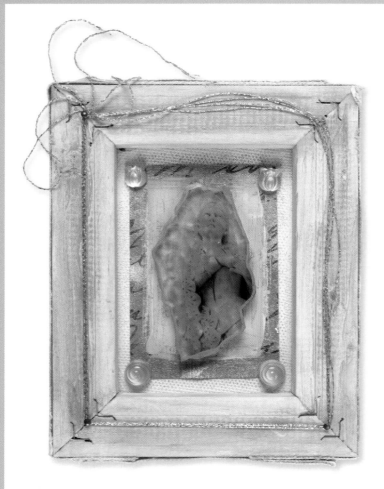
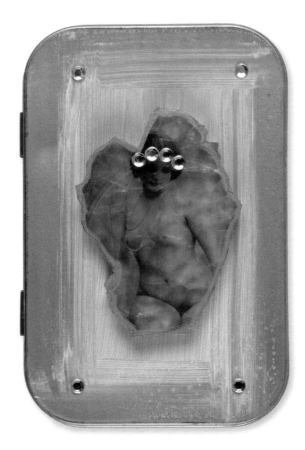
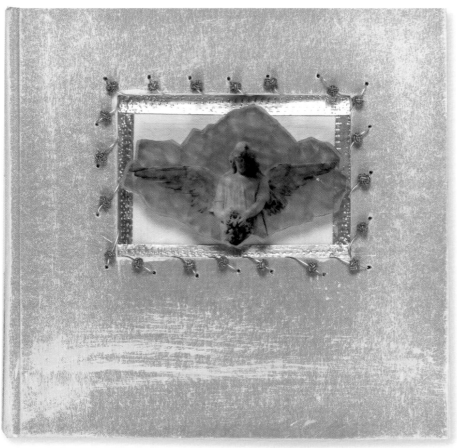

Crackled Glass Embellishments

by Melody M. Nuñez

These embellishments are one of my most unusual ideas of late, but are so versatile and beautiful! Not long ago, a rock hit one of the windows along the front of my employer's office, and the pane of glass crackled into thousands of pieces but stayed in place. It was a few days before the window company could come out and replace the window, and I kept eyeing it in the meantime. I thought the glass would be fun to use in one of my creations, and asked for some chunks of the glass when the repairmen were on site.

While I was mulling over transparencies and how they could be used, I hit upon the idea of combining the chunks of glass with the transparencies. These transparencies from ARTChix, layered over a piece of this crackled glass, are so soft and intriguing – and the embellishments can be used on virtually anything. Once I'd made the embellishments themselves, I incorporated them into other projects as shown here. These pieces are proof that inspiration and art materials can come from virtually anywhere. So pay attention, and you'll be rewarded!

Technique

TOOLS & MATERIALS

- Scissors
- Diamond Glaze
- Gold metallic marker
- Permanent black marker (Ultra-fine tip)
- Pre-printed transparency sheets (ARTchix)
- Chunks of crackled (broken) tempered glass

Please note: To properly protect yourself, you should work wearing safety glasses, gloves, and should cover your work surface with thick paper. I didn't do any of this when creating my embellishments, but it would be wise to do so!

Compare the size and shape of each glass piece to the images on your transparency sheets. Gently lift a larger section or chunk of the glass and lay it over the desired image. Shift the glass until you've got the best possible sections of the image covered by the glass. Trace the outline of the glass onto the transparency sheet using an ultra-fine permanent marker, then carefully set the glass piece aside. Cut the shape out using small scissors.

Attach the transparency to the glass piece by spreading a layer of Diamond Glaze with your finger onto the matte side of the transparency. Press the image down carefully onto the glass and let dry. Turn the piece over, spread a layer of Diamond Glaze over the back, and let dry. Once dry, add another layer of Diamond Glaze to the back side and let dry. This will help keep the embellishment in one piece later on. Edge the transparency with a gold marker, which will help create a finished edge where the glass and image don't meet perfectly. Use Diamond Glaze or double-stick tape to attach the crackled glass embellishment to a base (like a book, tag, or box), or wrap with wire to create an ornament.

Melody M. Nuñez lives in southern California. To learn more about her work, visit www.melodynunez.com.

Given that I had been experimenting

with new ideas for creating

mixed-media backgrounds

on fabric and canvas,

I knew that one of these surfaces

would be a great addition

and would work especially

well with the transparency.

DJ PETITT

Fabrics

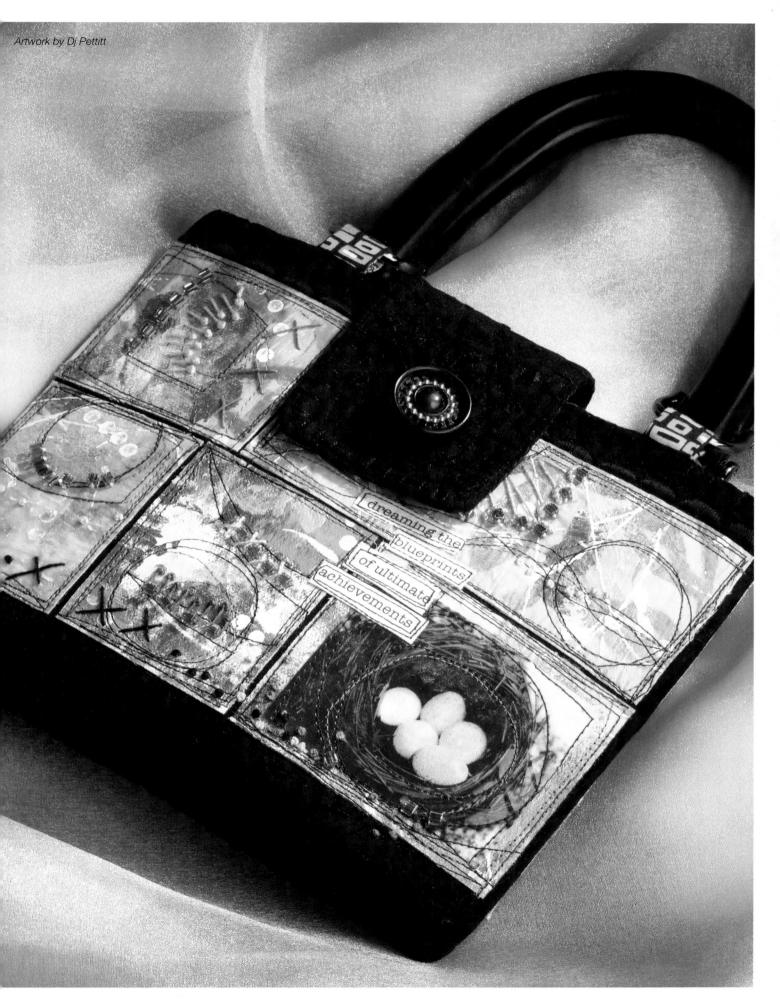

dreaming the blueprints of ultimate achievements

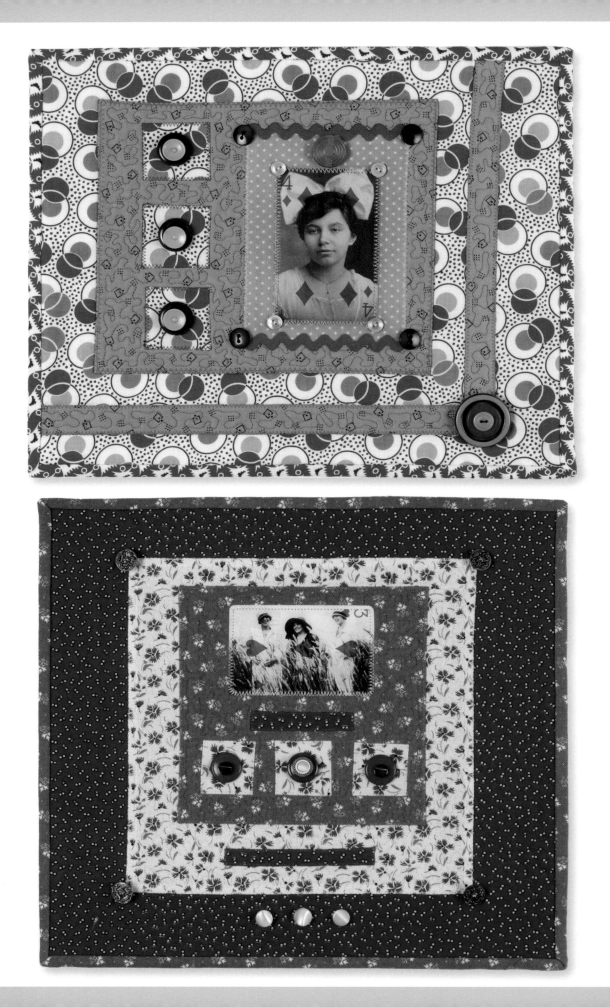

Mini Art Quilts

WITH TRANSPARENCIES

by Victoria Gertenbach

I adore vintage and retro images and use them often as focal points in my miniature art quilts. Finding just the right image is always great fun. Even better is printing the image onto a transparency sheet! New design possibilities open up as the image can now be layered with other images, prints, colors and/or text to create a focal point with added depth and visual interest. Transparencies are easy to sew through, and look wonderful when combined with other elements to make one-of-a-kind miniature art quilts.

Technique

SELECTING BACKGROUNDS

Select a transparency image and test it out by laying it on top of various backgrounds. Notice how the backgrounds show through the transparency. It can take many attempts until you find a suitable match. The trick is to find a background that offers visual interest, yet doesn't completely overwhelm the transparency image. Light-colored backgrounds that have some open space work best. Playing cards can offer just the right balance between neutral space and interesting elements that peek through the transparency image.

Another background option is wallpaper. Free samples can be had in abundance by asking a local supplier for any outdated sample books that are destined for the dump. They are usually more than happy to give them away.

Vintage texts, illustrations, and light-colored batik fabrics are also good options for backgrounds. Fine art fibers such as metallic Angelina Fibers can also be fun additions to sandwich between backgrounds and transparencies.

ATTACHING
THE TRANSPARENCIES

Using a straight stitch on your sewing machine, stitch each of the transparencies to their various backgrounds. For the playing card background, begin by applying a very small amount of glue stick just to the edges of the playing card and then center the transparency image on top. The glue will keep everything in place and keep the pieces from shifting during the sewing. Remember to use sparingly as the glue can show through the transparency. After stitching close to the playing card's edge, trim the excess transparency flush with the playing card.

When using wallpaper, cut the transparency to the desired size and lightly edge the transparency with a glue stick. Position the transparency onto the wallpaper. After sewing together, the excess wallpaper is trimmed flush with the transparency.

Before sewing with the batik fabric or the vintage texts or illustrations, first iron lightweight fusible interfacing to the wrong side of the fabric or paper. This helps to stabilize the background so it doesn't fray or rip while sewing. Playing cards and wallpaper are sturdy enough and do not require the fusible interfacing.

Cut the transparencies to size and apply glue stick lightly to the edges,

TOOLS & MATERIALS

- Threads
- Scissors
- Glue stick
- Assorted fabrics
- Sewing machine
- Large safety pins
- Thin quilt batting
- Angelina® Fibers
- Heat N Bond (light)
- Transparency images
- Basic quilting supplies
- Assorted embellishments
- Fusible interfacing (light-weight)
- Iron-on tear-away stabilizer (Sulky®)
- Assorted backgrounds (playing cards, wallpaper, fabrics, papers, etc.)

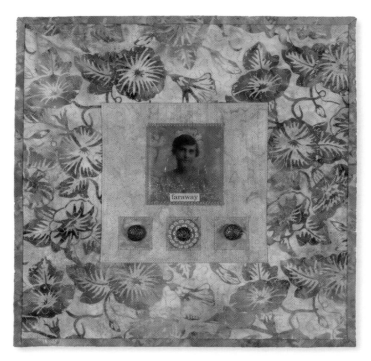

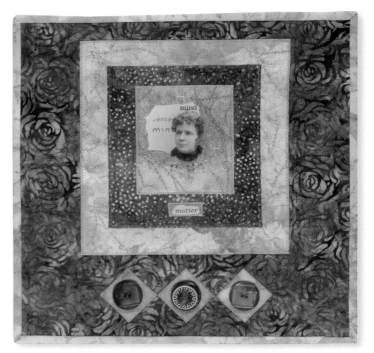

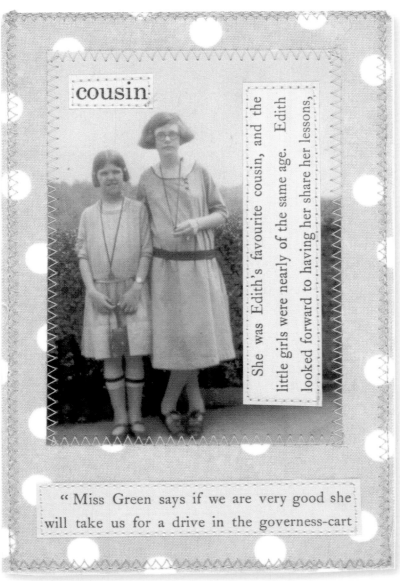

and place on top of the background and then sew and trim as described above. Before placing the transparency on the batik background, you can also layer the batik fabric with paper text and Angelina Fibers.

DESIGNING & CONSTRUCING THE QUILT

The transparency focal point is framed by one or more "inner borders," which are pieces of fabric cut into square or rectangular shapes to become borders onto which the focal point is later sewn. Take time selecting fabrics that work well together and complement the main image. Think about whether to use a symmetrical placement. Will you have one, two, or more borders? I spend a lot of time playing around with my focal point, moving it around on various fabrics until it feels right.

When you have a good idea for what you want, cut inner border pieces, remembering to add an extra 1/4˝ to 1/2˝ all the way around, and also to turn raw edges under. The extra length is then folded to the back, and pressed with a hot iron.

After deciding on your desired size for the finished quilt, cut from a piece of fabric that forms the "outer border" and to which the inner borders and the main transparency focal points will be sewn. Along with the inner borders and focal piece, cut and sew on additional accent fabric pieces. I prefer to use small fabric squares (generally in groups of three), and/or thin fabric strips. Because the accent pieces are very small, I don't bother to turn the edges under. Instead, I back the accent pieces with Heat N Bond Light — a lightweight, iron-on fabric "glue" that comes in sheets backed with paper, and keeps the edges from fraying.

Once you have determined the finished size for the quilt, cut it out to size. Cut a piece of stabilizer approximately the same size as the fabric piece. Iron the Sulky Stabilizer to the wrong side of the fabric. This will help stabilize the background fabric when the inner border and the accent pieces are sewn on to it.

Now that you have all your pieces -- transparency focal point, inner and outer borders and accent pieces, layer them all together one last time, making sure that you are pleased with the overall composition. Next, remove the focal point and use a glue stick to lightly tack down all the inner borders on top of the

outer border to keep them from shifting while sewing. Remove the Heat N Bond paper backing from the accent pieces, and iron them in place.

You are now ready to machine-stitch the fabric pieces in place. You will not stitch the transparency piece down until later. Set machine to a zigzag stitch. Think about what color threads you want to use. Threads come in many wonderful colors and types, such as cotton, silk, and shiny rayons. Thread style, color, type of stitch, length and width are all important parts of the overall design.

Go around each shape, both the inner borders and the accent pieces, sewing them in place to the outer border background piece. It is helpful to start and end any stitch with a few very small straight stitches. This helps to secure the thread and keep it from unraveling.

After all pieces (with the exception of the transparency piece) have been sewn down, flip the quilt top over and carefully tear away your stabilizer. (Use a pin to help pull up a small area that you can use as a starting point.) Don't worry if small pieces of stabilizer stay stuck underneath the stitches.

Cut out a piece of thin quilt batting slightly larger than the quilt top, which you have just sewn. Now cut a piece of fabric that will be used for the back of the quilt slightly larger then the batting. Make a "quilt sandwich" by laying the back fabric (right side down) and placing the quilt batting on top and the quilt top, (right side up) on top of the batting. Smooth out any wrinkles and using large safety pins, baste the three layers together.

You are now ready to machine-quilt your piece. Once the quilting is complete, it's time to sew the transparency focal point onto the quilt top. Use a little glue stick on the back of your focal point and stitch the transparency piece in place. Next, bind off the quilt and then attach embellishments such as buttons, beads and other lightweight items to the quilt's top.

Victoria Gertenbach lives in Reinholds, VA. She may be contacted via e-mail at g10bach@ptd.net.

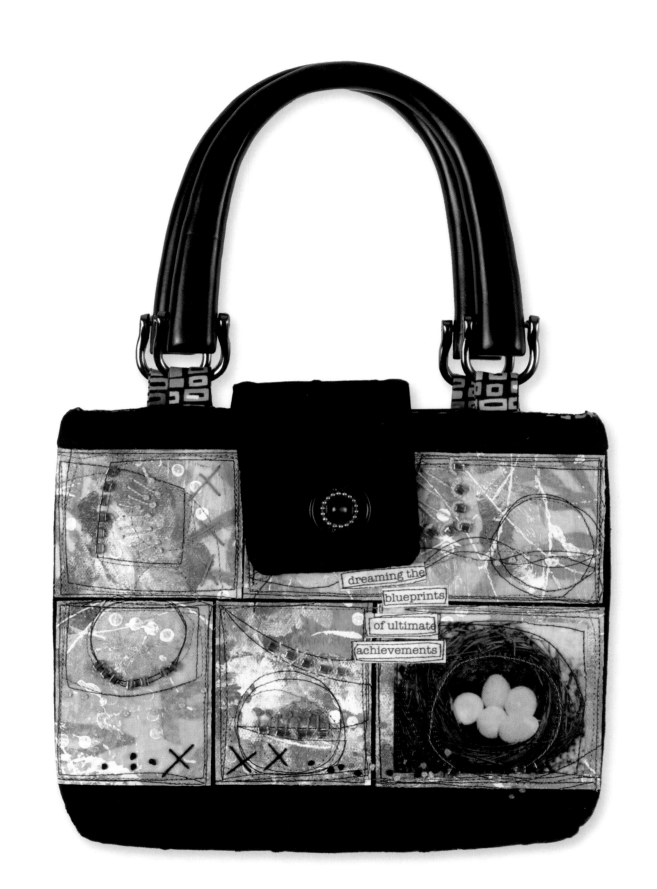

Mixed-Media Purse

by DJ Pettitt

I enjoy experimenting with a diversity of art mediums, methods, and surfaces, and looked forward to using a transparency in a way I hadn't tried before.

The color, the wonderful circular shapes, and my love of birds made it easy to choose this particular transparency image (Angela Cartwright for Stampington & Company) for this project. Given that I had been experimenting with new ideas for creating mixed-media backgrounds on fabric and canvas, I knew that one of these surfaces would be a great addition and work well with the transparency.

As I began creating, I had only a vague idea of what I wanted to do.

As I gathered coordinating fabrics and laid all the elements out, it occurred to me that although I had focused on the circular lines in Angela's photograph, the transparency itself was square. This became the inspiration to use circles, as well as a variety of rectangular shapes, to form a grid pattern and apply the transparency to one of the blocks.

Technique

Cut the fusible web in half and lay one half on your work table with the web side facing up, and tape down corners. Using a variety of methods and tools, apply acrylic paints randomly on the fusible web. Once dry, peel off the paper backing and tear the web into several irregular-shaped pieces.

Apply a medium coat of white gesso to the unstretched canvas using a brush or palette knife. Once dry, use your finger or a soft brush to apply white gesso to the back of the transparency.

Once dry, prepare it for fusing by laying a kitchen towel on a hard surface and place a piece of parchment paper cut larger than the canvas on the towel. Place the canvas on top of the parchment paper and spread a thin layer of Tar Gel with a palette knife. Lay the sheer fabric on top of the Tar Gel and drizzle a second layer of Tar Gel. Lay the pieces of painted web randomly over the fabric layer, and top with a second piece of parchment paper, also cut larger than the canvas.

Fuse this stack together by first preheating an iron on the highest setting with no steam. Set the iron down on one section of the top layer of parchment paper, and without moving the iron from that spot, heat the Tar Gel until it is set. It will produce steam and you will hear a soft bubbling. When the bubbling stops (about 15-20 seconds), move the iron to a new section and repeat this process until the entire canvas is heated.

Flip the stack over, and heat the back about a minute, or until the parchment paper is dry. Cool and pull up a corner of the parchment paper to make sure the Tar Gel is set. If it is sticky or stringy, place it back on the towel and repeat the process. When the Tar Gel is properly set and the stack is cooled, remove the parchment paper completely. It will not stick and the paper will easily come off.

Use a skewer or small dowel to make dots and lines on the canvas using white acrylic paint or white gesso. Apply more swirls and detail using the white paint and applicator tip. Let dry.

Cut out the purse following the pattern instructions and a black fabric of your choosing. Follow manufacturer's instructions and fuse the remaining piece of web to the backside of the canvas. Remove paper backing, cut the canvas in desired shapes to fit on the front and back panels of the purse. Lay panels flat, arrange the blocks and fuse them to the canvas with the fusible web.

Using fabric glue, adhere the transparency in the desired position and allow to dry. With coordinating thread, machine stitch randomly on the front and back purse panels with the canvas blocks. Create squiggles, circles, and rectangles. Also, sew around the edges of each canvas block and the transparency. Hand-stitch whimsical flowers and shapes with embroidery floss. Add beads as desired. Assemble the purse following pattern instructions.

DJ Pettitt lives in Central Point, OR. To learn more about her work, visit http://webpages.charter.net/jndpettitt/.

TOOLS & MATERIALS

- Iron
- Beads
- Towel
- Fabric glue
- Small dowel
- Purse pattern
- Sewing machine
- Parchment paper
- Gesso (white, gold)
- Basic sewing supplies
- Clear Tar Gel (Golden)
- Unstretched canvas (12˝x12˝)
- Sheer, flocked fabric (12˝x12˝)
- Acrylic paints (lime, teal, cream)
- Perle cotton embroidery floss (#5)
- White acrylic paint with fine-point applicator tip
- Transparency (Angela Cartwright for Stampington & Company)
- HEATnBOND Lite fusible web (double the size of canvas)

I See Her Sweet and Fair

by Sarah Fishburn

Combining transparencies with fabric can yield fun and fabulous results! After all, printed fabric is much like beautifully printed paper, with the additional element of a woven texture. The warp, weave, weft, and weight of any given fabric make special contributions to the overall look of the piece.

One of the exciting qualities of the transparency/cloth combo is that, in addition to being able to build layers of images, one can also create an almost three-dimensional effect. For this journal cover, I chose to use two fabrics and three transparencies. The fabrics anchor the disparate transparency images by placing an outside border around the entire composition. Underneath the photo of my mum, the light color of the muslin allows her photo to really stand out. The loose weave creates a feeling of airiness while enhancing that dimensional quality, which is further emphasized by the additions of a bit of red tinting on her lips and an actual muslin bow "tied" into her hair.

For the rose image transparency, I acheived a much richer background through the use of an exquisite scrap of handmade felt, dyed yellow. I pinked the edges to create consistency with the muslin, but the thickness and tight weave of felt allow for a degree of contrast as well.

Without that contrast, and without the addition of colors, sizes, and textures of the buttons (which hold the entire thing together and are stitched on with waxed linen), without the transparent rose poetry element and the title printed onto black labeling tape, well, my simple collage would be much too stationary and achromatic. Through the deliberate coordination of all these elements, a lovely sense of balance, dimensionality, and elegance grace this little journal cover.

Sarah Fishburn lives in Fort Collins, CO. To learn more about her work, visit www.sarahfishburn.com.

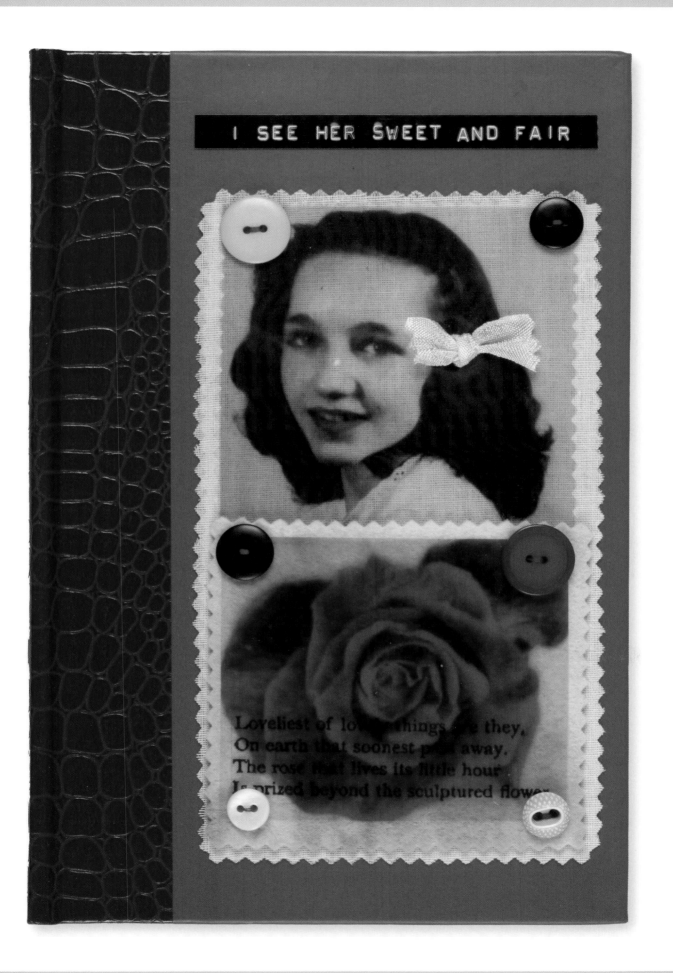

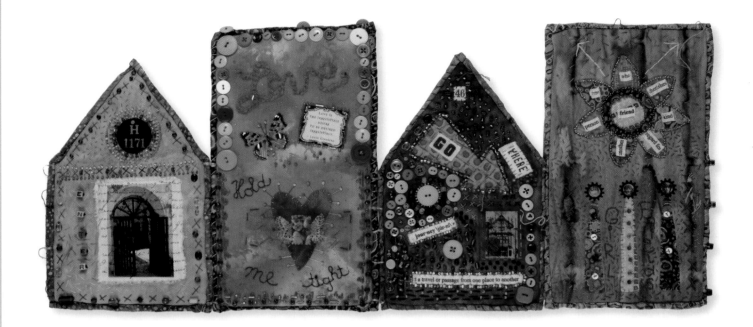

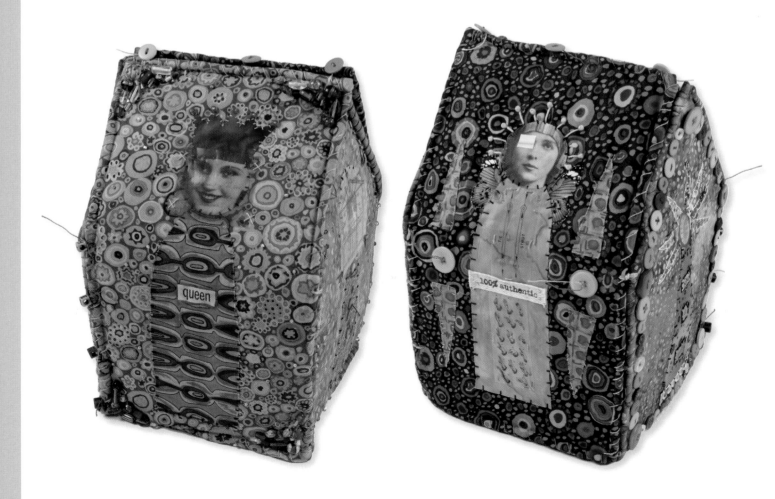

A Woman's World

by Belinda Schneider

Using transparencies in my mixed-media artwork became natural a few years ago since their use is so easy and versatile. They add depth and interest to any collage or surface. I also like to create pockets with them. While ARTchix Studio offers the most amazing selection of transparencies, I also like to print my own. This allows me to custom size the image or text for my specific needs.

When I worked on the concept of the fabric house, I though it would be fun to create a house which can be folded open and be used on both sides. The thread I used for this project is from Valdani (www.valdani.com). They offer amazing threads and I tend to use their "crochet cotton" most of the time. They are thinner than traditional six-strand threads and look more interesting. Their assortment of hand-dyed variegates is simply fabulous.

I opted for beads and buttons as simple closures as well as thread hinges. Choosing the fabrics was the most challenging part. I prefer the look of the rolled-up edges and wanted them to be colorful and contrasting, yet coordinated with the background fabric. While it would have been so much faster to use a sewing machine for this fabric house, I prefer to hand-stitch my fabric projects because of this unique freestyle look.

Technique

BASIC HOUSE CONSTRUCTION

First, draw a house shape onto Craft Vilene using a ruler and a permanent marker. Cut it out and use it as a template for a second piece. Next, measure out the side of the house (including a roof) and trace it onto Craft Vilene. Cut it out and use it as a template for a second piece. Next, lay these four pieces onto sheet batting and cut them out, each side twice.

For the first house, select four coordinating fabrics for the backgrounds and lay the fabrics onto the Craft Vilene templates and cut them. Be sure to add a ¾″ for the seam. Repeat same procedure for the second house.

Assemble corresponding pieces of fabric, batting and Craft Vilene for the first house together and pin each piece along the edges. Repeat same procedure for pieces of the second house (no stabilizer needed). Now all pieces are ready for individual collage and embellishments.

EMBELLISHMENT NOTES
HOUSE SIDE ONE

Enter (Panel 1): Cut out transparent number and door images and punch in holes. Glue fabric piece onto fabric. Lay number transparencies onto fabric and carefully poke in hole with small sharp scissors. Attach with pink mini-brad. Lay door transparency onto printed fabric and carefully poke in holes with small sharp scissors. Attach with yellow mini-brads. Add beads and decorative stitches to this and all other panels.

Girlfriends (Panel 2): Cut out three images of women's heads to create long body shapes with assorted fabrics. Cut out and glue onto background. Stitch down edges. Stitch on words. Glue three black halo transparencies onto each head. Cut a flower from assorted fabrics and stitch onto background. Cut printed twill into pieces and glue onto flower. Stitch on two arrows.

Journey (Panel 3): Cut arrow from fabric and stitch onto background. Create frame by stitching on beads. Glue on fabric image and found number and text images and printed twill, stitch down edges. Cut out transparency and create a pocket by stitching down

TOOLS & MATERIALS
- Ruler
- Scissors
- Sobo glue
- Mini brads
- Sheet batting
- Needles & pins
- Assorted fabrics
- Permanent marker
- Printed twill (7 Gypsies)
- Assorted embellishments
- Handheld 1/16″ hole punch
- Fabric images (ARTchix Studio)
- Solid & variegated threads (Valdani)
- Assorted six-strand embroidery yarns
- Transparency images (ARTchix Studio)
- Craft Vilene (or other extra heavy interfacing)

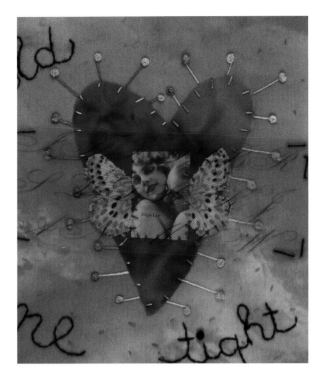

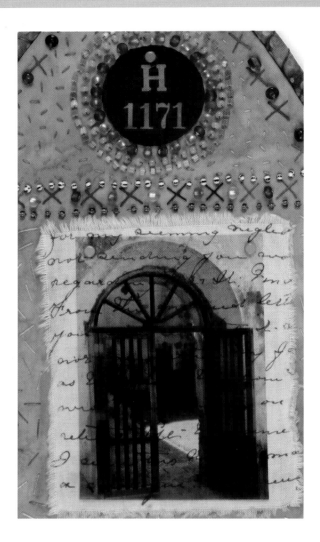

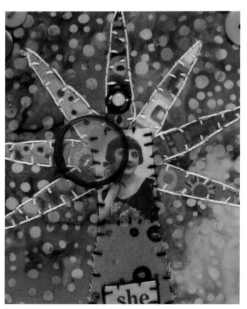

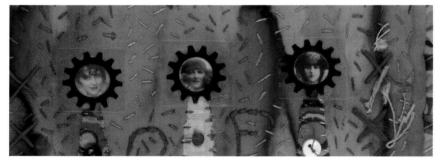

3 edges, leaving the top open and insert coin. Leave ends of floss hanging down.

Hold Me (Panel 4): Cut heart from fabric and stitch down. Add rays with straight stitches and French knots. Glue on couple image and butterfly wings. Attach text transparency over heart collage with stitches on four corners. Stitch on text and spell out word with wool piece and stitch down. Lay on butterfly and quote and stitch down.

HOUSE SIDE TWO

Queen (Side 5): Cut out image of female face, body shape, and crown from fabric and glue onto background. Stitch down edges. Glue on Queen, frame with red thread. Lay transparent text over face and attach with stitches on corners. Stitch beads to crown and create photo corners from glass beads.

Housewife (Side 6): Cut out image of female head, body shape, and halo

from fabric and glue onto background. Add rays with straight stitches and French knots. Stitch down edges. Lay house diagram transparency over face and attach with stitches on corners.

Pretty (Side 7): Cut out image of female head, body shape and rays from fabric and glue onto background. Stitch down edges. Punch hole into vintage lens transparency, and attach with blue mini-brad. Glue on words and numbers and stitch down edges.

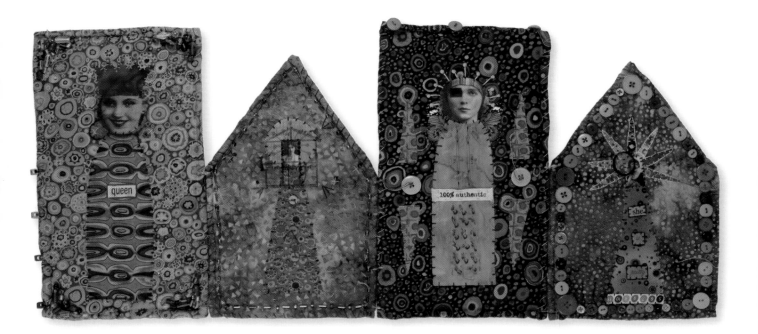

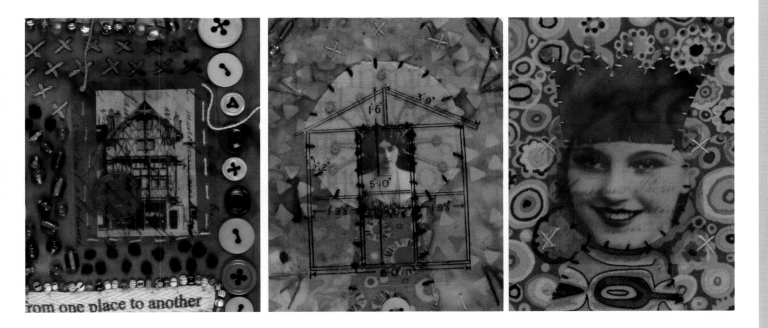

Authentic (Side 8): Cut out image of female head, body shape and wings from fabric and glue onto background. Stitch down edges. Add rays with straight stitches and French knots. Glue word transparency over eye. Stitch printed twill onto body. Attach transparencies to body with several stitches. Cut out four triangles from fabric and stitch down. Stitch on buttons, leaving thread ends hanging down.

ASSEMBLAGE

Assemble corresponding fronts and backs and whip-stitch together. Using Valdani multicolored thread, roll up ¾″ fabric frame (toward you) and over-sew it all the way around. Repeat with all four sides.

Lay pieces flat next to each other. Start sewing on "thread hinges" by threading and connecting two corresponding corners. Continue on sides, leaving the two opening sides open, as well as the roof.

Stitch on letter buttons to front side opening. Attach four 2″-long threads on the opposite side per bead. Sew on three buttons to one side of top of roof. Attach three 2″-long threads on the opposite side per button. Fold house together and tie thread ends twice around the beads. Next, tie thread ends twice on roof around buttons.

Belinda Schneider lives in Munich, Germany.

Whether it's an altered book, a card,

or many other projects,

transparencies can add

a whole new look to your art.

I especially like how transparencies

can cause the entire mood of a piece

to change when placed

over different background papers.

NANCY GENE ARMSTRONG

*Books &
Journals*

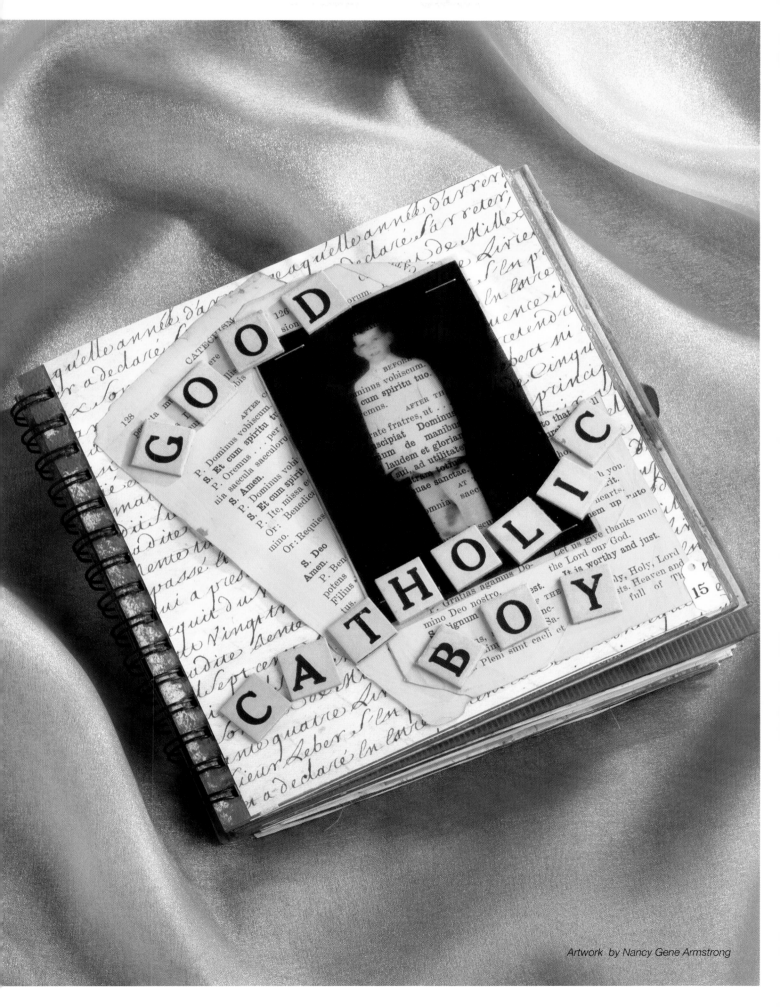

Artwork by Nancy Gene Armstrong

BETWEEN THE DARK

COMES A PAUSE

Gramercy
GARDEN &
ANTIQUES
SHOW

EB. 27-28-29

THE ARMORY

AND THE DAYLIGHT

My Little "Children's Hour"

ALTERED BOARD BOOK

by Sarah Fishburn

Oh, I just have to tell you what a fun time I had putting together this altered board book! For one thing, it's small, and I love any book that you can hold in just one hand. For another, I went absolutely *wild* with two of my favorite supplies – masking tape (lime green, in this case!) and photo transparencies.

I used a combination of transparencies that I printed myself of family and found photos, and several that I purchased from fabulous companies (Magicscraps, Sandie) that now include transparencies with their other collage sheets.

DYMO LABELS

While looking for new opportunities for my personal altered book making, I actually created this book as an exercise in illustration. Using a Dymo Labeler with black tape, I punched out words from the first few lines of an old favorite poem of my mother's: "The Children's Hour," by Henry Wadsworth Longfellow.

A FUNKY DESIGN

I didn't really do anything special to prepare the book pages ahead of time – no sanding or painting. I simply adhered select pieces of newspaper pages – in this case from the *New York Times* – directly to the original surface. To achieve a funkier, slightly distressed look instead of trimming the edges with scissors, I tore around them while my glue was not quite dry. A small amount of hand-coloring was applied to certain areas of the newspaper and then I began laying down the transparencies.

By carefully placing each transparency with adequate consideration to what lies beneath, the design is enhanced. Once the photo transparencies were in a position that was pleasing, I attached them. I used a combination of neatly cut black graphic art tape and roughly torn green masking tape. Finally, I applied liberal amounts of red and blue metallic rub-on pigment to the masking tape as well as to the newspaper.

AN AIR OF MYSTERY

Although each of the spreads in the book includes several brilliant splashes of color, there is still a distinct air of mystery to its pages. Every one of the childish faces seen peeking from the transparencies – between the strong vertical lines formed by the tape, the words of the poem and the natural design and layout of the newspaper itself – suggest hidden secrets we may no longer be able to decipher. But if we wish, we can always allow our grownup selves a brief return to visit the mysterious secrets of *The Children's Hour.*

Sarah Fishburn lives in Fort Collins, CO. To learn more about her work, visit www.sarahfishburn.com.

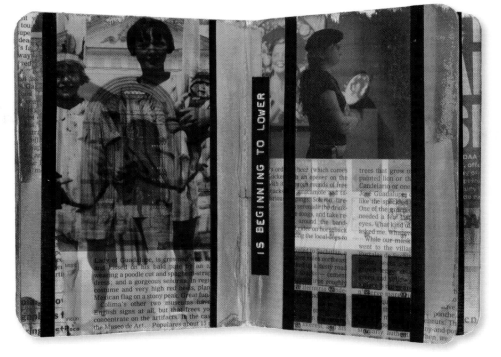

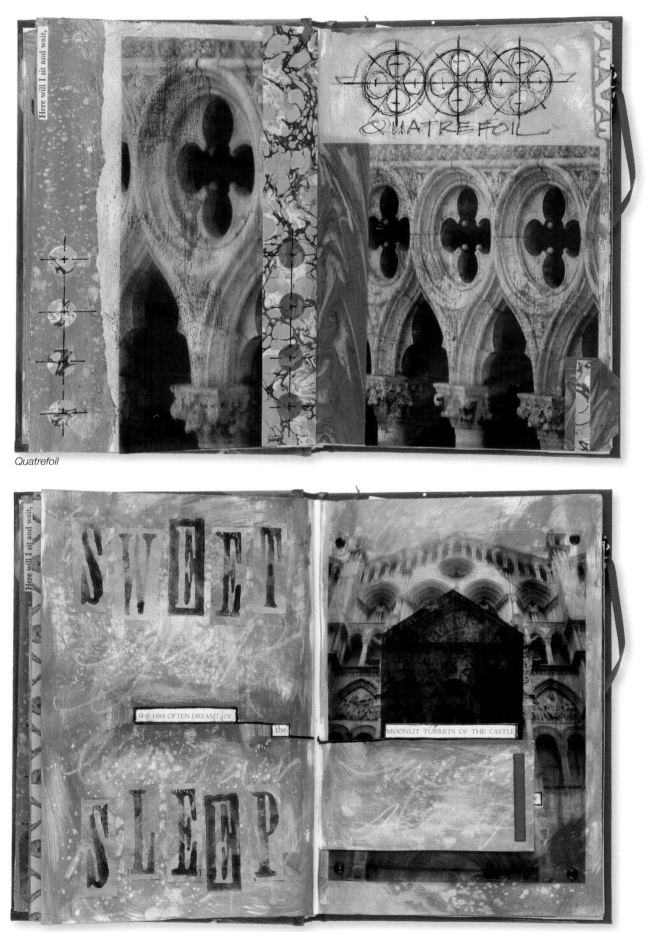

Quatrefoil

Enchanted Castle

Innovative Attachments

FOR ALTERED BOOKS

by Michelle Ward

There are no rules for how to create an altered book or visual journal. It's all about exploration and expression and often, experimentation. At some point in the process of fashioning interesting page layouts, an artist may choose to investigate using ink-jet printed transparencies, or machine-copied images on acetate. These illustrations reveal four techniques for methods of attachment to get you started.

QUATREFOIL

In this two-page altered book spread, both printed transparencies are tipped in by attaching them to trimmed pages of the book. The advantage of this technique is that the transparent image rests over the painted background of the following page, but it can also be flipped over to the previous page for another interesting appearance. This method also affords a strong connection, holding the transparency in place between the trimmed book page, and an applied decorative paper strip. As an option, you can add a tab to the edge of the transparency, as an indication to lift the page.

- Set a cutting mat beneath two pages of a book.
- Using a metal ruler and sharp craft knife, trim pages to 1″ from spine.
- Using contact cement, glue printed transparency over the top of the trimmed book page, ½″ from spine.
- Cut a 1″-strip of decorative paper, and glue into place over transparency, creating an under and over connection, holding the transparency in place.
- Repeat with second image.

ENCHANTED CASTLE

This altered book spread incorporates a printed transparency that is attached with eyelets. The key to making this page unusual, is to cut out a shape from the page the transparency gets mounted onto, so that the following page can be seen through the transparency. This makes the most of your imagery. In addition, there is a portion of the transparency that has been cut away so that the words beneath can be read clearly.

- Punch 1/8″ holes in each of the four corners of the printed transparency.
- Set the transparency onto the page and mark the holes with a pencil.
- With an awl, poke out the holes in the book page.
- Before making the attachment complete with eyelets, take the opportunity to pencil in a shape that relates to the image. Cut the image from the page by setting a cutting mat under the page, and use a sharp craft knife with a metal edge ruler to make the cut.
- Before the connection is final, review the words on the page that will be under the transparency. Select a phrase that might be suitable to highlight, and pencil lightly around it. Overlay the transparency into position, and mark where the chosen phrase is located. Remove the transparency, and carefully cut out the marked portion with a sharp craft knife.
- Set the transparency back into place, carefully aligning it with the marked holes, as well as the highlighted text, then gently fit four eyelets into place, turn over to the back, and hammer the eyelets with setting tools.

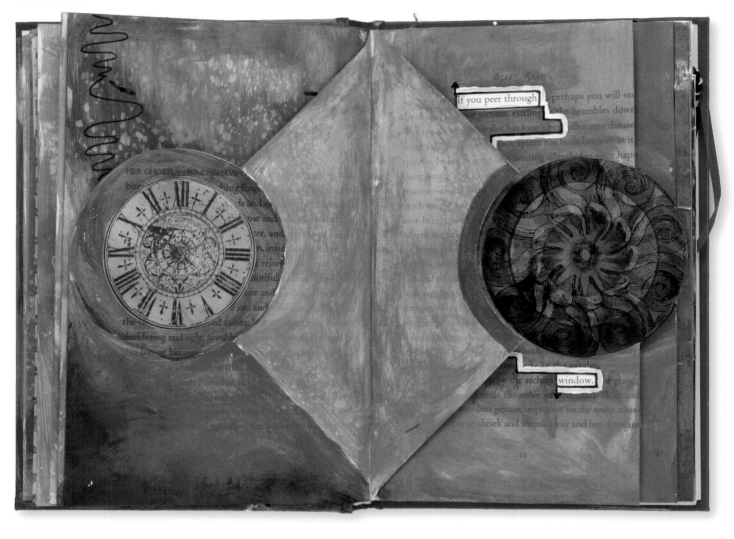

SERIES OF CIRCLES

Here is an example of how a transparency can be held in place by inserting it into an opening in the paper. It is sandwiched between two pages that have circles cut out. As an alternative, the transparency can have an exposed edge. The printed acetate is trimmed closely on one side of the circle, but an excess portion of the acetate should be left on the other half of the circle, as it will be the base where the image gets glued. Before the transparency is fixed into place, take

this opportunity to trace the circle cut-out onto the preceding and following pages, to reinforce the circle subject, and to create a continuity of pattern across several pages. I cut additional pages to mimic the circle, and painted out additional circles on nearby pages.

- With a circle template, pencil in a large circle.
- Place cutting mat under two consecutive pages, cut out circle with a sharp craft knife.

- Before doing anything else, pencil through the cut-out, tracing outline of circle to preceding and following pages. This gives you the opportunity to reinforce the circle motif with an exact match-up as the pages get turned.
- On only half of the printed acetate image, trim closely around the circle.
- Create a vertical fold across the portion of the circle cut-out pages.
- Set partially-trimmed transparency behind first circle cut-out page, so

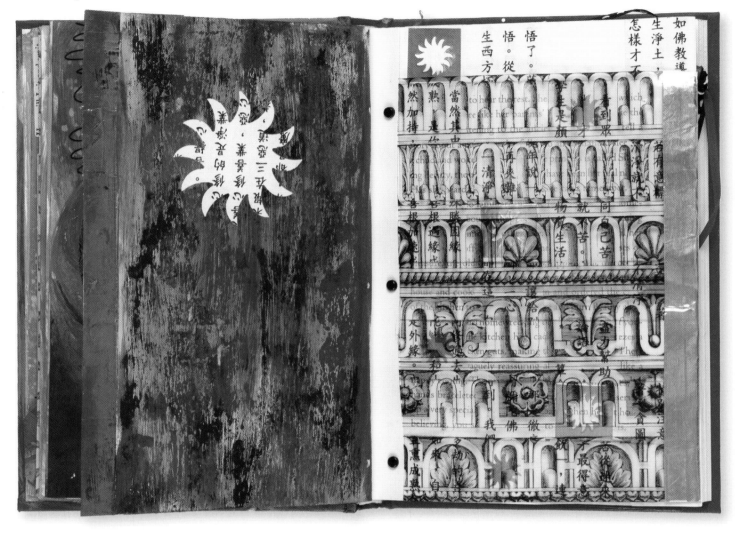

the trimmed portion of the circle sticks out, completing the circle image.
- Glue transparency into place on first page, then add more glue and attach to second page, creating a sandwich around the transparency.

FULL PANEL PAGE
Making a full page in an altered book out of a printed transparency is simple. It adds interest, as well as surprise. Edging the transparency in metal tape gives the page a striking finishing touch, as well as making the page easier to turn.
- Set cutting mat under two consecutive pages in your book.
- With a sharp craft knife and metal edge ruler, trim pages to ¾″ from spine.
- Trim printed acetate transparency to match page size.
- Set the transparency in between two trimmed pages and lightly glue into place.
- With an awl, poke in three holes along the trimmed paper channels.
- Fit mini-brads into openings, and split open.
- Edge transparency with silver or copper tape.

Michelle Ward lives in Piscataway, NJ and serves as an editorial advisory board member for Somerset Studio magazine. To learn more about her work, visit www.greenpepperpress.com.

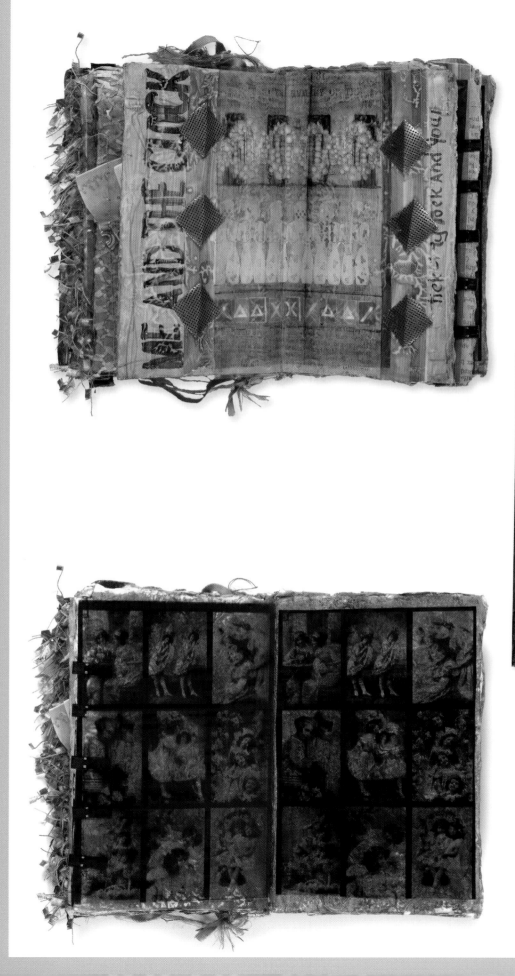

I Scream, You Scream

by Bev Brazelton

This book is a continuation of my exploration of using transparencies in altered books. The transparencies for this book were developed by placing the finished full page layouts on a color copier and printing them onto a piece of transparency film. I then used portions of the copy – attaching them on top of the pages to add unique richness to the feeling of the pages.

This book became an introspective exploration – a journal of sorts. Each page represents a part of me that I am constantly exploring through my art. The transparency film was perfect for the feel I wanted to achieve. It added to the depth of feelings and enhanced the content's beauty.

TOOLS & MATERIALS

- Pencil
- Scissors
- PVA Glue
- Paint brush
- Assorted papers
- Embellishments
- Transparency film
- Collage images & text
- Acrylic glazes (Golden)

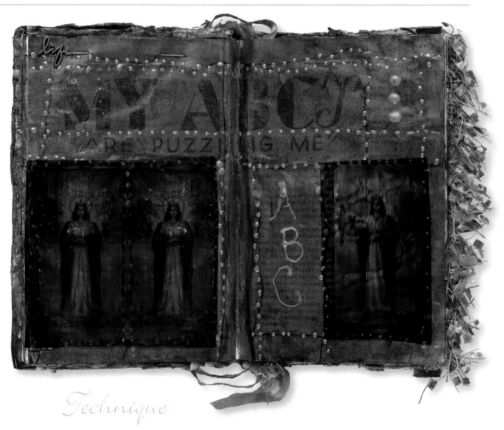

Technique

Although I used different colors of acrylic glazes on different pages, the pages in this book were all developed in the same manner. Each full-page layout was first painted with a coat of acrylic glaze (Golden). Once dry, PVA glue was used to adhere text, images and assorted papers. This was followed by another application of acrylic glaze.

Once thoroughly dry, the entirety of each layout was placed on the glass of a color copy machine and copied onto transparency film. It is important that the transparency film you are using matches the type of copy machine that is being used. After generating the transparencies, parts were cut out and adhered over the top of the corresponding page of the book. A dot of PVA glue was added to each corner of the film for the adhesion.

Additional embellishments complete the layouts.

Bev Brazelton is the author of Altered Books Workshop published by Northlight Books and available for purchase at www.stampington.com. She teaches workshops on altered books, book-making and paper arts around the country. To learn more visit her website at www.bevbrazelton.com.

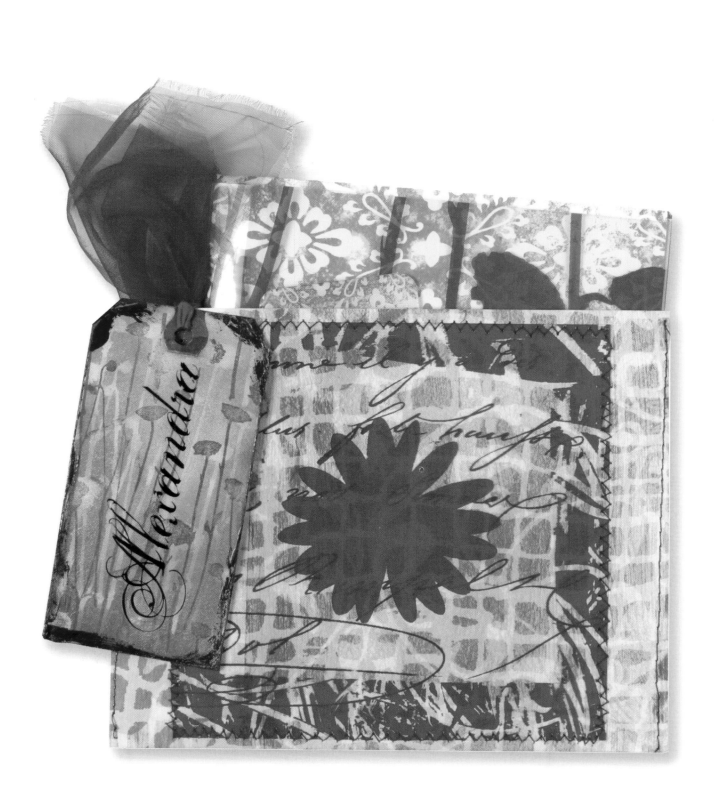

Garden Mini-Books

by Christine Adolph

When my daughters were infants, I frequently took them to Quail Botanical Gardens where I would squeeze in as many sketches of the beautiful surroundings before loading them back in their car seats to head back home. During these excursions, I would daydream about a time when they would be old enough to sit amongst the blossoms and make sketches of their own, alongside me.

In the blink of an eye, my baby girls have grown up and this past spring, it was the perfect time for us to gather paints and pencils with a picnic in hand, and head to Quail Botanical Gardens. We found the perfect spot to sit and I was able to take a lot of wonderful photos of the girls studying and drawing the flowers.

I designed these mini-books to remind us of our special trip together as artists.

By using transparencies that already come loaded with brilliant colors and beautiful images, I was able to add quite a bit of depth in very little time. We will take these books back to the garden and continue to fill them with photos and drawings to remember this fun mother-daughter activity.

Technique

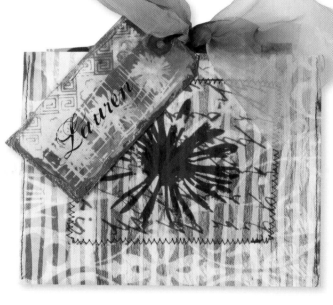

THE BOOKS

Cut 12″x12″ transparencies, batik-patterned paper, and cardstock in half. Each cut piece will now measure 6″x12″. Layer transparency, patterned paper and cardstock together and fold in half. Punch holes in the folded crease and then thread a ribbon through the holes and tie in a bow. Embellish with coordinating epoxy stickers and stamped tags.

THE TAGS

Paint tags with coordinating colors of twinkling H2O's. Stamp with bleach for a resist effect. If desired, overstamp with in a darker hue of pigment inks. Apply foil glue with your finger along the edges. When the glue is dry, it will feel tacky to the touch, at which time you can apply colored foil by placing the foil sheet over the glue and burnishing it well with your fingers. Use Impress-ons to spell names on the tags and tie them to the outside of the mini-book.

TOOLS & MATERIALS

- Foil
- Ribbons
- Pigment ink pads
- Impress-on alphabet rub-ons (Creative Imaginations)
- Epoxy stickers (Christine Adolph for Creative Imaginations

- Tags
- Cardstock
- Foil glue (Aileen's)
- Twinkling H2O's (Luminarte)
- Art paper (Christine Adolph for Creative Imaginations)

- Bleach
- Hole punch
- Art stamps (Christine Adolph for Stampington & Company)
- Transparencies (Christine Adolph for Creative Imaginations)

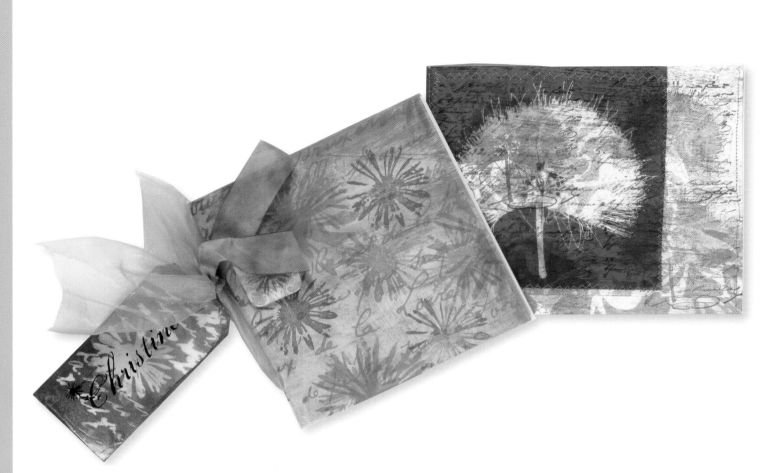

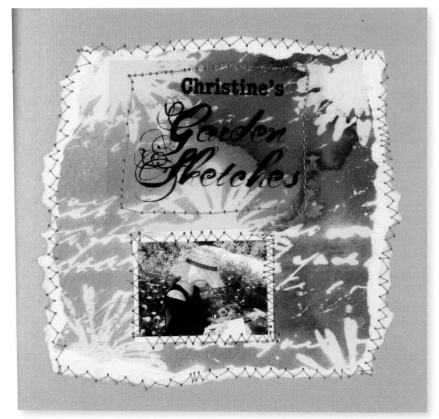

Tips

- For a more personalized look, use art stamps to create your own background paper.
- By using the design principles of scale and repetition, you can create a harmonious and balanced layout. In the turquoise book, for example, the dandelion transparency is in large scale, and on the background paper the image (through stamping) is repeated at a medium scale, and finally you see it small scale on the sticker.
- Foil can be used to embellish the transparency edges as well.

Christine Adolph is an artist and writer who lives with her family in southern California. To see her full line of art stamps, visit www.stampington.com. To learn more about her art papers, stickers, and transparencies, please visit www.creativeimaginations.com.

Wee Ones

by Nancy Gene Armstrong

Whether it's an altered book, a card, or many other projects, transparencies can add a whole new look to your art. I especially like how transparencies can cause the entire mood of a piece to change when placed over different background papers. Pretty floral papers, vintage text papers, and weathered cardboard papers can yield a multitude of different effects, especially when layered with the variety of transparencies that are available for purchase or that can be generated from your computer.

You can go to your local office supply store to purchase transparency film but due to their popularity, they are starting to become available at many local craft stores. If you intend to generate images from your computer onto transparencies, make sure you buy the sheets intended for your printer and not the write-on kind. And remember to make the most of the sheets by fitting in as many images onto a sheet before printing.

As you can see in this project, I prefer to use transparencies in dark, rich colors. I like to add plain light-colored pieces of paper behind the facial portions to help bring out the expressions.

TOOLS & MATERIALS

- Glue
- Buttons
- Inkpads
- Re-inkers
- Ephemera
- Art stamps
- Matte medium
- Transparencies
- Patterned papers
- Decorative brads
- Game piece letters
- Book (for alteration)
- Eyelets & setting tools
- Mini tags (for page numbers)

Technique

Before you get started, select a theme for the altered book and gather as many papers and transparencies that fit within the book's selected theme. The spreads shown here are from my altered book project titled "Wee Ones." As you can see, I used images of children throughout the spreads.

For each spread, select coordinating patterned papers and either cut or tear them to the size of the pages. Select the transparencies for each spread and use additional papers and ephemera to design layouts that are attractive and well balanced.

After the design is complete, you will need to decide how to attach the transparencies to the pages. Glue will usually show through the transparencies so brads or eyelets are what I generally use. I have also had success with small

amounts of matte medium rubbed on the edges of the transparencies. Staples, buttons, and ribbon are also great to use when adhering transparencies.

Once the transparencies have been attached to the spreads, you can use additional ephemera that complement the design. For this project, I also made page numbers by adhering mini tags at the bottom corners with stamped numbers.

For page one, I colored the page with chestnut brown re-inkers. Once dry, I tore a piece of the star patterned paper (Paper Pizazz) and adhered it to the top. After stamping an image of the world (Above the Mark) onto cream cardstock, I aged it, cut it out and adhered it to the page. A small light piece of paper was placed behind the faces of the transparency, which was adhered onto the stamped image with matte medium. The page was completed with game piece letters.

For page three, I adhered a floral patterned paper (Daisy D's) to the page and then cut a piece of cardboard box sized to fit the page. The transparency was placed over a photocopy of an old signature page from an old book and attached to the cardboard piece with square brads. These layers were then adhered to the page with patterned paper.

For page 10, photo corners were used to attach the transparency to another layer of patterned paper.

For page 14, decorative paper (7 Gypsies) was cut to size and glued down to page. Transparency of boy was adhered to page with a bit of glue on the corners. Old buttons were then added to the corners to prevent the glue from showing through. The same image of boy was printed onto cardstock, cut out and adhered to the left corner.

For page 16, patterned paper (Anna Griffin) was cut to size and glued down to page. A vintage postal stamp with a rocking horse was glued to center of page. The transparency was then adhered over the postal stamp using a small amount of matte medium.

- When printing ink-jet transparencies, let them sit to dry before handling. Also, be sure to keep your hands clean when handling as it is hard to completely clean off all smudges.
- If you use a lot of dimensional items the book will end up fanning out once finished. To hold it all together, consider poking holes to the front and back covers and threading ribbons through them to tie everything together.
- Remember that if you want the transparency to be attached to the main patterned paper with brads or staples or eyelets, the attachment should be done prior to the paper becoming adhered to the page.

Nancy Gene Armstrong is a frequent contributor to Somerset Studio and lives in Shreveport, LA.

Fireplace

Ghost Story

by Amy Blandford

This project started with a used book I bought last year. I planned to replace the original pages with my own, featuring stories about long-gone people whose presence is still felt, printed onto clear sheets for a ghostly, vaporous quality. I knew that this approach would make good use of the old photos that had wandered into my studio over the past years.

The song "Ghost Story" kept playing in my mind as I thought about the book so I decided to borrow the lyrics and turn them into a journal, which somehow evolved into the memoirs of a Confederate soldier. Reinterpreting the theme song also allowed me to incorporate a few of the 80 or so vintage medicine labels I've purchased on eBay.

Transparencies are easy to work into altered books. The 8-1/2″x11″ size can be trimmed to fit inside most book covers. It just takes a little practice, and experimentation with your printer settings to get the colors just right. The transparencies allowed me to create the mood I was going for in this project. It just wouldn't have been the same on plain paper.

Technique

When working with ink-jet transparencies, I prefer to hit the "Flip Horizontal" feature on my image-editing software before I hit "Print." This allows the image to read right through the backside of the materials. The side you print on is textured to hold the ink and the "wrong" side is smooth. I like to have the smooth side

TOOLS & MATERIALS
- Ink-jet printer
- Sharp craft knife
- Ink-jet transparency film
- Heavy-weight matte paper
- Aleene's® Paper Glaze™ (Duncan)
- Image-editing software (e.g., Adobe PhotoShop)

up on because it's nicer to touch, and fingerprints wipe off easier. It also provides more protection from scratches for the inked side of the image once it's adhered to the book.

I chose a book that's a bit smaller han 8-1/2″x11″. Since it's impossible to print all the way to the edges of the sheet, I like to trim the pages after printing. Most of the photos used in this book are available from the Library of Congress website. Outlined below are some specifics about the pages presented here.

FIREPLACE
The transparency for the "Fireplace" page is sandwiched between two sheets of paper that have identical cut-

out shapes, thus creating a "window" that shows the art on the next page. When printing onto transparency film, remember that white areas will remain clear. Light colors are more transparent and so for dark colors that require more ink, the more opaque the transparency sheet will become. While positioning the images, keep in mind that once you turn the page, part of the sheet before the window page will also show through.

In the photo-editing software, a mirror image of the page was also created so that when the pages are glued back to back, the openings line up. After printing, trim top and inside edges of each page to line them up correctly and use a sharp craft knife to cut the window in both layers at the same time.

Remembering

Imagingation

REMEMBERING

For the "Remembering" layout, I used transparent images to suggest that the narrator is imagining or remembering people who aren't really there.

You can create more of a layering effect by filling in the background of just a portion of the transparent page. On the backside of the first transparency, I used silver rubber stamp ink to make fingerprints around the inside edges of the small photo. Once dry, I filled the entire square with an opaque white calligraphy pen. The "backside" is really the rough, printable side, so the ink and paint is added on top of the toner. Dab it on, like you're painting a stencil. If you rub too hard, it could smear the toner.

The image of the baby girl was created by scanning a small sepia-toned photograph at a high resolution and then adjusted to size. I selected her eyes and adjusted the hue to a blue tint. On a white background, this is a very faint image. In addition to the old photograph, this page also has real lace, daisies, and a compartment that holds a hand-written letter on old paper.

The transparency helps to protect these fragile dimensional items.

IMAGINATION

For the "Imagination" layout, I used the "stamp" filter in PhotoShop to turn an image of a statue figure into a custom rubber stamp image. After printing, I embossed it with paper glaze to get a glossy and dimensional effect.

The image of the woman on the right side was printed on a transparency to give the impression that she is only present in the narrator's imagination. I scanned an old telegram and printed onto a sheet of scrap booking paper that already had a pattern printed on it.

Places

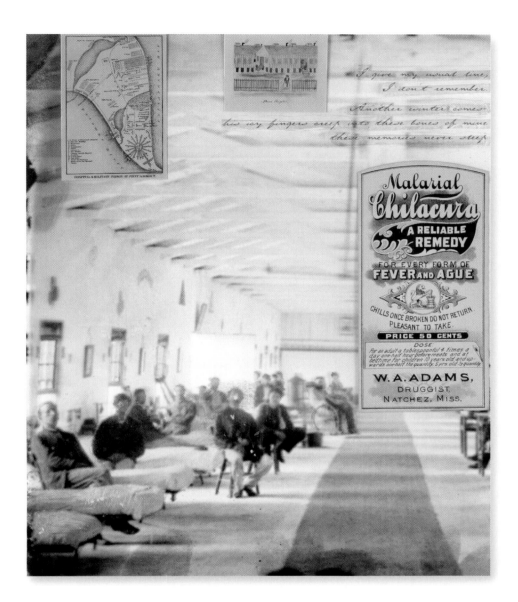

PLACES

For the hospital scene, in the "Places" layout, I layered old medicine labels above and underneath the film. I like that this sort of layering preserves the labels, even though only portions of them can be seen at first glance.

For the second scene, I selected and combined photos of people and backgrounds to create a ghosting effect. I used image-editing software to erase the original backgrounds from around the figures, and re-position them on top of the new backgrounds. The metallic words were created by running silver tape through a Dymo label maker. To antique the edges of the letters, these labels were colored with a permanent black marker and then immediately wiped off again.

Amy Blandford lives in Dana Point, CA. She can be contacted via e-mail at amyblandford@cox.net.

Travels

by Tammy Kushnir

This "Travels" book is about traveling, but not necessarily the kind that involves a vehicle. This book was made to chronicle my memories and photos of the first months of my youngest son, Jake's, life. I had created one for my eldest, Michael, and felt that Jake needed one as well. This book is different in that I only chronicled the first three months of his young life. He is now nearing his first birthday and these earlier days seem eons ago. However, as with any trip, viewing the photos always helps me recall the memories of our life's "travels" with great fondness.

Technique

TOOLS & MATERIALS

- Awl
- Scissors
- Adhesives
- Hemp cord
- Watch parts
- Electrical tape
- Assorted ribbons
- Sharp craft knife
- Dymo label maker
- Children's board book
- Assorted embellishments
- Bristol board (Strathmore)
- Acrylic paints (Folk Art by Plaid)
- Transparencies (Altered Pages, ARTchix Studio)
- Collection of photos (optionally altered in Photoshop)

CREATING THE CARDS

Of the pages shown, each contains a smaller card that was created before placing them into the pages. I took three of my favorite photos and taped them onto bristol board. For the "Time" page, I altered the photo using Adobe Photoshop CS and printed it on transparency film. For the "Love" page and the "Read" page, the taped photo was followed by a piece of transparency (Altered Pages) taped over it.

After the photos and transparencies are in place, I added assorted embellishments to each card. I used a Dymo Label Maker to create and adhere word labels for each card.

ENCASING THE CARDS INTO BOOK

The pages of a children's board book were painted with coordinating colors of acrylic paints and allowed to thoroughly dry. On all three pages, cuts were made to remove the inner portions of the pages in order for the cards to be placed between two pages and be viewed through the cut out "window." For the "Time" page, a brass frame and a crown charm (ARTchix Studio) were centered above the photo. For the "Love" page, electrical tape was added to the edges. For the "Read" page, holes were punched in the corners and findings (Nicole) were placed over the top. Hemp cord was tied through, to hold the pages together.

Tammy Kushnir lives in Philadelphia, PA.

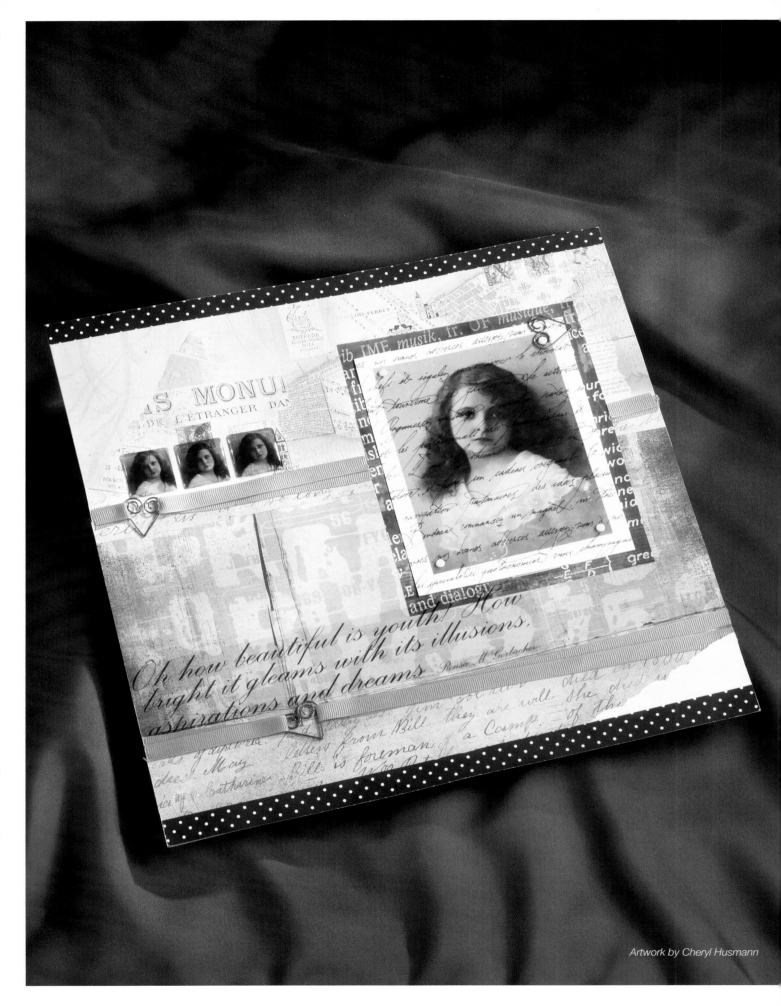

Oh how beautiful is youth! How
bright it gleams with its illusions,
aspirations and dreams. *Henri W. Longfellow*

Vintage images printed

on transparencies appear

soft and rather ethereal.

When the image is placed

over decorative papers

such as text or script handwriting,

the effect is just wonderful.

CHERYL HUSMANN

Memory Art

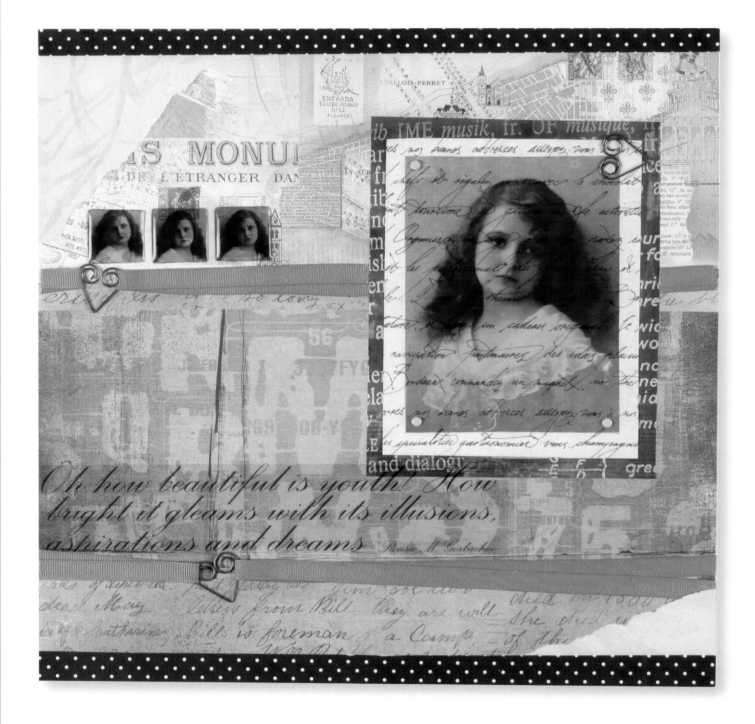

Oh how beautiful is youth! How bright it gleams with its illusions, aspirations and dreams *Rosa N. Gorbachev*

LAYERS OF
Color and Imagery

by Cheryl Husmann

I love my vintage photos. There are photos of my mother as a toddler in 1932, photos of my father as a daring young man in a flying machine, and photos of total strangers that I've purchased at flea markets and antique stores. All of these dear photos seem to plead with me for original and wonderful ways to be included in artwork for family and friends. Vintage images printed on transparencies appear soft and ethereal. When the image is placed over decorative papers such as text or handwriting, the effect is wonderful.

REPRODUCING IMAGES

One of the best ways I've found to reproduce images from my collection of photos is to scan the photos and copy them one by one into a Word, Power Point, or Photoshop document. Once scanned, you can manipulate the photo's size, depth of color, crop out unwanted details, etc. Alternatively, you can take photos to a local office supply store or copy shop and have them photocopied onto acetate sheets.

Carefully choose the photos you wish to print on transparencies. You will want to select ones that have a lot of open or light areas. These areas will allow the pattern and color of the background papers to show through. By layering with delicate vintage photos, a feeling of softness is created. Once you have selected the photos, reduce their size so that you may repeat the photo on or in another element on the page. It is a very creative way to enhance the message you are trying to convey or to fill space on a 12″x12″ page when working with one photo. The smaller images can be punched, trimmed and included on tags, within label holders and slide mounts, or under clear acrylic tiles.

COORDINATING BACKGOUND PAPERS

After your photos have been selected, resized, and printed, you are ready to dig into your stash of decorative papers. Keep in mind that all colors and designs of the selected papers will show through the transparency. Choose a variety of papers to begin, selecting them by color and by the type of design or print. Lay the transparency over the top of the papers until you find one that appeals to you.

You will find that in general, extremely busy patterns do not look good under the transparent photos. Neither do papers with extremely large print or line art, as they are often too big to be able to distinguish it as anything other than a blob of color. You will want to select prints such as small text or script, perhaps a map if it is not too busy, or a small tone-on-tone print. Move the transparency around on the paper until you are happy with the pattern that shows through. You may choose at this point whether this is a paper you wish to use as a main layer on the page, or if you just want to use it as a mat onto which the transparency gets layered.

USING TISSUE PAPER & PAINT OR GLAZE

If you find a paper that you truly love, but it is still too busy no matter how you position the transparency, there are a couple of tricks you can use. Tear a small piece or two of light-colored tissue paper or mulberry paper and lay this under the areas of the transparency that need lightening up; perhaps behind a face and hands, for example.

You might also try a small amount of acrylic paint or glaze in some of the open areas. Take care when using paint to turn the transparency over and paint upon the side that is not printed. When the transparency is dry, you can turn it back over and continue to assemble the page.

Build layers by adding a transparency under an acrylic tile right on top of the main image. Layer part of the page title across the transparency by using letter stickers. Use a transparency of scenery, leaves, sky or flowers and layer this over just part of the main photo image.

Tips & Ideas

- Trace a tag onto the transparency and cut out tag-shaped transparency portions.
- Use a transparency (perhaps one that did not print as well as you had hoped) and punch or cut letters to use for a page title.
- Use a larger-sized transparency of a photo as the background to which smaller versions of related photos can be placed.

Cheryl Husmann lives in Grafton, WI.

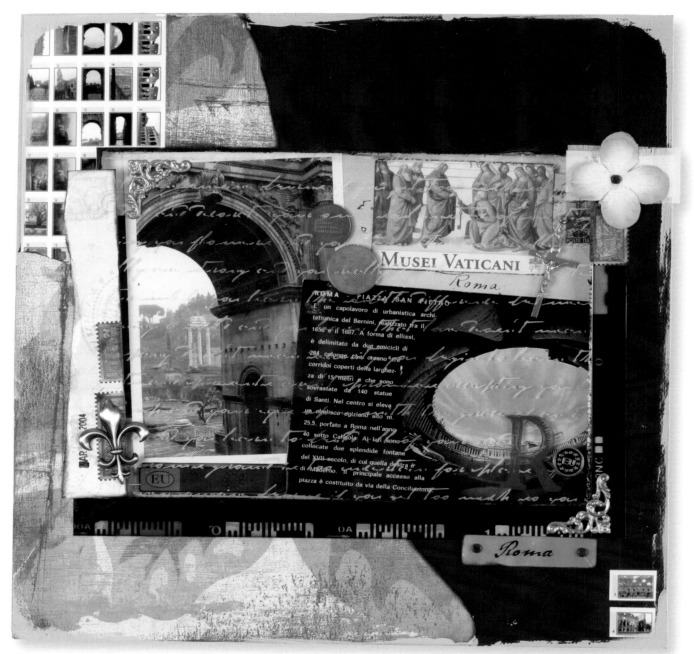

Roma

Tried and True

by Karen Russell

I have found through the years that as a scrapbooker, I go through stages where I have a tendency to reach for the same products over and over again. It usually lasts for a couple of months before I move on to the next product and then the cycle repeats. Transparencies, however, have been the exception to this pattern as it is the one product for which I never tire. I continue to reach for transparencies over and over again and in so doing, continually discover new ways to use them. Transparencies are versatile, they're artistic, and they always seem to add the perfect touch to my projects.

Thankfully, transparencies are everywhere these days and are available in a wide variety of sizes, themes and options. From 12″x12″ pre-printed sheets, to negative strips made from transparencies, envelopes, metal-rimmed tags, slide mounts, clear epoxies, mini-albums, labels, stickers, bookplates, frames and more, all are now made with transparencies. It's a transparency-lover's dream!

As a person who loves to experiment, I find myself constantly experimenting with transparencies. I layer, paint and tear transparencies. I sew and fold them. I cut, emboss and print on them. In the two years I've been working with transparencies, I've yet to run out of new ideas for using them and with so many sources of inspiration and so many new transparency-related products available, I'm guessing that my love affair with transparencies is just beginning.

I hope the techniques explained below for the three layouts with transparencies shown, will inspire you to experiment, create, and discover the thrill of transparencies.

TOOLS & MATERIALS

- Brads
- Label tape
- Acrylic paints
- Stickers (MAMBI)
- Metal banker's clip
- Metal photo corners
- Fonts (P22 Ladanse)
- Index tab (Autumn Leaves)
- Metal accents (EK Success)
- Rub-ons (Creative Imaginations)
- Foam stamps (Making Memories)
- Ink-jet transparencies (Hammermill)
- Negative strips (Creative Imaginations)
- Transparent labels (Creative Imaginations)
- Transparencies (Creative Imaginations, K&Co.)
- Patterned papers (Basic Grey, Autumn Leaves, Anna Griffin)

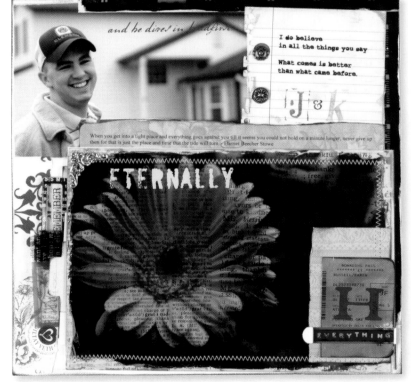

And He Dives in Head First

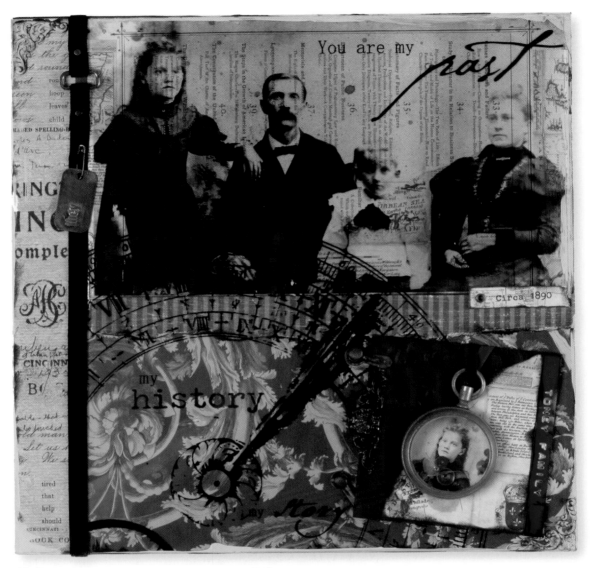

My Story

Technique

ROMA

I love the look of depth in a layout, so I of course love creating shadowbox-style layouts utilizing transparencies. For this layout, I cut foam core to create the shadowbox and filled it with memorabilia. I used a pre-printed transparency to create the "window" which also adds to the overall feel of the layout. I framed the window using patterned paper, photo index prints, negative strips and other ephemera.

There are times that I want to add text or imagery to a pre-printed transparency. I have found that it is easy to accomplish this with acrylic paints, StazOn inkpads, stickers or rub-ons. To add the red "R" to my layout, I used red acrylic paint and a foam alphabet stamp.

AND HE DIVES IN HEAD FIRST

Through experimenting, I have found that one of my favorite techniques is printing photos onto transparencies. It is such an easy way to add a beautiful, artistic look to any layout. For this layout, I used Photoshop to de-saturate a portion of my photo of a flower and then printed the photo onto a transparency. I used sandpaper to sand the edges of the transparency and then layered the photo on top of a pre-printed transparency. I used rub-ons to add the word "Eternally" to the transparency's top.

Using a zigzag stitch on a sewing machine, I sewed the layers of transparencies to the layout to create a pocket for hidden journaling and photos. Transparent labels were used for each of the hidden elements.

MY STORY

Using a combination of preprinted and computer-printable transparencies provides a never-ending amount of options. For this layout, I used Photoshop to add the first portion of the title: "You are my past," to my photo and then printed it onto an ink-jet transparency. I then layered the photo over a page that had been scanned from an old book. I also cut out a clock from a pre-printed transparency and added the remainder of the title: "my history. my story," by printing it onto an ink-jet transparency and layering it underneath the transparent clock.

Karen Russell lives in Grants Pass, OR.

Clever Disguise

by Renee Camacho

When you are looking to products that will help you showcase design elements, look to ones that are transparent, allowing you to view many layers within a design. There are many ways to layer them onto your projects. My preferred method is in smaller dosages that don't compete with the overall look and design. Transparencies can add a lot of punch to an otherwise lack-luster item, such as this store-bought photo mat turned into a photo frame.

After it was placed onto the layered book page background mat, it seemed dull in comparison to the surrounding elements. By simply layering on a pre-printed transparency portion that was trimmed to fit exactly over the mat, instant pizzazz was added. The trick to adhering items of this nature is to also make sure that you cover any adhesive with some sort of embellishment, thus cleverly disguising the adhesive point.

Technique

To create the layout as shown, simply start with a decorative scrapbook paper as your background. Add torn pages from vintage books with a sewing machine. Trim the dictionary transparency with a sharp craft knife to fit exactly over the photo mat frame. Adhere in the top right hand corner with a glue dot and cover the adhesive point with a vintage button and feather as a decorative element.

Print journaling and trim into strips, adhering to bottom portion of page. Add name and date onto vintage fabric label and adhere to page as well. To complete, simply sew feathers onto the left hand portion of the page using a sewing machine. Hand-stitch buttons to left hand corner of page using linen thread. Finish by trimming additional strips of transparency to use as simple embellishments to upper and lower corners.

Add the rub-on letters for the title portion. Complete the decorative elements by simply adding a machine stitch element to the lower right-hand corner of the page.

Renee Camacho lives in Nashville, TN.

TOOLS & MATERIALS

- Feathers
- Glue dots
- Sharp craft knife
- Sewing machine
- Vintage fabric label
- Linen thread & needle
- Transparency (7gypsies)
- Patterned paper (BasicGrey)
- Vintage buttons (Manto Fev)
- Found book pages (Manto Fev)
- Rub-on letters (Autumn Leaves)
- Old Remington font (Autumn Leaves)

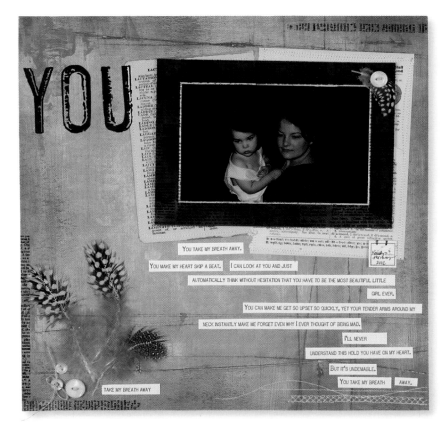

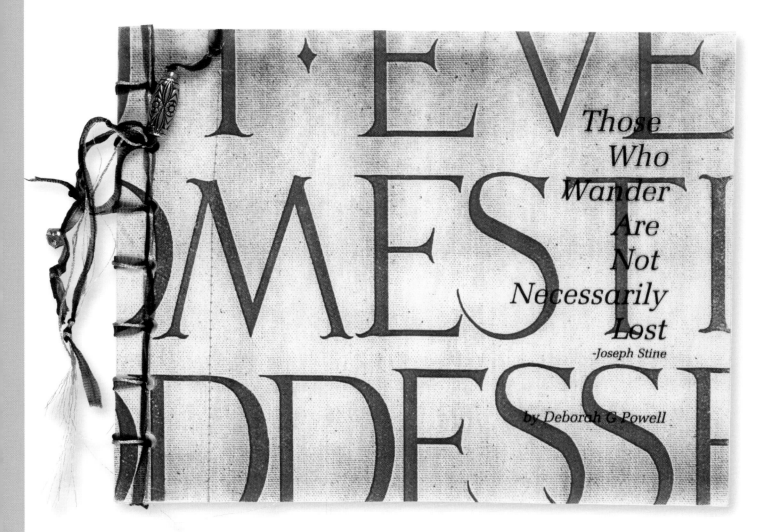

Those Who Wander Are Not Necessarily Lost
-Joseph Stine

by Deborah G Powell

To AWAKEN in a strange town is one of the most PLEASANT sensations in the world. *Freya Stark*

Some experiences simply do not translate. You have to GO to KNOW.

Calligraphic Travels

by Deborah G. Powell

It was the occasion of a class assignment at an adult school that lured me into thinking about transparencies. Barbara Close, the instructor, had issued a challenge to create a background with italic brush lettering and have it interact interestingly with an italic typeface. Use of a computer was encouraged. I had just returned from a trip to Europe so the book assignment seemed ideal for creating an unusual journal. Prior to the trip, I was given a book of travel quotes by a friend, which became a perfect source for the quotes I would select for some of the transparency overlays.

I began to visualize the softness of off-white paper, layered with a light wash of lettering and collage elements, overlaid by a clear, shiny transparency containing a computer-generated quote in a simple black italic font. Right away, I could see my favorite elements of texture, color, and contrast at play. The use of transparencies would offer me an opportunity to layer without sacrificing clarity of the lettering. This project not only allowed me to keep a record of interesting places I visited but also took me to some unexpected places as I constructed the book.

Technique

After deciding to use primarily black on white for the book pages, I made photocopies of souvenir ads, postage stamps, photographs, and lettering samples using clear vellum and occasionally copied directly onto Arches Text Wove paper. Actual postage stamps that I had collected on the trip were also used to create small collages of color throughout the book. My main goal, however, was to keep as much white space on the lettering page as possible, so the transparency could create its own impact with the column of black lettering I would choose for overlays. Some of the pages also had flaps of Arches Text Wove paper or transparencies to create even more layers.

The pages were organized according to order of travel: London followed by Brussels, Bruges, and Paris. Even the sheet of "mini prints" that I received from the photo developer became part of my "cut and paste" mindset. I photocopied them onto vellum, cut the strips to size, and used them for collage purposes. On

TOOLS & MATERIALS

- Buttons
- Photocopies
- Sewing machine
- Colorless vellum
- Arches Text Wove paper
- Chisel-edged brushes (1/4″, 1/2″, 1′)
- Computer-generated lettering on transparencies
- Hole punch
- Metallic thread
- Textured ribbons
- Luminescent watercolors
- Diluted black tempura paint
- Assorted paper ephemera (from the trip)

another page, I used a portfolio cover I found in Bruges, photocopied a portion of it onto vellum, and applied a gold twinkling watercolor accent. Lettering was done with chisel-edged brushes and diluted black tempura paint.

Because of an adhesive problem I encountered when using a glue stick, I decided to use my sewing machine to adhere and add texture by sewing the pages in a somewhat random fashion. I threaded the machine with metallic gold thread and had a good time stitching where design or necessity required. In the end, I think I was happiest with the added element of stitching, which I hadn't initially considered.

The Arches Text Wove pages had been cut so that they could be folded in half, into 8"x10" pages. This meant that only a single page of text would be viewed at a time, which worked out well when I decided to sew the front half of the pages. The under side

My
favorite
thing
is
to go
where
I've
never
been
before.
Diane Arbus

stitching was covered by the other half of the folded page.

After reducing or enlarging quotes in italic font, I generated them onto white paper and then took them to a copy center, where they made them into single text-sized transparency pages.

Once the pages were assembled and clamped in place to prevent movement, I used an adjustable hole punch to make several holes, 1/2" from the left edge of the folded pages. Using the Japanese stab binding method, I wove two textural ribbons through the holes, tied them off and decorated the ends of the ribbons with buttons and beads.

Deborah Gerwig Powell is a freelance calligrapher who lives in Orange, CA. She has two grown children, a crazy dog, and a workaholic husband who almost tolerates her messes. Deborah may be contacted at dgp2ink@yahoo.com.

Sometimes, I like to jazz up

a transparency by painting the back

with various acrylic paints

or using gel pens

to color the designs.

I also like to accent

the top of a transparency

with glitter paint pens, gel pens

or permanent markers.

TRACI BAUTISTA

Collage

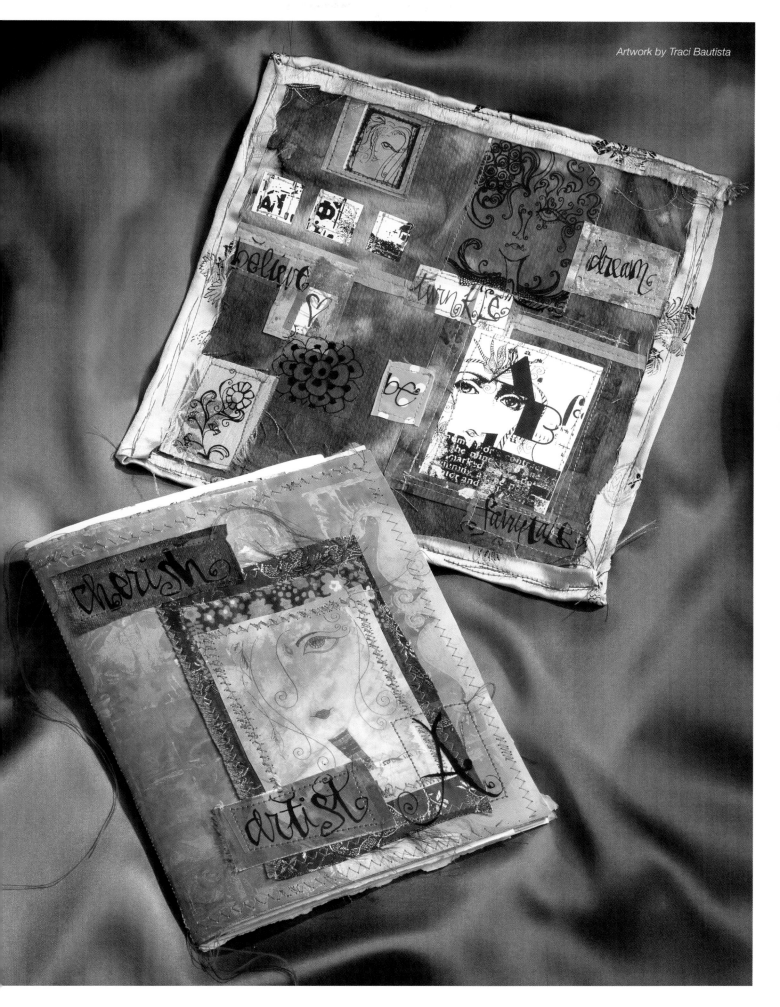

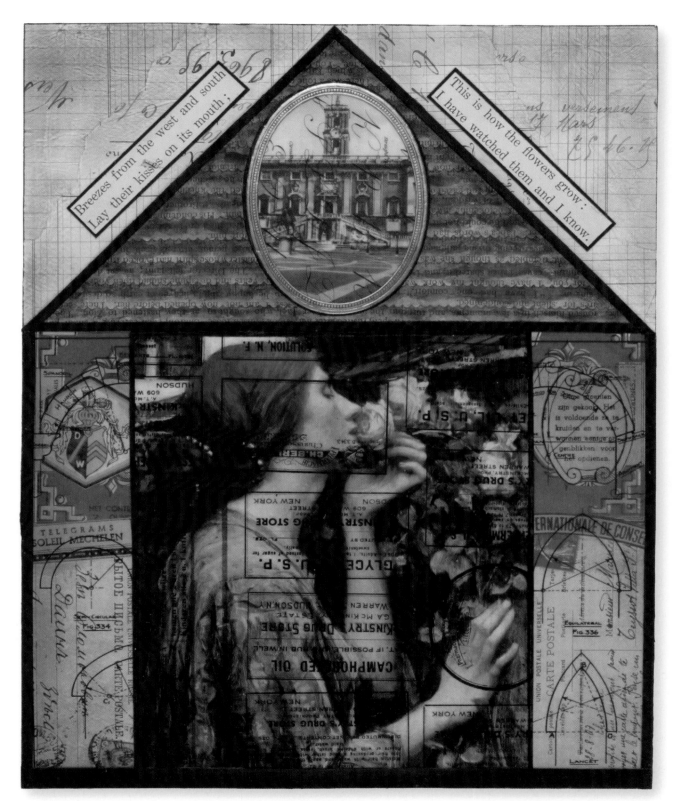

Breezes

Layers of Depth & Mystery

by Karenann Young

A few years ago when I started making collages, I worked solely with black and white clipart. I worked in this format because at the time, I was afraid of color. As time went on, my collages became more complex. My current art philosophy is that more is better and much more is better yet! Later, I decided to explore color and discovered the endless possibilities. Soon afterward, I came across transparencies by ARTchix Studio. They were the perfect touch to my art, adding another layer of depth and mystery.

When I start making a collage, I bring together everything that speaks to me at that time. The elements may seem unrelated but they soon find a place in my art. I think collage is like life. The world is full of interesting images from majestic mountains to an old rusty sign. These are things that we see everyday and become part of us. As human beings, we also have many layers. In one day we may feel the joy of playing with our cat, the warmth of a stranger's smile or the heartache of a lost love. We are complex beings and I want my collages to reflect that. I want them to be interesting to look at and full of wonder at what certain elements may mean. Life reflects art and art reflects life.

TOOLS & MATERIALS

- Brads
- Art stamps
- Acrylic paint
- Matte gel medium
- Double-sided tape
- Assorted ephemera
- Old photo album page
- Computer-generated words
- Transparencies (ARTchix Studio)
- Metal bits (round metal tag, metal frame)
- German scrap (gold or silver covered paper frames)

Technique

BREEZES COLLAGE

Begin this collage by gluing found papers to create a background on either canvas or matboard. For the roof, cut out strips of found papers with decorative scissors and glue them down. Glue together an old picture of a building, a transparency, and a German paper foil oval frame. Adhere these layers on top of the roof. Next, adhere the transparency of the woman to the lower portion. Cut out selected poem and also adhere to the collage. Finish by trimming the house shape with thin black tape.

TRUE LOVE COLLAGE

This collage also begins by gluing found papers to a ground of choice to create a background. Layer an old photo with a transparency and adhere these layers to the back of an old photo album page and adhere black photo corners. Punch holes in the album page on the left side and insert brads. Glue the entire album page to the prepared background. Write on the photo album page with light-colored pencils and then adhere a keyhole-shaped transparency with brads. Finish by adhering transparency words, small postcard, and computer-generated words.

True Love

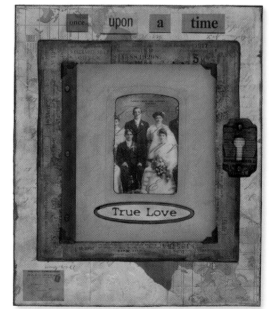

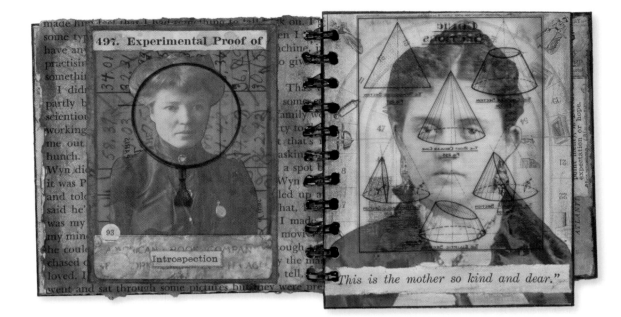

497. Experimental Proof of

93

Introspection

"This is the mother so kind and dear."

Published by
Karenann Young
P.O. Box 17003
Tucson AZ 85731-7023

www.picturetrail.com/KARENANNYOUNG

© 2005
All rights reserved

winter

ISBN 0-7893-4876

girl

Made in the United States

Library of Art

Karenannyoung@yahoo.com
15 14 13 12 11 10 9 8 7 6 5 4 3 2 1

play

341

she

is

lost!

afraid.

memories

205

Begin

It is cold.
The trees are bare.

LITTLE BOOKLET

A friend of mine gave me this wonderful 3″x3″ blank little booklet that came with covers made of thick black cardboard. The background for the cover is of diamonds that I made from my own hand-carved stamp, accented with paint and gold dots. The red hearts were cut out from red cellophane from a Valentine's Day candy box and adhered, followed by two contrasting rectangles of words glued on top.

For "The Little Birds" page, found papers were glued down as a background and a layer of acrylic paint brushed on. The rays were made by stamping text onto paper with red ink, and then cutting into points and adhered to the page. A small metal frame was painted and layered with an image of a face and a transparency, followed by the bird image and words. The remaining spreads from this book: "Winter Girl," "It is Cold," "Introspection," and "Mother is so Kind" were composed with similar techniques.

Tips

- When you don't want the glossy shine of a transparency, brush on a thinned coat of matte gel medium directly onto the transparency.
- A metal tag can quickly and easily be decorated by using double-sided adhesive to attach a transparency to it.

Karenann Young lives in Tucson, AZ. To see more of her work, visit www. picturetrail.com/karenannyoung.

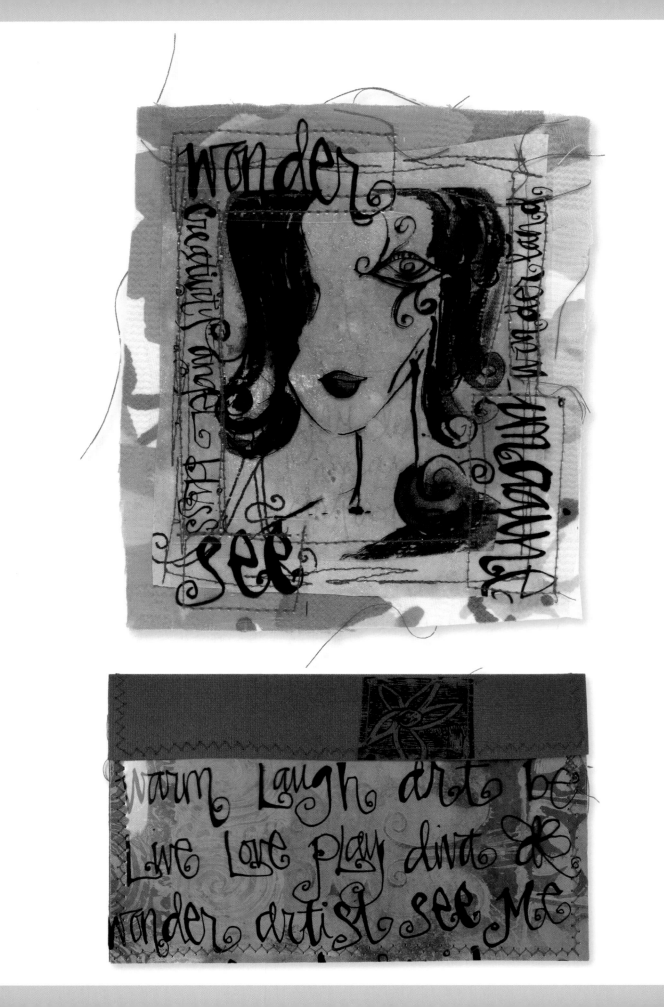

You Go Girl!

by Traci Bautista

When I was in college about 10 years ago, I used to create "overlays" for my graphic design projects, which were pieces of acetate printed with typography, rub-on letters, and laser copies of my original illustrations. I have taken this art technique a step further to create an endless amount of transparent pieces to incorporate into my current art projects. The possibilities are endless … you can create your own transparencies and then alter, layer, attach, and "go" in whichever direction you desire!

To create transparencies for my artwork, I start with back and white line art created from my original drawings, writings, doodles or computer-generated images. It is important to me to include my own marks in any piece I design, so if I'm using a commercial image, I will combine it with my original illustrations.

Sometimes, I like to jazz up a transparency by painting the back with various acrylic paints or using gel pens to color the designs. I also like to accent the top of a transparency with glitter paint pens, gel pens or permanent markers. To create metallic effects, I use heat transfer foil and iron over the top of toner areas.

Transparencies can be incorporated into various art projects including ATCs, business cards, invitations, book covers, envelopes, wall hangings, and as accents to fabric journals and tags.

CREATING CUSTOM TRANSPARENCIES

Listed below are some of my techniques and ideas in creating custom transparencies. Note the printing method for these techniques determines the type of transparency that is used. Images can be printed on transparencies in a number of different ways, including photocopying original art on a copy machine and printing on an ink-jet printer. I prefer transparencies for copy machines, as they are smoother and faster to work with.

NOTE: The following can be done directly onto an overhead or copy machine transparency, available in office supply stores:

- Stamp images with permanent ink (like StazOn).
- Adhere rub-on letters.
- Doodle or draw with a permanent marker.

NOTE: The following are techniques to use before generating the art onto a transparency through the use of a printer (with or without the use of a scanner) or a photocopy machine.

- Transform color images and photos into black and white art using Photoshop.
- Type out words related to a project's theme in Microsoft Word.
- Layer text and letterforms in a graphics program (like Photoshop) to create interesting backgrounds and patterns.
- Scan original drawings, photographs and doodles from journals to create black and white line art.
- Create handwritten words with a calligraphy pen.

NOTE: The following are ideas to use when experimenting with a photocopy machine.

- Layer transparencies on top of each other and then make a photocopy onto another transparency with all the layers.
- Playfully experiment with a photocopy machine by creating images by making black and white copies of color illustrations; enlarging and reducing portions of writing and doodles.

USING TRANSPARENCIES IN COLLAGE

Once you have the desired artwork generated onto a transparency, you're ready to go. There are many ways to layer the transparencies into art, which can open up many wonderful possibilities in enhancing collage projects.

One of my favorite attachment techniques is stitching with a sewing machine. I stitch them over hand-painted fabric and paper, even dyed paper towels backed with interfacing. There are a variety of techniques to attach transparencies, which can be reviewed in the "Transparencies 101" article by Sarah Fishburn at the beginning of this book. Listed below are techniques and ideas for using transparencies in collage.

- Attach two transparencies together with a piece of artwork in between, like a dried flower, glitter, sequins, fibers, confetti, fabric swatches … anything that fits between the two transparencies.
- Stitch a transparency piece over a piece of brocade fabric.
- Make envelopes with see-through panels by layering a printed transparency onto a piece of cardstock or vellum and stitching the edges closed.
- Stitch strips of assorted papers to the transparency to create a multi-colored background.
- Create metal tags with tin, fabric and a word transparency.
- Sew a transparency onto ribbon.
- Print an image onto one transparency, then words in another color on a different transparency and layer onto each other.
- Create a transparency sandwich and attach with eyelets and wire wrap the edges with beads and charms.
- Layer a transparency over a painted background, strips of painted paper, or colored laser print.
- Make a transparency quilt by stitching the edges to pieces of hand-painted fabric and paper.
- Make a wall hanging of transparency sandwiches attached with eyelets, wire and beads.
- Cut out a square in the middle of a piece of painted illustration board and suspend a transparency sandwich with an image in the middle of the cut-out.

ONE LAST TIP

Once I have a finished piece, I take it to a copy center and "play" by photocopying it on the color laser machine, alter it by enlarging, reducing, copying in black and white, reversing the color and flipping the artwork. This creates an endless supply of images to use in my collage work and handmade journals. Always keep playing and always exploring new possibilities. And remember: You go, girl!

Traci Bautista lives in Fremont, CA. To learn more about her work, visit www.trecidesigns.com.

Soul Painting

by Kelly Kilmer

As an artist, it's always best to try to push yourself outside of your "comfort zone" every now and then and try something new. I rarely work with transparencies, so this project was a "push" and a bit of a challenge for me. I began by spending a couple of weeks trying to figure out which images to use and how. I tried different ways to approach the "mixed media" aspect of working with transparencies my way. The trick is to step outside of your box every now and then, and make something different. It keeps your work unique and fresh.

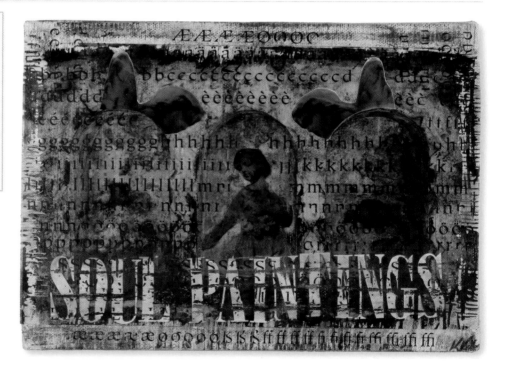

TOOLS & MATERIALS

- Bone folder
- Paint brushes
- Transparencies
- Acrylic paints (Golden)
- Paper towels & old rags
- 5"x7" gesso-primed canvas
- Soft gel gloss medium (Golden)
- Rub-on letters (Making Memories, Letra Set)
- Caran D'ache Watersoluble Wax Pastels (NeoArt)

Technique

Start by moving the images around in different positions and directions, layering them onto a blank background to configure a design that you are satisfied with. Once this is done, paint the backs of the angel transparencies with Titanium White acrylic paint (Golden) so you can see the images better when layered onto another transparency.

Use various colored pencils to color the transparency figure. I scrub, layer, swipe, and brush various acrylics onto the canvas. I recommend applying thin layers of paint. The thin layers will dry quickly. Excess paint should be wiped off with paper towels and old rags throughout the process.

Cut and arrange transparencies onto the canvas as desired. Start by layering the bottom piece, spreading a thin layer of soft gel gloss medium onto the back of the bottom transparency. Keep the amount of medium somewhat thin and keep the brush strokes in the same direction as the application of the glue. Adhere first image to the canvas, burnishing lightly with a rag to adhere images to canvas, and wiping away any excess gel medium. Layer images as desired. Let dry. Apply more layers of paints to the canvas and the transparency borders as desired. Wipe, swipe and scratch into paint as desired. Let dry. Use various rub-on letters (Making Memories, Letra Set) as desired. Burnish with a bone folder. Using Caran D'ache Neo Art Watersoluble Wax Pastels, brush on color to the rub-ons and blend colors into the letters with your finger. Use fingers to also remove any excess pastel in any area that is undesirable. Finish by taking a bone folder and "scratching" into the rub-on letters, removing letters and certain areas of the letters as desired.

Kelly Kilmer lives in West Hollywood, CA and can be contacted via email at Egorey99@worldnet.att.net. To learn more about her, visit.www.KellyKilmer.com.

"a dream"

Making Faces

by Erika Tysse

Are you like me: always looking for new ways to incorporate and mix media together to form a unique, one-of-kind personal piece of art? This is exactly the reason why I started using transparencies a couple of years ago – experimenting with different images to create a more layered and interesting look to my art; a transparent window if you will.

I found that with transparencies, I could take a rather flat piece of artwork and by popping in a transparency, I could create an almost three-dimensional look to any piece of work. I started small: 5″-square paper collages and from there, added them to various bases including canvas, wood, and paper. I've made a plethora of altered trading cards, bookmarks, and original greeting cards using small transparency scraps. Challenge yourself to find interesting ways to incorporate transparency in your own work.

Technique

To create "Many Faces II," I primed a wooden box and then added a vintage paper background. I prefer working with original, vintage papers as they are rather thin and delicate. The nature of old papers makes them easier to adhere to the background without annoying air bubbles that frequently surface when using newer, thicker papers. This is important to keep in mind when using transparencies, as you will get the best results if the transparency is applied to a flat, primed base.

As the base dries, apply masking tape randomly on background and tear off, pulling bits of the original papers. Apply a coat of acrylic paint if desired, and let dry. Next, find a transparent image that you would like to use in your art. For "Many Faces II," I used a found photo of school children to generate an ink-jet transparency. To the back of this transparency, I adhered pieces of found papers. Two transparency pieces prepared in like manner were sewn together and then adhered to the base with gel medium. After adhesion, it is important to press the entire piece under books or in a press to ensure a flat, finished piece. There's nothing worse than a wavy transparency!

For the smaller "A Dream" card, I started by gluing background papers down onto black piece of artistamps (100proofpress.com). Transparencies (ARTchix Studio) were then layered on top of the papers with either glue or stitching. Embellishment marks were made with an oil stick and then the entire image adhered to the black cardstock.

Tips

- When printing out a transparency using an ink-jet printer, go to "page setup" and select "transparency" as the paper type. This will cause the printer to automatically adjust the ink flow to give you a clean, crisp result every time.

- Be sure to print the image as a mirrored image. This way, you can adhere the transparency ink-side-down and avoid having to worry about the ink smearing or the image coming out unclear once you add a final touch of medium or varnish.

To learn more about the work of Erika Tysse, visit www.erikatysse.com.

TOOLS & MATERIALS

- Oil stick
- Cardstock
- Found papers
- Masking tape
- Acrylic paints
- Copyright-free images
- Wooden box as collage base
- Blank artistamp sheet (100proofpress)
- Ink-jet transparencies of found images
- Gel medium (or adhesive of your choice)
- Pre-printed transparencies (ARTchix Studio)

Collage, Coincidence & Chance

by Melissa Lowry

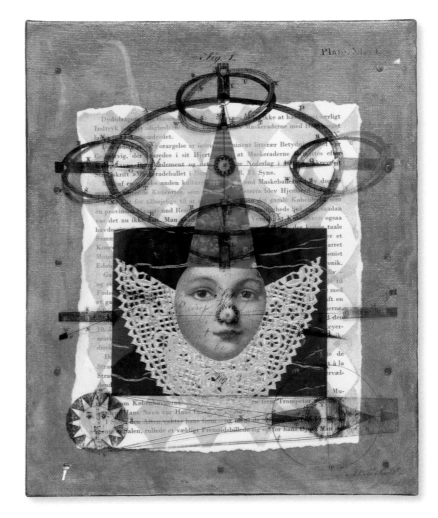

The piece began as a simple paper collage of a face on a painted canvas background. It was an interesting composition but it felt unfinished. I wasn't seeing a message or a story there, and it seemed to demand a unifying aspect, more integration. I sorted through my voluminous collection of images and ephemera, randomly selecting and discarding, waiting for something to speak to me.

An acetate transparency of a vintage solar system fell out of my hands and slid across the canvas. Not only was the black diagram of the planets proportionately perfect over the existing collage, it lent a surprising depth to both canvas and paper. The alignment of the superimposed figures gave the face a new perspective and transformed the piece.

Adhering the transparency invisibly, plus aligning the slippery overlay precisely upon the underlying collage, provided another conundrum: glues, vellum tape, adhesive spray all had their own set of limitations, and I wanted to preserve the clarity of the overlay and to create an organic whole. Having run out of adhesive solutions, I took a low-tech approach and nailed the transparency onto the canvas – right through the stretcher bars – with copper nails. I was delighted to see the resulting effect was one of tiny planets or orbiting bodies that were also rather jewel-like.

Now, instead of being merely a pleasing pile of attractive collage ingredients, the piece had become a visual tale of a Renaissance princess and the emergence of the new world of astronomical theory.

Although we cannot force solutions to most artistic challenges, we can encourage answers by being open to happy accidents and random acts of fate. Call it what you will, chance, fortune, serendipity or coincidence brought together materials which I might not have thought to combine, until a dropped piece of acetate changed the face of my art.

Melissa Lowry lives in Portland, OR. She can be contacted via email at mjlowry@ix.netcom.com.

Barn of Imagination

by Angela Cartwright

It's a long and desolate drive on Pear Blossom Highway when returning from the glitz and glamour of Las Vegas. During the journey back home, I found myself staring out the passenger window of the car listening to James Taylor croon his wistful music and Joshua trees sporadically came in and out of view.

I reached for my camera and snapped a few pictures of the lone specimens.

Gazing through the viewfinder at the landscape whizzing by, I experimented with a slow shutter speed to get movement in the final black and white negative. Suddenly, there appeared a solitary barn ...

I snapped the shot as it left the frame of my camera. It made me wonder ... who used a barn out here? What was stored there? When the film was developed, I found that I had captured on celluloid, my "Barn on the Run" image, anxious to be given new life amongst poetic words and paint.

TOOLS & MATERIALS
- Art board
- Sandpaper
- Art stamps
- Copper wire
- Acrylic paints
- Gesso (Golden)
- Stretched canvas
- Watercolors & paper
- Crackle paste (Golden)
- Glaze Gelly pen (Sekura)
- Embossing powder & heating tool
- Transparency (Angela Cartwright for Stampington & Company)

Select a stretched canvas to serve as the frame for your selected transparency image. The idea is to use the backside of the stretched canvas to become the front side of the finished piece. Apply gesso and crackle paste to the backside frame and let dry. Follow with applications of acrylic paints in colors of your choice. Once dry, add highlights with additional paint colors and then slightly sand the surface.

Next, apply watercolors to watercolor paper and let it dry completely before writing a poem with a black Glaze Gelly pen. Attach the poem to the canvas inside the opening and then place the transparency over the writing but attach it to the back of the canvas frame, leaving space between the written words and the transparency. The space will allow light to enhance the transparency and add dimension to the piece.

Finally, emboss pieces of art board with embossing powder, and during the heat setting process, stamp into the melted powder with various art stamps. Wrap copper wire around the canvas and intertwine the embossed pieces within the wire.

Angela Cartwright lives in southern California. To learn more about her life and work, visit www.acartwrightstudio.com.

Castles in the Sky
by Nila Barja

Peaceful vignettes, windows, and portals all appeal to me, and show up often in my art. I love using the vivid colors of my native home of Bolivia. The transparency of Angela Cartwright's transparency image used in this piece reminds me of my dream home: a peaceful refuge built within my imagination.

TOOLS & MATERIALS

- Lace
- Sand
- Gesso
- Beeswax
- Paint brush
- Pastel chalks
- Acrylic paints
- Stretched canvas
- Favorite fabric print
- Black and white copy of favorite picture of fruit
- Transparency (Angela Cartwright for Stampington & Company)

Technique

Start by mixing gesso with sand to a thick consistency. Spread this mix onto stretched canvas with a wide brush. If you enjoy lots of texture and pattern, this is the time to layer it on. Next, take the transparency and place it on the portion where the window will be. Make sure you put an extra amount of the gesso/sand mixture on the edges of the transparency. Cut strips of a favorite fabric and place them in strategic portions on the gesso while it is still wet. Use glue to make sure it stays in place. Mix paints with water to create watercolor consistency, use this to make a light drawing of the window and table.

Take the black and white copy of fruit and hand-color with pastel chalks, rub colors into the image and tear to fit on the table. Use glue or gel medium to adhere to canvas. Take lace and put over fabric wall and cover the left side of canvas. When all is dry, use acrylic paints to create a window, table, chair and flowers. Be impressionistic, let the fabrics and textures tell the story and show how the light falls on the table. The last detail is to drip beeswax over the transparency, which makes the flowers and table the main focus.

Nila Barja lives in Santa Barbara, CA and can be contacted at nilaart@yahoo. com. To learn more about her art, visit www.nilabarja.com.

Beautiful
VINTAGE CEILING TILE

by Sarah Fishburn

Who would have guessed that the smooth, shiny surface and bright colors of a printed transparency could combine so gracefully with the shabby chic surface of a vintage ceiling tile to make such an appealing little hanging?

Well, darling, let me tell you! It's an ideal combination of art supplies. The tile itself forms a natural frame, with its own juxtaposition of elegant embossing and distressed finish, while the painted flower photo transparency adds the perfect burst of fresh and lively color!

Be sure to keep your eyes open for some of these old ceiling tiles to use for all kinds of projects, especially those including transparencies. Although reproduction tiles are easily found, the wear, tear and rust on the old ones only add to their already considerable charm.

Technique

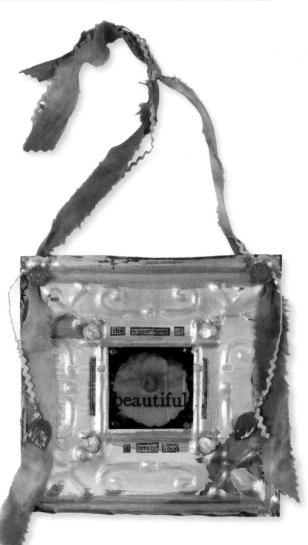

After adding some highlights with paint and metallic rub-ons, I used simple brad attachments at each corner of the floral transparency, which was layered over a transparency printed with the word "beautiful." NOTE: Use a hammer and small nail to make the holes through the tile. Use a tiny hole punch to make the holes on the transparency.

I used a few descriptive words stamped onto kraft paper to add some additional bordering around the transparency and used Diamond Glaze to adhere an elegant vintage glass floral element at each corner of the small interior "framed" area.

The piece was completed when I added lengths of ribbon for hanging the tile. I first made holes in each top corner, then threaded hand-dyed vintage silk ribbon and hand-dyed rickrack through, knotting at the top. Finally, for a bit of color contrast and dimensional interest, I attached small red glass roses and wired leaves.

Depending on your chosen transparency, you might want to use buttons, beads, charms or anything else which could easily be tied, stitched or wrapped on. The addition of each detail only serves to delicately accent the two true focal elements: the artfully deteriorated tile, and the exquisite transparency placed within.

Sarah Fishburn lives in Fort Collins, CO. To learn more about her work, visit www.sarahfishburn.com.

TOOLS & MATERIALS
- Art stamps
- Kraft paper
- Hole punch
- Ceiling tiles
- Old ceiling tile
- Hammer & nail
- Diamond Glaze
- Assorted ribbons
- Metallic rub-ons
- Pearl Magenta Lumiere paint (Jacquard)
- Glass roses & wired leaves (Blue Moon Beads)
- Flower transparency (Angela Cartwright for Stampington & Company)

Having just helped my son
identify and memorize 100 birds,
I had birds on my brain.
So when I ran across these
wonderful transparencies,
I knew that I just had to turn them
into something beautiful.
RHONDA SCOTT

Fun Projects

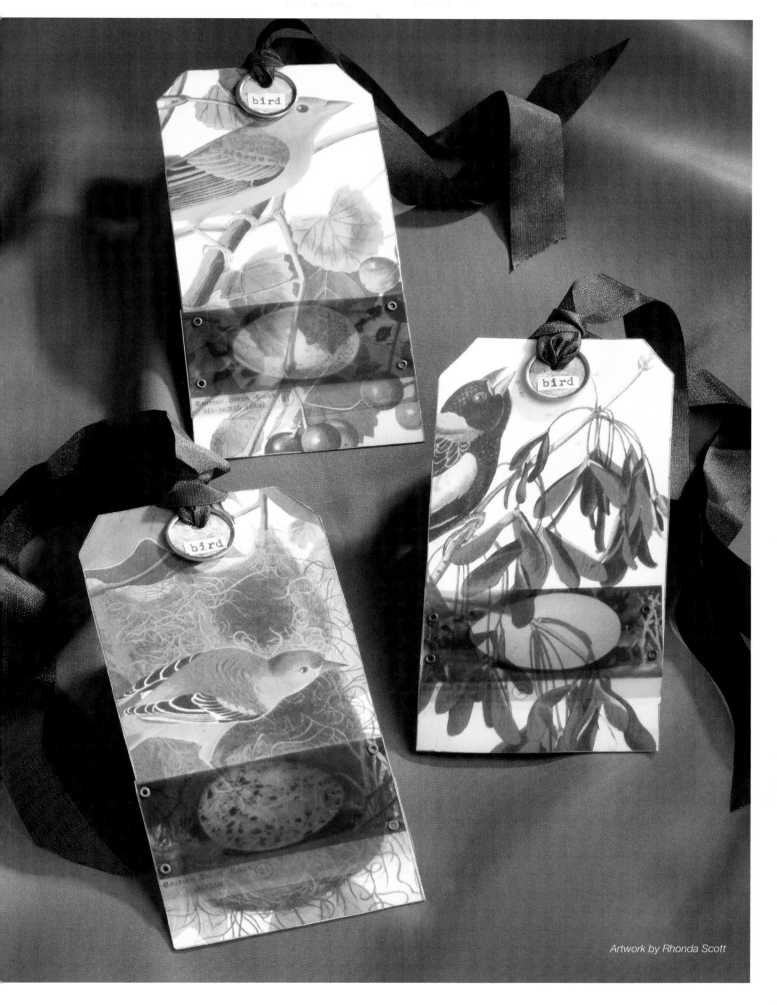

Making ATCs

by Jenny Doh

For the past several years, artists have discovered the thrill of creating art in a miniature format and trading them with other artists. These creations that typically measure 2-1/2″x3″ are known as Artist Trading Cards, or ATCs for short.

In *Artist Trading Cards: An Anthology of ATCs*, published in 2004 by Stampington and Company, artists shared work that they had made within this mini format, with art mediums as diverse as the artists themselves. The mediums included paints, watercolors, stamps, transfers, beads, found objects, metals, and fabrics. A few of the artists within the book also incorporated the medium that is the focus of this book: transparencies.

When the call for artwork for *Transparent Art* was issued, several artists submitted ATCs they had made with transparencies. Shown on these pages are ATCs by **Sarah Fishburn**, **Diana Tisch**, **Debbie Metti**, **Jennifer Black**, **Lisa Martin**, **Kathleen Green**, and **Patti V. Crump**. In speaking with these artists, one sentiment seemed common among them: Never underestimate the power of a transparency, even on the smallest of creations, like the ATC.

Karenann Young
Tucson, AZ
Contact: Karenannyoung@yahoo.com

To make this ATC, an actual manila folder with a tab was cut to size. Using double-sided adhesive, a transparency (ARTchix Studio) was adhered to the ATC base, and then the sides of the ATC melded together by singing it with a stick of incense. Additional images and ephemera were adhered to complete this ATC.

Sarah Fishburn
Fort Collins, CO
Contact: www.sarahfishburn.com

For this intriguing ATC, Sarah used a playing card for a template and then used pinking shears to cut the red and white fabric to size. The fabric was not-so-securely attached to the playing card – just enough security to keep it in place while the other elements were put together. A small section from a paint sample sheet (Golden) was placed atop of the fabric and finally over that, a clown girl transparency (Sarah Fishburn) attached with buttons sewn on each corner. To finish, a Dymo labeler was used to generate text that was attached on the side.

Says Sarah: I don't usually use clown images; this little girl was an exception. When I was attaching her, I was thinking to myself: This is only a test. That is, if it didn't look good to me, I wouldn't use it. But it looked swell, hence the label!

Patti V. Crump

West Hollywood, CA
Contact:
pvictoriacreates@sbcglobal.net

Patti started this ATC by setting the transparency from ARTchix Studio's "Her Wish" collection onto the background paper (Autumn Leaves) and moved the transparency around until "just the right spot" emerged. The paper was cut and glued to a piece of cardstock, and the transparency affixed with gel medium. The wings were cut from another piece of background paper and affixed with a bit of gel medium. The card was trimmed with a strip of German Scrap (ARTchix Studio) and highlighted with diamond glitter glue.

Says Patti: I would say that unlike regular Fun Projects where you begin with an image and add to enhance it, I let the background and the transparency work together to become one combined effect rather than two different pieces in a bigger picture.

Tips from ATC artist

- Use transparencies to highlight what lies beneath. In other words, place a focal area of the transparency over a focal area of the underlying ATC.
- It will add interest if you mix up the sizing – that is, try using a larger transparency image over a more delicate background, or vice versa.
- Choose images that speak to you. Even images that appear too large can be effective in an ATC with the right words and embellishments.
- Because of their small size, "less is more" for ATCs. You either want to take advantage of the transparency so you can see the background, or you want a plain background so the transparency takes center stage.
- Choose an open design when printing a transparency, keeping in mind the proportion to your main subject. The design should complement and not compete with the main focal point of the Fun Projects.
- Move the transparency around over the Fun Projects to find the best placement then trim away excess. Avoid design lines resting in eyes, mouths or pointing up noses – unless of course that's what you want! Position the design toward the outer edges to help "frame" the subject and enhance depth.
- Consider using transparency adhering methods that build on your overall design. Stitching, decorative tape, eyelets, brads and staples can enhance your theme, composition and color scheme.

Jennifer Black

Waco, TX
Contact: jenniBFun Projects@yahoo.com

Playing cards were used to serve as the base for this series of Asian-themed ATCs. Assorted papers, including sheet music and Asian text were torn and adhered to the cards, followed by transparent images cut and adhered on top of the torn papers. Additional images were also adhered, along with computer-generated words, and miniature swirls (Hero Arts) rubber stamped with black ink.

Diana Tisch
Cincinnati, OH
Contact: dianeandwilbur@aol.com

Lisa Martin
Woodbury, TN
Contact: picturetrail.com/feyprincess

A portion of beautifully patterned paper (Christine Adolph for Creative Imaginations) was used as the background for this ATC. The foil accents found on this paper peeks strategically through the transparency image that is attached with decorative black brads.

Says Diana: I like the transparencies because you can try them on all kinds of backgrounds before you decide which one you like the best. It makes it so easy, as you can see what you are getting right away.

The base of this ATC is a miniature quilt. For the quilt top, assorted fabrics in bright colors are pieced together, along with coordinating ribbons and fibers. After sandwiching the top with batting and backing fabric, a piece of white muslin is cut into a star shape and sewn on top. Next, a small ATC of a woman is sewn on top of the star. Seed beads and buttons are sewn on to complete this ATC.

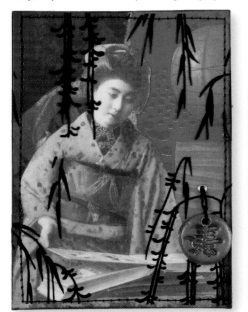

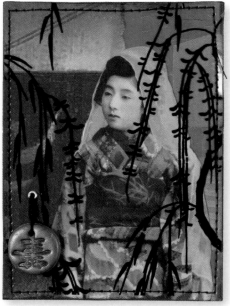

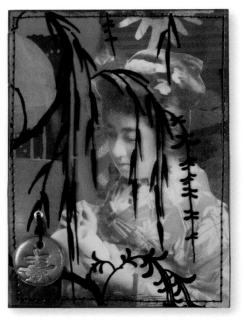

Kathleen Green
Aukland, New Zealand
Contact: www.kathleengreen.com

This ATC series begins by composing mini Fun Projectss of Asian-themed patterned papers onto black ATC-sized cardstock. Next, images of Asian women are cut and adhered over the papers. The willow design is printed onto a transparency and arranged on top of the Fun Projectss, trimmed to fit, and machine-stitched along the edges. Using gold polymer clay with black ink, an Asian rubber stamp (Club Scrap) is stamped into circular pieces of clay, with holes poked at the tops with a needle. Before baking according to manufacturer's instructions, antique gold Pearl Ex is brushed over the pieces. After setting micro eyelets into the ATCs the polymer clay charms are attached with black thread.

Says Kathleen: One of my favorite things is to create a sense of depth or intrigue, even in the small canvas of an ATC. I love how layering a printed transparency over a Fun Projects gives you the feeling of peeking into another's world.

Debbie Metti
Parma, OH
Contact: ohkitten@cox.net

After selecting the desired images from ARTchix Studio's "Coquette" transparency sheet, Debbie Metti cut them out and also cut six ATC-sized pieces of watercolor paper. White mulberry paper with red heart inclusions were then glued to the ATC watercolor paper bases. Each transparency cut-out was fed through a Xyron machine (with the adhesive cartridge), and adhered to the ATC's. Computer-generated text was also adhered, followed by strategically attached red brads.

Says Debbie: Even though the transparency images are sized to fit into glass slides, that also makes them the perfect size for ATC's. The black and white images needed a punch of color so I went with white and red for the background and embellishments, then accented with words on pink paper. The red brads in circle and heart shapes added just the right touch of dimension.

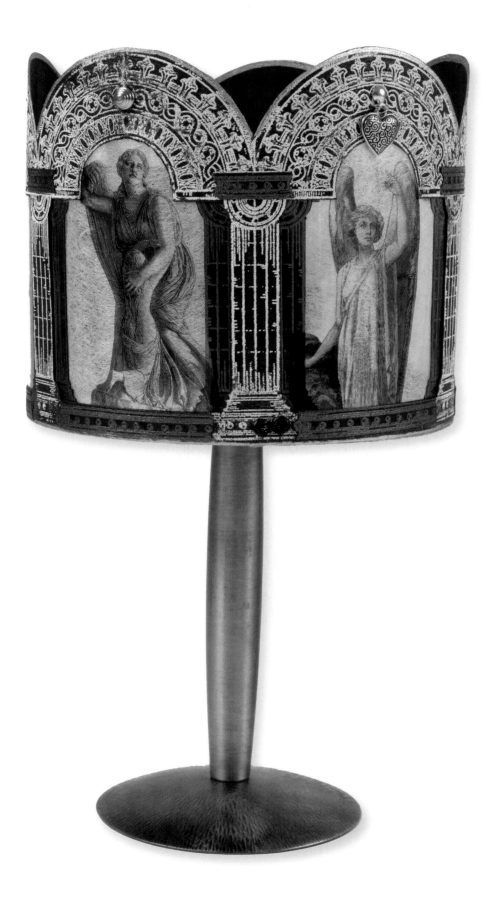

Guardians

by Cher B. Lashley

We cannot always control our environments in our day-to-day hectic lives, but there are times that we can create a peaceful space, a place to breathe, relax and let the worries of the day melt away. There is nothing more relaxing to me than the sound of a violin quietly singing in the background, a comfortable armchair and the soft glow of a scented votive candle infusing my space with that richness only this simplicity can offer.

The added texture and line art animated by the dance of the candle's flame through the printed transparencies on this little lamp shade has now added another layer of dimension to the enjoyment of these moments. These angels have become the guardians of my peaceful space and a piece of unique art reminding me of the creative spirit that affords us all our own unique space.

TOOLS & MATERIALS

- Fine-gauge wire
- Encore gold inkpad
- Embossing powders
- Guatemalan lace paper
- Copyright-free images
- Eyelets & setting tools
- Mi Teintes paper (black)
- Votive candle pedestal base
- Scraps of marbleized rice paper
- Triptych arch stamp (Stamper's Anonymous)
- Lampshade form with bottom mount to fit candle cup
- Adhesives (double-sided ¾" tacky tape, glue stick, Crafter's Pick ultimate glue)

Technique

Stamp the arch image three times onto the black paper with gold ink. Make sure the images align end-to-end, and emboss with white embossing powder randomly shaken over the image after each stamping. Carefully cut out, trace outline and cut out this tracing and set aside.

Stamp the image three more times on black paper, then emboss with gold embossing powder and cut out the pillars, platforms, and decorative capital strips and set aside. Using photo-imaging software, select five clip art images and size them to fit arch openings. Print this onto an ink-jet transparency and let it dry overnight. Adhere images in viewing area of archways using a glue stick, then, attach a gold pillar to either side behind the transparency with craft glue. Adhere a strip of the lace paper behind all portions, followed by the blank black cut-out, and an extra scrap of paper at end for joining with the craft glue. Adhere the gold platforms and capital strips over the white-embossed areas on the front with craft glue.

Wrap the outer wire of the shade form with the tacky tape then, cover with marbled rice paper. Position the shade form onto the paper shade, mark where the three wire supports will meet the paper, then set eyelets on either side of markings, adding an extra at both ends of shade. Run a length of the tape at bottom of shade, then, roll shade onto form. Attach craft wire around wire supports through eyelets, then, cover all with another length of marbled rice paper. Attach loose end of scrap on last image to the first archway image, then, affix charm with covered brads to join first and last pillar. Remove candle cup, screw shade onto pedestal and replace cup.

Cher B. Lashley lives in St. Augustine, FL.

Just For Today

by Denise Lombardozzi

"Just for Today" has been my mantra for many years now. To me, these words say it all and will continue to bring me peace and serenity in bad times and keep me grounded in the good times. When I first spotted the "Mystery" transparency collage sheet from ARTchix Studio, I knew that these ethereal images would be fitting "illustrations" for my favorite slogan. Since then, I have used these images in collages, assemblages, and even slipped them into bottles to catch light on a sunny windowsill!

TOOLS & MATERIALS

- Paint brush
- Hole punch
- Tri-fold card
- Adhesive foam
- Alphabet stamps
- Watercolor paper
- Twinkling H2Os
- Krylon leafing pens
- StazOn inkpad (Timber Brown)
- Transparency (ARTchix Studio)
- Text stamp (A Stamp in the Hand)
- Miniature eyelets & setting tools (Making Memories)

Technique

Using Twinkling H2Os in various colors, randomly brush over wet piece of torn watercolor paper. Once dry, stamp text over the top with StazOn inkpad. Cut paper to measure 2-1/2˝x3-1/2˝. Trim transparency images to fit over the paper. Attach the two layers with mini eyelets.

Prepare a tri-fold card with splattered paints and then stamp the words "Just For Today." Finish by adhering the previously prepared paper and transparency layers to the tri-fold with adhesive foam.

Tips

- For a dream-like quality, sand over the transparency.
- Use paper punchers to expose the surface behind the transparency.
- Use StazOn inks to stamp over the transparency for added depth and mystery.

Denise Lombardozzi lives in St. Charles, Missouri. To learn more about her work, visit www.firstbornstudio.com.

Nature Tags

by Rhonda Scott

nspiration for these nature tags came easily for me as I am an avid bird watcher and nature enthusiast. Having just helped my son identify and memorize 100 birds, I had birds on my brain. So when I ran across these wonderful transparencies, I knew that I just had to turn them into something beautiful.

As a bird lover, I have collected many images of birds over the years. For these particular tags, I used images from an older set of John Audubon prints. I coupled these images with the "In the Garden" transparency images from ARTchix Studio. The results were simply beautiful.

Technique

After cutting out the transparency image you want to use, try out different areas on the bird image that might show off the details. Once you have found the right composition, place a large office tag over that area and then cut out. Glue the print down onto the tag.

Next, find a nice nature-inspired paper, trace around this as well and set it aside. Cut out the egg images from the transparency sheet. Punch holes in all four corners. Lay the transparency image on the tag and with a pencil or pen, mark where the holes are. Next, punch the holes in the tag. Place the transparency on top and line up the holes and set the eyelets.

After attaching the transparency to the front of the tag, glue the decorative paper onto the back of the tag. Then use a metallic marker to mark around the edges of the tag. Finish with additional embellishments of your choosing and add ribbons to the top. Use these tags to mark your place in a book or to top off a special gift.

Rhonda Scott lives in Friday Harbor, WA and can be contacted via e-mail at retrorose@rockisland.com.

TOOLS AND MATERIALS

- Glue
- Ribbons
- Paper punch
- Embellishments
- Metallic marker
- Tags (4-3/4˝x2˝)
- Images of birds
- Eyelets & setting tools
- Transparencies (ARTchix Studio)

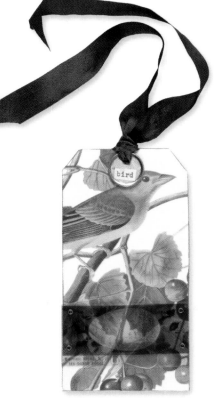

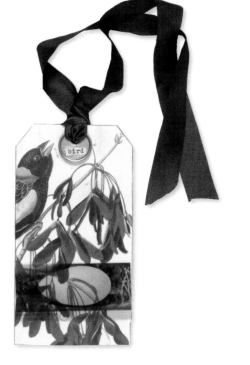

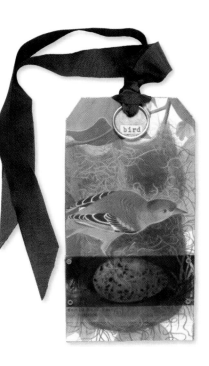

SQUARE-PUNCHED
Magic

by Steph Schirmer

Ever since I got my first transparency, I have been looking at different ways to use them. I have made everything from cards, altered book layouts, to trading cards and more. Last Christmas, I made some trading cards where I sandwiched a transparency between two pieces of cardstock, decorated them and sent them out as my "random acts of kindness" for the Christmas season. After that, I decided to try and go smaller and make little ornaments. The simple secret is in using a square-shaped paper punch to make the ornaments' windows.

Technique

First, take a full sheet (8-1/2˝x11˝) of white cardstock and cut it into quarters. Cut one quarter in half vertically, and then once again, horizontally. Each piece should measure 2-1/8˝x2-3/4˝. Insert each of these pieces into a square-shaped paper punch and punch out the center. (Save the punched squares for later use.) Select a transparency, trim to fit within the punched out center of the cardstock.

Next, take the white cardstock that has the square punched out and run one side thru a Xyron machine (with the adhesive cartridge.) Lay the cardstock with the adhesive side up and put the transparency down so it is centered in the cut out square. If you have a light box, it will help you in the process of precisely centering the transparency.

Cut selected fibers to lengths long enough to use as hangers and lay them down so they also connect with the adhesive side of the cardstock. Once secure, add the other punched out square piece on top, making sure that everything lines up. Press the two pieces together firmly. Trim any excess and cut to size.

Take the square you punched out earlier and lay it over the transparency to protect it while you decorate the rest of the cardstock. Using the direct-to-paper process, apply layers of coordinating colors of distress inkpads to the fronts and backs of the ornaments. Take a gold Krylon pen and outline along the edges and add embellishments of your choice.

Steph Schirmer lives in Pulaski, TN and can be contacted via e-mail at redbaron1@charter.net.

TOOLS & MATERIALS

- Fibers
- Embellishments
- White cardstock
- Gold Krylon pen
- Light box (optional)
- Distress ink pads (Ranger)
- Square-shaped paper punch
- Art stamps (Hero Arts, Magenta)
- Transparencies (ARTchix Studio)
- Xyron machine (with adhesive cartridge)

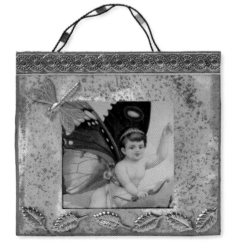

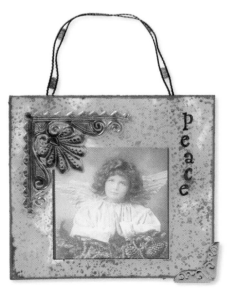

As a tribute to our readers,

Transparent Art

is proud to

conclude this book

with the following

gallery section

– featuring numerous

wonderful pieces

with sample instructions.

Gallery

Secret Princess
4-1/2˝x6˝

Kathleen Green
Auckland, New Zealand
Contact: contact@kathleengreen.com

Stamp frame (Stampers Anonymous) with black StazOn ink onto transparency. Paint from behind with metallic acrylic paints and allow to dry. Stamp woman image (Oxford Impressions) onto white cardstock with black ink and cut out. Adhere woman image to mauve wallpaper remnant. Overlay transparency attaching with Terrifically Tacky Tape. Stitch wallpaper panel onto fabric remnant. Emboss the edges of a piece of lavender cardstock with lavender and gold embossing powder. Adhere the fabric panel to the lavender card then attach to a folded black card. Using a gold staple, staple the fabric with the corner folded up.

Live, Laugh, Learn
6-1/4˝x6˝

Cheryl Husmann
Grafton, WI

Tear and layer patterned papers and adhere to purple cardstock. Adhere transparency over another piece of patterned paper. Attach transparency with mini brads and photo hinges. Attach two pink leather flowers (Making Memories) with mini brads. Adhere pieces of lace and a paper clip to finish.

See How Happy
2˝x2˝ (closed)

Tammy Akervold
Auburn, WA

Sponge lilac and white paint onto the front and back of three slide mounts. Let dry. Cut small roses and leaves out of decoupage paper and adhere to the front of each slide mount. Layer vintage images of children (ARTchix Studio), dictionary text and transparencies (ARTchix Studio). Glue to the backs of the slide mounts using craft glue. Cover the backs with irregularly torn green mulberry paper. Cut out words from a book and glue to the fronts using Mod Podge. Glue on vintage buttons. Punch small hole in the corner of each slide mount and tie with fiber.

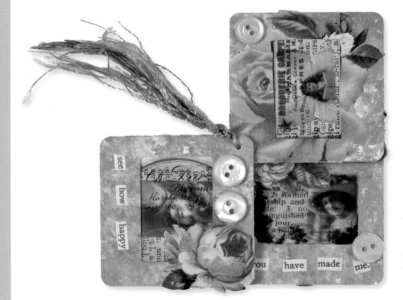

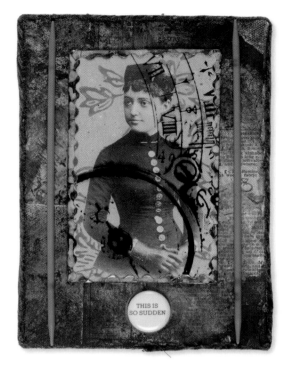

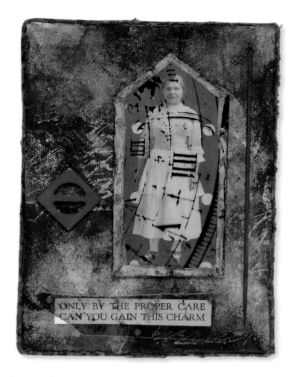

This is So Sudden & Charm
5″x7″ (each)

Olivia Thomas
Phoenix, AZ
Contact: pezman@concentric.net

Cut out images of vintage ladies, attach to decorated paper glued to lightweight cardboard. Lightly attach pre-printed transparency cut to size along edge. Next, wrap copper tape around edge of entire piece. Treat tape with modern options to patina. Onto the canvas, glue vintage book pages and before completely dry, rip off. Repeat this step several times to build up an interesting layer of background. Next, use paint washes and sponge-on paint techniques to add color and depth. Mount transparency section to canvas, and add various found objects. For This is So Sudden, add two old knitting needles, a slogan button, and a belt buckle. For Charm, add a large old rusty sewing needle. Also adhere text under a chunk of mica attached with three map tacks. Finish off all canvas edges with velvet fabric in coordinating colors.

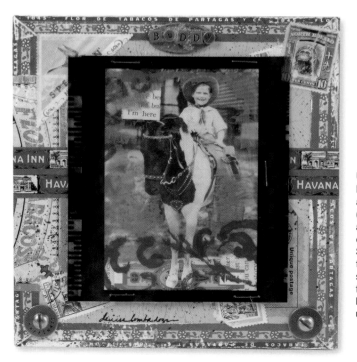

Buddy
6″x6″

Denise Lombardozzi
St. Charles, Missouri
Contact: www.firstbornstudio.com

Using an old cigar box lid covered in brightly colored paper, adhere cigar bands and postage stamps with a glue stick. Sand over the piece to give it a gently worn appearance. Using red acrylic paint (Golden) and a swirl stamp (Postmodern Design), stamp the swirl design on the inner side of the "negative" acetate (source unknown). Swipe some gold green acrylic paint (Golden) also on the inner side. Once dry, scrape away some of the paint to reveal the image. Staple the image and the acetate together, then using Zap-A-Gap, adhere it to the lid. Drill two holes in the bottom corners to attach two zinc round-head slotted machine bolts, a variety of brass nuts, and washers (Making Memories) for the stand. Further embellish with a brass oval disc (source unknown), metal letters (Making Memories), and vintage glass glitter (Art Glitter Institute), affixed using Diamond Glaze.

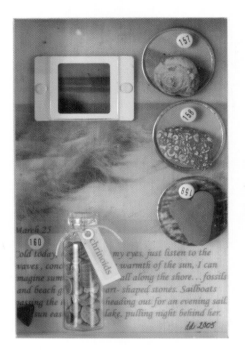

Spring Beach
5"x7"

Debra Davis Lymburner
St. Joseph, MI
Contact: debradavislymburner@msn.com

For this project, I started with a ready-made shadow box lined with muslin. I layered a transparency of a journal entry under the beach scene created from a photograph I had taken. The irregularities of the muslin cloth peek through the transparencies adding texture. The key tags were aged with coffee before being covered with acetate scraps and beach findings. The tags were affixed with old map pins picked up at an antique store.

Nathaniel
3-1/4"x3-1/4"

Scottie Magro
Contact: Scottiemagro@earthlink.net

Purchase a small wooden frame from a craft store and paint with acrylic paint. Once dry, squeeze Elmer's Squeeze 'N Caulk onto the surface of the wood frame. Lay patterned paper (Family Traditions) onto the frame, burnish, and let dry over night. To remove the paper, wet the back of the paper and rub the paper backing off. Use lots of water and do not rub hard. If a white haze appears, re-wet and rub the remainder of the paper off. (This caulking method is outlined in detail by Claudine Hellmuth in her book: *Collage Discovery Workshop*.) Adhere button and nameplate (Details), beaded fringe and art fibers.

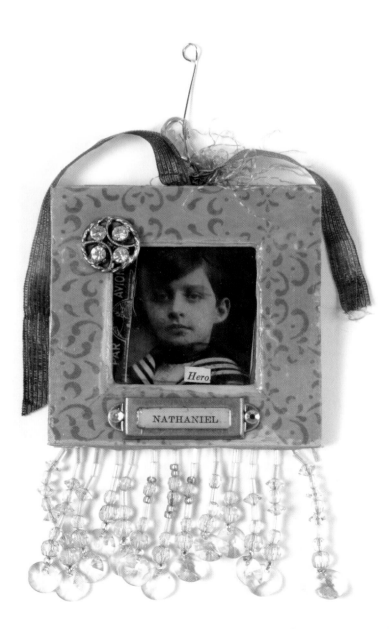

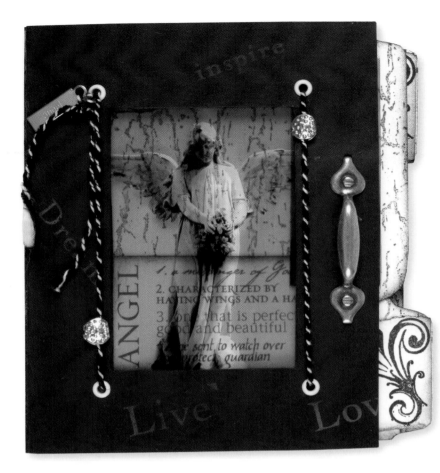

Angels
5˝x7˝
Patti Johnson

Cut 5˝x7˝ slide mounts from black cardstock, and 5˝x7˝ file folders from white cardstock. For cover, stamp words (Postmodern Design) on slide mount with white ink. Place angel transparency (ARTchix Studio, Mystery) in slide mount and glue closed. Attach eyelets and a black and white cord. Attach assorted charms and a silver handle (Frost Creek Charms). The angel definition (Making Memories) is behind the transparency, attached to the second "file folder" page. For inside layout, stamp background (Stampin' Up) in black ink. Stamp "Sing" (Wordsworth) over background in black ink. Tear a piece of white cardstock, ink edges in black, and attach. Cut a hinge (Frost Creek Charms) in half and attach. Stamp face (Postmodern Design) on vellum in black ink. Tear out and ink edges. Attach over the "Sing" phrase. Stamp flourish element (Uptown Design) in black. Tear, ink edges, and attach to the tab on the file folder. Attach the word "Inspire" with black eyelets to white cardstock and mat with black cardstock. On the right page, stamp words (Postmodern Design) in white ink. Attach the filigree transparency (ARTchix Studio, Mystery) in the slide mount on the diagonal and glue closed. Attach white eyelets and tie cord through eyelets. The angel transparency (ArtChix Studio, Mystery) is attached to the next "file folder" page.

Caged Muse
4˝x4˝x4˝
Margert Ann Kruljac
Atlanta, GA
Contact Info: mementosdiarte@gmail.com

Computer generate a text box that measures slightly larger than 4˝x4˝. In the text box, type words and text of your choice, in a light-gray color. Two boxes of text will fit onto one 8-1/2˝x11˝ transparency sheet. Once printed, these will become the sides of the box. Trim each box of text to measure exactly 4˝x4˝. Save the scrap pieces of transparency and set aside. With remaining transparency, cut an additional two 4˝x4˝ squares for the top and bottom. Take a strip of packing tape and place it onto a piece of scrap transparency. Trim to a length of 4˝x1/4˝. Cut 12 of these strips. Taking the front square, attach it to one of the side squares using a strip of packing tape. Since it had been placed on the transparency prior to cutting it to size, it should easily lift off. Continue to assemble remaining printed squares, taking care that the text on the back of the box can be read from the front. Adhere the bottom of the box in the same manner and set aside. Stamp image using StazOn onto a scrap of transparency. Punch two small holes at the top of the stamped image and also corresponding holes in the top section. Thread ribbon through the holes of stamped image and the box lid. Set the lid of the box on top of the assembled box and adhere with packing tape strips. Adjust ribbons so that the stamped image hangs freely and tie.

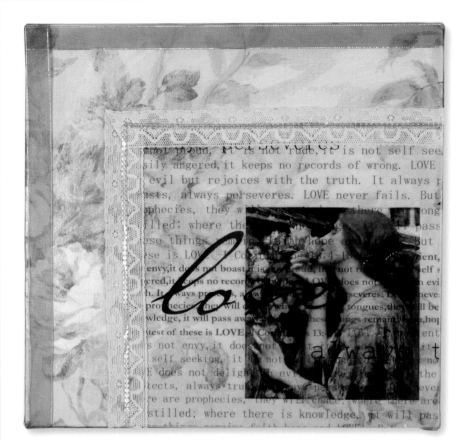

Love Is
12″x12″

Patti Victoria Crump
West Hollywood, CA
Contact: pvictoriacreates@hotmail.com

Cover a 12″x12″ canvas with a piece of floral fabric, glue in place using gel medium. Distress fabric with buff white fluid acrylic (Golden). Let dry. Highlight flowers and leaves with iridescent gold acrylic paint (Golden). Glue image from "Bliss" transparency sheet (ARTchix Studio) in place using gel medium. Glue love script transparency (source unknown) over that using gel medium. Trim with lace and small "German Scrap" gold flower (ARTchix Studio). Trim with green and gold ribbon and glue cream-colored grosgrain ribbon around edge of canvas.

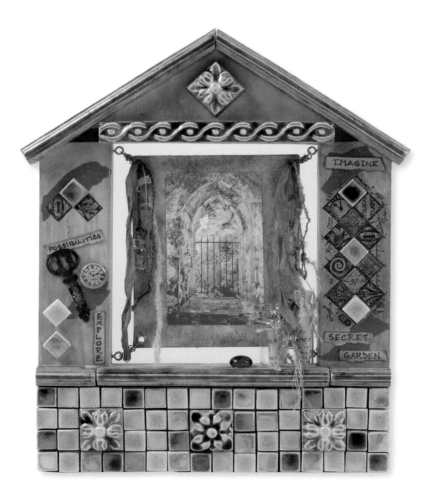

Ceramic Shrine
10″x12-1/2″

Debbie Russell
Grants Pass, OR
Contact: Debbie@encoreceramics.com

As a tile designer for Encore Ceramics (www.encoreceramics.com), I immed-iately thought of a shrine with tiles when my dear friend Angela Cartwright asked me if I would test out her new transparencies developed with Stampington & Company. You can build a shrine from old wood scraps or buy a pre-manufactured one. Cover in gesso to add a little texture. Paint with various acrylic paints (Golden). Using rubber stamp "tile" images (Stampers Anonymous), stamp on tissue paper and apply to shrine with PPA. Add embellishments of your choice. Attach tiles with heavy gel medium. Various mosaic tiles can be purchased at tile stores or home improvement stores. Cut two pieces of cardboard to the desired frame size. Texture with gesso and gel medium. Finish with various paints and Lumiere Brass. Place the transparency between the two pieces of cardboard and glue together with gel medium. Attach the frame to the shrine by using eyelets in the four corners of the frame and wire it to screw-eyes on the shrine. Hang various yarns and charms from the eyelets. Put secret messages in miniature glass bottles and attach with Diamond Glaze.

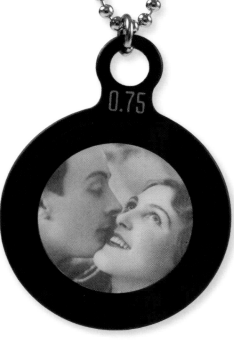

Love Pendant
1″ (diameter)
Helga Strauss
Victoria, BC, Canada
Contact: Helga@artchixstudio.com

Cut out transparency image (ARTchix Studio) and feed it through a Xyron machine with the adhesive cartridge. Adhere to an optometrist lens.

Sisters
3″x6-1/2″
Nancy De Santis
Santa Fe, NM

Cold-laminate transfer of typed out quote placed on top of glass on bottom. Cut photocopy of photograph same size of glass and place underneath glass and affix with tin tape (Home Depot). Tear rice paper to fit over cardstock and emboss edges with silver embossing powder. Adhere double-sided tape to back of photo and place on top of black rice paper. Cut additional black cardstock same size and sandwich a wire between the two cardstock pieces for a hanger and tape together using more double-sided tape.

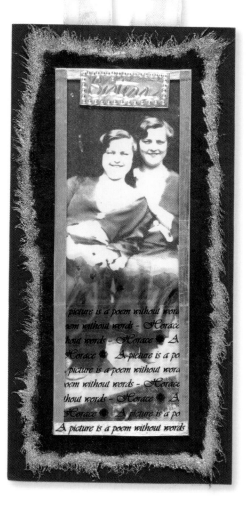

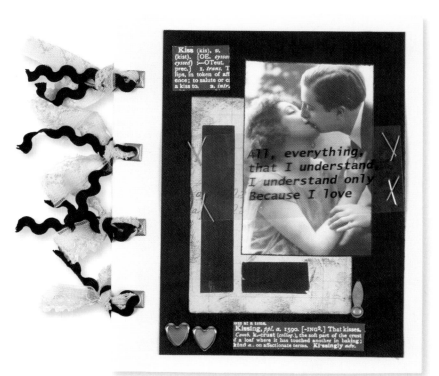

Everything that I Understand
5-1/2″x6-1/2″
Christine Carrington
Australia

Attach the image of the couple kissing (Red Letter Art collage CD) over paper with the stenciled letter. Type the text (quotation by Leo Tolstoy) on a computer and print onto plain transparency and cut to size. Staple the transparency across the image of the couple and attach to a piece of black card. Embellish with heart shaped brads and "kiss" word definition (7 Gypsies) at the top and bottom. Attach a photo turn with a brad and adhere to cream card. Attach four square eyelets down the left hand side and thread ribbon and lace through each.

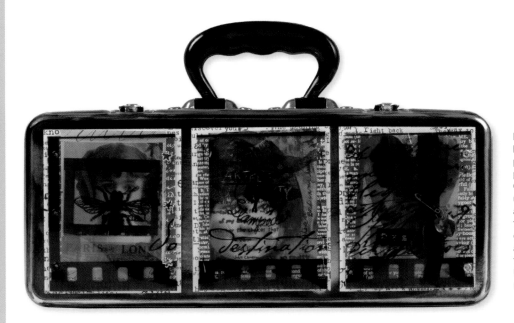

My ATCs
11″x5″x2″
Sharon Wisely

St. Louis, MO
Contact: sharonartwisely@yahoo.com

Distress the front of a metal carrying case with black ink. With heavy cardstock, create three panels, each measuring 3-1/4″x4″. Layer the panels with coordinating patterned papers. Cut transparency with film reel image (source unknown) slightly smaller than the three panels and stamp with various art stamps. Adhere the transparency pieces with patterned paper pieces on the sides and bottoms by using staples, eyelets, and brads. Insert assorted artist trading cards into these pockets and adhere to the prepared panels. Use foam tape to adhere all three panels onto the metal case.

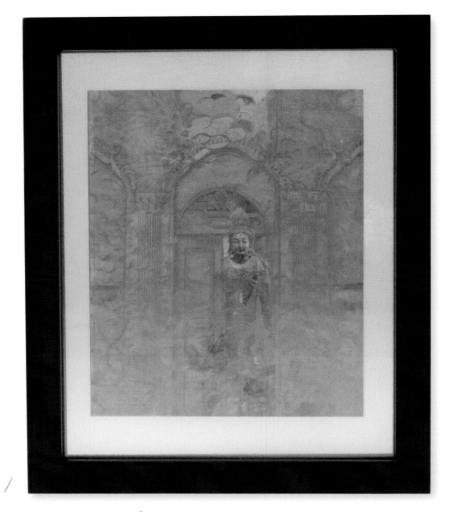

Cloud Nine
8″x10″
Karen Landey
Contact: ventura@easystreet.com

Using PhotoShop or other digital imaging program, create a digital collage. Print out the collage onto Apollo Ink Jet Printer Transparency Film (CG7031S). Create a mat to cover the border of the print and lightly spray the back of the image with pearlescent metallic spray paint. Remove the mat and lightly spray paint the entire piece to blend the edges. Frame in a float-glass frame.

Small Lanterns
8″ (tall)
Scottie Magro
Contact: Scottiemagro@earthlink.net

These small glass lanterns were purchased at a local discount store. The glass is intended to be lifted up and out of the metal frame to allow for the handling of a votive candle. Create miniature collages onto slide mounts using transparencies (ARTchix Studio, Little One). Attach metal rings to the collages and attach them to a beaded chain long enough to have the slide mounts dangle from the metal frame. Before attaching to the frame, insert the collage into the glass and thread the chain through the top. Once in place, affix glass in place with a strong adhesive. Use stickers, rhinestones, and rub-ons to finish.

Bottled Up
6″ (tall)
Denise Lombardozzi
St. Charles, Missouri
Contact: www.firstbornstudio.com

All that is needed for this project are old and/or new bottles, and transparent images (Tracy Roos, Limited Edition, ARTchix Studio). Using a pencil, wrap the pre-cut transparency small enough to fit into the bottle opening, place it with a tweezer, then add vintage glass glitter, beads, buttons, and charms. Put a cork in at the top, then poke a twisted wire message holder (7 Gypsies) into the cork. Embellish with transparent "simple fairies" ATC, transparent words, a negative, and a little ribbon.

Ideal
4-1/4˝x5-1/2˝

Karenann Young
Contact: karenannyoung@yahoo.com

With most of my artwork, I start out by looking at all the ARTchix images and transparencies I have. I put aside everything that strikes my fancy at the time. For Ideal, layer a panel with torn papers. Cut and fold a piece of copper mesh and attach black snaps at each corner. Position transparency over art paper and sew with black thread around edges and onto the copper mesh. Add an "ideal" charm at bottom and green ribbon at top.

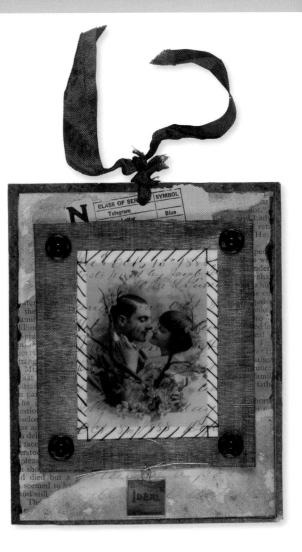

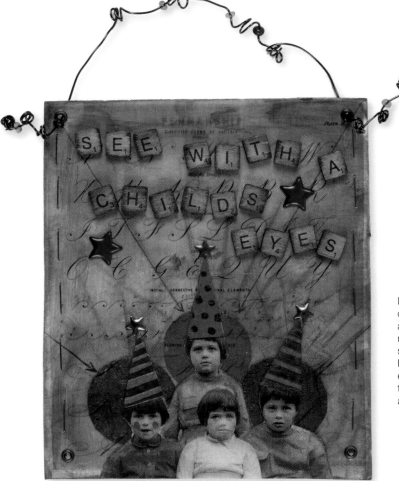

Child's Eyes
5˝x6˝

Lisa Martin
Woodbury, TN
Contact: Feychilde90@yahoo.com

I took some cardstock and added inks and acrylic paint until I got the desired background. I then added three spheres of handmade paper and coated the whole thing with gel medium. I sketched arrows and rays and then attached an alphabet transparency with colorful blue staples (ARTchix Studio) then collaged an image of little kids (Green Frog Studio). Next, I added little hats and star brads and little star embellishments using Crystal Glaze. Also added were mini scrabble tiles that I hand-colored with turquoise and red ink. Four grommets were added and finished with a colorful beaded wire hanger.

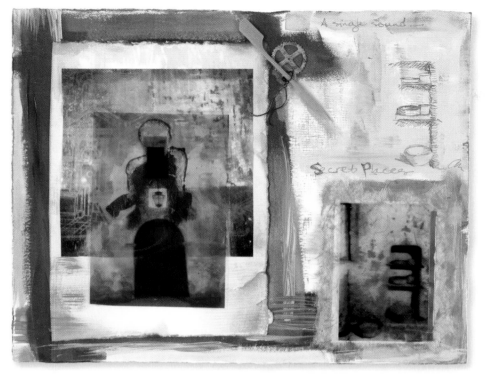

Secret Places
12"x9-1/2"
Ashley Sinclair
Contact: ashnicrouge@yahoo.com

Add color with acrylic paints onto a piece of heavy watercolor paper. Tear another piece of watercolor paper and add slight color. Follow by adhering layers of images and a piece of transparency (Angela Cartwright for Stampington & Company). Add smaller piece of torn art paper and adhere a transparency on top. Add embellishments, including hand sketches and lettering.

May 5, 1927
7"x10"
Sarah Fishburn
Fort Collins, Colorado
Contact: sarah@sarahfishburn.com

Start with a blank journal page. Add some color just around the edges. I rubbed on just a bit of golden cadmium yellow Neoart water-soluble wax pastel (Caran d'Ache), not at all thickly. Over that, layer a somewhat muted piece of decorative paper or cardstock, cut or torn slightly smaller than the journal page. Print a postcard sized (or smaller) version of a previously journaled page or collage onto vellum. You could also use a plain photo image if you prefer, it needn't be collaged! Adhere that onto the decorative paper. With a red Sharpie, write your new journal entry, covering the entire decorated area, including the vellum. Using pre-printed lettering or words you print out, collage a label onto the vellum image. Mine says "this is the place." Collage a flower image (I cut mine from a catalog) at the lower left corner. Now layer the transparency (Angela Cartwright) over your journaled area. Attach at the top and bottom with black graphic artists' tape. Cut or tear two narrow strips of the decorated paper you used for the background to your journaling & adhere them vertically at either side. Attach a letter element of your choosing. (I used "M" as my journal entry was for May. The element I used was an oval die-cut from old ledger paper, with the letter "M" printed over.)

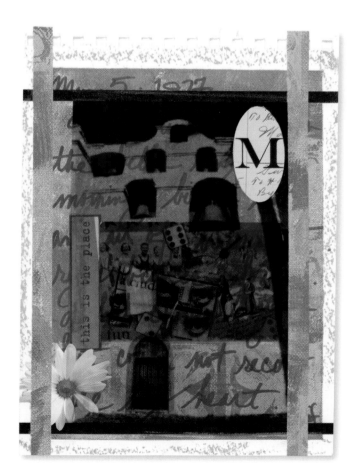

Angel Shrine
4-3/4″x3-1/4″ (open)
Lisa Cook
Amherst, WI
Contact: cooster@wi-net.com

Age Altoid tin by carefully placing it in a fire or on a grill. Clean with a cloth to get rid of soot residue. I use Perfect Paper Adhesive (PPA) for gluing paper items and the transparency, and Elmer's Clear Caulk to adhere dimensional items. Glue vintage ledger paper to right side of tin's interior. Glue a yellow clay poker chip and red ribbon along the top and bottom edges. Attach another set of red ribbon strips to the top and bottom of the angel transparency (ARTchix Studio). Cut out letters from books and glue to the back of the transparency. Cut ledger paper into a 7/8″x11″ piece; scallop the edges (Fiskars) and punch tiny holes. Make cuts in the paper to fit it inside the tin at each corner. Fold over the scalloped edge and glue the straight sides into the tin so the scallops show. Cut a red clay poker chip in half with a small saw; attach a gold embossed letter and top coat with PPA. Attach a piece of copper mesh to the bottom of the chip and glue to top of tin. Sew velvet leaves, copper wire, and berries to an old quilt piece. Glue wood letter and add batting under the quilt piece. Tuck under quilt edges to fit the left side of tin and glue in place.

What a Man
4-1/4″x5-1/2″
Helga Strauss
Victoria, BC, Canada
Contact: Helga@artchixstudio.com

Paint green watercolor onto Italian Watercolor Artist Trading Card Blanks (ARTchix Studio). Cut out adorable couple image (ARTchix Studio) and glue down onto background. Attach transparent text (ARTchix Studio) to an optometrist lens (ARTchix Studio) using a Xyron machine. With brown embroidery floss and a needle, tie lens onto the card, covering the green shamrock. Rubber stamp words and draw a halo using a circle template.

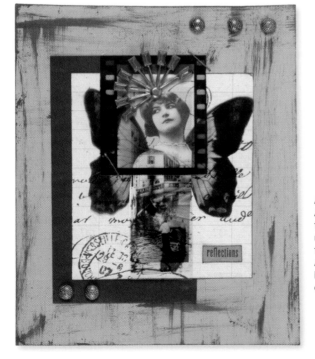

Reflections of Venice
4-1/4″x5-1/2″
Christine Carrington
Australia

Attach a pair of transparent butterfly wings to the back of the cut out image of the girl. Adhere to scripted, postmarked paper and staple the transparent image of Venice over the top (ARTchix Studio). Attach the transparent negative to frame the face of the girl using glue in the darker areas to obscure the adhesive. Attach a halo with a brass brad to the girl's head and the word "reflections" in the bottom corner, adding ink to the edges. Attach a rectangular piece of brown cardstock to a piece of cream cardstock that has been distressed with brown paint. Attach the images to the centre of this piece and embellish with brass nail heads.

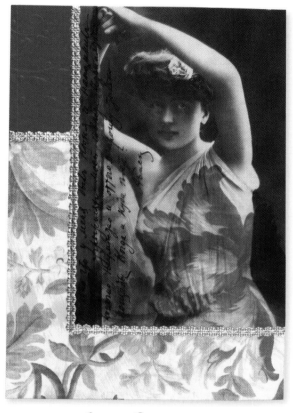

Im Dreaming
4-1/4″x5-1/2″

Patti Victoria Crump
West Hollywood, CA
Contact: pvictoriacreates@hotmail.com

Glue pink cardstock to side of folded card. Layer with a strip of embossed red cardstock. Cut out a piece of floral background paper (Anna Griffin) and lay transparency image cut from "Her Wish" transparency sheet (ARTchix Studio) over the floral paper. Tear paper away from the skin part of the image but leave it where the dress is to give depth to the dress. Trim with vintage "German Scrap" small gold flower border (ARTchix Studio).

Her Wish
4-1/4″x5-1/2″

Helga Strauss
Victoria, BC, Canada
Contact: Helga@artchixstudio.com

Layer transparency image (ARTchix Studio) with ledger paper onto a panel and attach with black mini brads. Adhere red rickrack on the outer edges from the back.

My Dream
6-1/4″x4-3/4″

Annette Priest
Middletown, VA
Contact: priest.annete@wps.k12.va.us

Create a collage piece, then adhere a black and white copy onto the transparency. Set aside original collage for another use. Trim transparency. Attach with pewter brads to same size brown patterned paper. Mount with foam tape to pink crackle paper, edge with brown ink. Continue to attach to rust paper, trim with decorative scissors and then attach all layers to rust card. Stamp doll images (Lost Coast Designs) on cream paper with black ink. Edge with brown ink. Embellish with butterfly wings. Trim and attach as shown. Mount small butterfly on left side of finished card. Glue three golden sequins to clown hat.

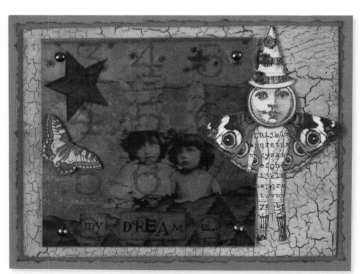

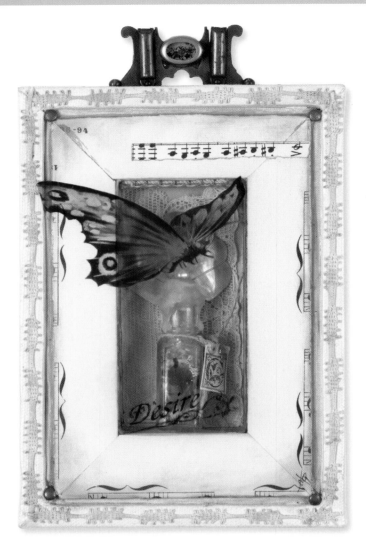

Desire
5″x7″
Cher B. Lashley
Contact: rosecottagedes@msn.com

Computer-generate word and image onto a transparency and allow to dry. Paint front and back of a 5″x7″ canvas with Titan Buff fluid acrylic (Golden). Cover back of niche with vintage paper scrap using thinned crafter's glue (Crafter's Ultimate) and paint inside using Pastel Peach Walnut Ink (7 Gypsies). Vintage wallpaper scrap was adhered to the inside wood structure and a piece of hand-tatted vintage lace was adhered to the back of the niche. Using a bamboo skewer, run a bead of crafter's glue along the bottom of one wall of vintage bottle and another bead at the top of cutout collage sheet image (ARTchix Studio). Insert image into bottle, aligning with bottom glue bead, gently press. Once dry, add mixture of microbeads, insert cork and seal with beeswax. Adhere additional embellishments as desired.

Cut transparency to fit over opening and attach with crafter's glue. Cut side margins from vintage music, gild edges with gold leaving pen (Krylon) to layer over wood "border" using thinned crafter's glue: add strip of notes as indicated. Fill space between borders with satin ribbon and mini brads in corners, then, attach hand-tatted vintage lace to outside border using full strength crafter's glue. Cut butterfly transparency image (ARTchix Studio). A glue stick (Uhu) was used only on the wing areas of the image that was layered onto the sheet music margins and smoothed with a soft rag. Attach antique hardware piece to the top of the canvas using small wire brads. A tiny scrap of transparency (ARTchix studio) was inserted into an oval frame that was attached to the hardware.

Miss Merryvale
8″x10″
Sharon Benini
Hartly, DE
Contact: proff246810@yahoo.com

Apply various encaustic waxes to the surface and sides of an 8″x10″ wood frame, layering for both color and texture. Paint an 8″x10″ canvas surface with Titan Buff (Golden) acrylic paint. Apply transparency of image to canvas board with glue dots at all four corners. Apply wine cork paper to create frame around image using glue stick. Center diagram transparency (ARTchix Studio) on outside of frame. Mark three "pilot" holes (on each side) of transparency and punch all six holes with 1/16″ hole punch. Center transparency again and hand-press upholstery tacks through pilot holes, adjusting transparency for proper fit where necessary. Lightly finish insertion of tacks with small hammer. Paint back of canvas with Golden acrylic paint (Red Oxide) to match encaustic waxed colors on frame. Using double-stick tape, apply around all four inside edges of canvas. Press canvas firmly to back of wooden frame to adhere.

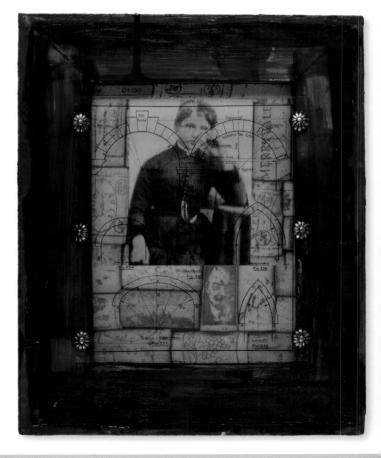

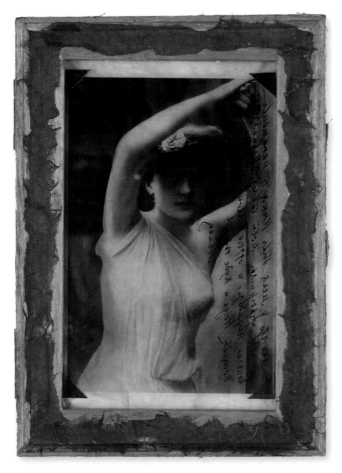

Boudoir Wish Box
5˝x7˝x3˝

Tracy R. Emerson
Vancouver, WA
Contact: instant.glamour@herspace.com

Cut and tear mulberry paper to size and adhere to the surface areas of a wooden hinged box with a glass lid. Cut transparency to size (ARTchix Studio) and attach it to the inside of the glass with photo corner adhesives (Fiskars).

Good Penmanship
5˝x7˝x4˝

Denise Lombardozzi
St. Charles, MS
Contact: www.firstbornstudio.com

Cover box with Golden Light Molding Paste, let dry. Dry-brush Lumiere olive-green paint over the box, then sand lightly. Dry brush Golden quinacridone crimson over that, sand lightly. Cover the inside of the box with Basic Grey paper in Chalk. Use an old cabinet card of a curious little girl to cover with the ARTchix Penmanship transparency ... sand transparency well, trace and cut circle around her face, then place a transparent optometrist lens over the little girls face (also ARTchix). Affix an old printer's block. Finish with crystal pebbles as feet.

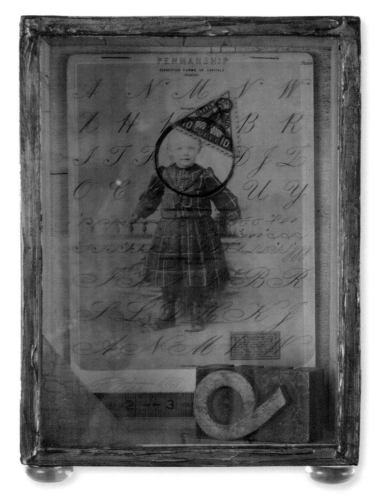

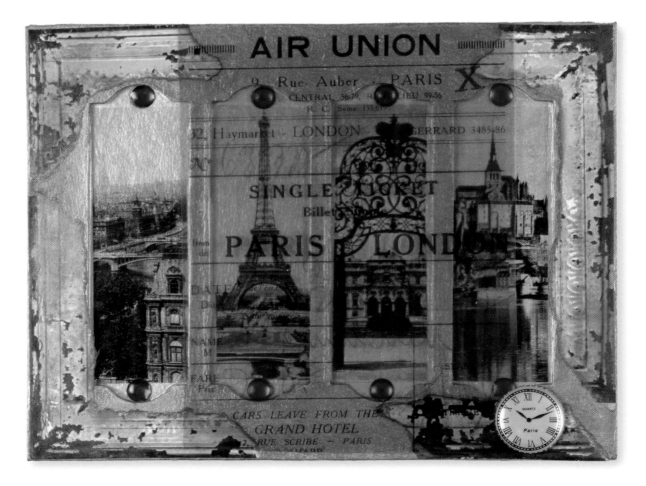

Scenes From Paris
5-1/2"x4-1/4"

Debbie Metti
Parma, OH
Contact: ohkitten@cox.net

Remove the top flap from a large slide mailer and paint remaining part with Bronze Lumiere. Paint the inside of each of the four niches with Silver Lumiere. When dry, select images from the ARTchix "City Splendor" transparency sheet, cut out and glue to each niche using Diamond Glaze. Add a red cabochon (Rubber Baby Buggy Bumpers) at the top and bottom of each niche. Tear corner sections from Vintage Tin Tiles collage sheet (River City Rubber Works) to make a distressed frame, and age with bronze and teal metallic inkpads. Cut "Air Union" image from the ARTchix "To From" transparency sheet. Trim to fit and use Diamond Glaze to glue it over the top of the slide mailer. Finish with a Paris clock charm (source unknown).

Dear Friends
4"x5"

Denise Lombardozzi
St. Charles, MS
Contact: www.firstbornstudio.com

Take a store-bought note card (Dear Friends: American Photographs of Men Together,1840-1918 pub. by Abramsbooks.com) and then cut a portion from the "This Place" transparency (ARTchix Studio) and strategically punch holes in the transparency so the faces on the note card can be revealed. Attach with aged copper mini brads (ARTchix Studio).

Air Union
3″x5″
Karenann Young
Contact:
karenannyoung@yahoo.com

For Air Union, use travel-themed paper to make small collage. Cut additional text and images related to the theme and adhere. Using mini brads, attach transparency image (ArtChix Studio to the top portion. Use a round corner punch on all corners.

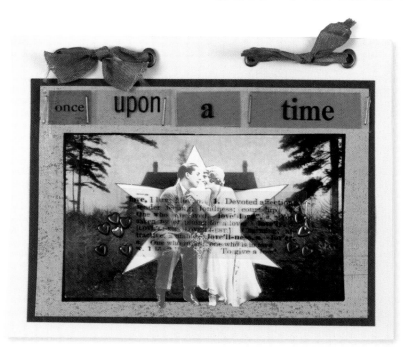

You
3-1/4″x3-1/4″
Scottie Magro
Contact: Scottiemagro@earthlink.net

Purchase a small wooden frame from a craft store and paint with yellow acrylic paint. Once dry, squeeze Elmer's Squeeze 'N Caulk onto the surface of the wood frame. Lay patterned paper (Autumn Leaves) onto the frame, burnish, and let dry over night. To remove the paper, wet the back of the paper and rub the paper backing off. Use lots of water and do not rub hard. If a white haze appears, re-wet and rub the remainder of the paper off. (This caulking method is outlined in detail by Claudine Hellmuth in her book: *Collage Discovery Workshop*.) Use transparencies (ARTchix Studio) to compose a collage and insert into the frame. Attach beads and charms to a metal bar (7 Gypsies) and adhere to the bottom of frame. Attach additional embellishments and fibers.

Once Upon a Time
6-1/4″x5″
Christine Carrington
Australia
Contact: kcarrington@iprimus.com

Adhere image of the couple (Red Letter Art collage CD) to the picture of the house (ARTchix Studio). Attach to layers of cardstock. Staple transparency text (ARTchix Studio) across the top of the image. Computer-generate the "love" definition onto a plain transparency and attach with staples and heart-shaped brads. Embellish with hand-dyed ribbon threaded through attached eyelets.

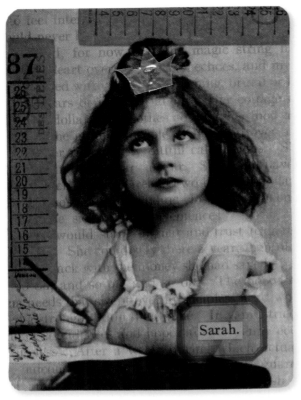

Sarah
2-1/2″x3-1/2″

Tina Aszmus
Contact: www.papertart.com

Compose a collage on an ATC-sized card by layering and adhering background patterned papers and transparency images. Adhere another small transparency of a red tag with the name "Sarah" cut and sandwiched between card and tag transparency. Cut a piece of gold foil into the shape of a crown and adhere.

Imagine
2-1/4″x4-1/4″

Karenann Young
Contact: karenannyoung@yahoo.com

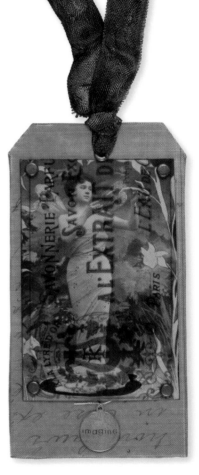

Cover a tag with metal wire mesh by folding and burnishing on all sides. Layer image of woman with a piece of transparency (ARTchix Studio) and attach to the tag with mini brads. Add a small "imagine" charm at the bottom by attaching it with gold thread to the wire mesh. Attach an eyelet at the top of tag and tie with a piece of ribbon.

Poetry
2-1/2″x3-1/2″

Danielle Torres
Omaha, NE
Contact: Danielle_torres@hotmail.com

Glue vintage picture of Eiffel Tower to a 2-1/2″ x3-1/2″ baseball card. Glue mini images of man and woman in profile (ARTchix Studio) on either side of the Eiffel Tower image. Glue small dried rose across bottom half of the card. Attach a transparency of vintage writing to the card with eyelets in all four corners of the card. Glue the word "poetry" on top of card in the center.

He Loves Me
4″x5-1/2″

Helga Strauss
Victoria, BC, Canada
Contact: Helga@artchixstudio.com

Glue loving couple image (ARTchix Studio) to inside of daisy image. Cut out daisy image with scalloped scissors and glue to card. Cut out piece of transparent text and attach to card with copper brads (ARTchix Studio).

Lotto
4-1/4″x5-1/2″

Karenann Young
Contact: karenannyoung@yahoo.com

Using mini brads, attach image of a girl to a piece of vintage green and cream game card. Cut portions from a dictionary and text and adhere to card. Take the same image of the girl in transparency format and adhere it to a round piece of glass using the Xyron machine with the adhesive cartridge. Adhere entire composition onto a white card.

Lucky Girl
Travel Girl
5″ (tall)

Helga Strauss

Most art supplies for this project are from ARTchix Studio. Draw body shape on matboard and cut out. Cover entire body with vintage text, glue down and trim to size of body. Cut dresses out of transparencies and adhere transparencies to body with brads. Cut out head images and glue to body. Attach velvet leaves, hand charms (ARTchix Studio) and shoe charms with needle and embroidery floss.

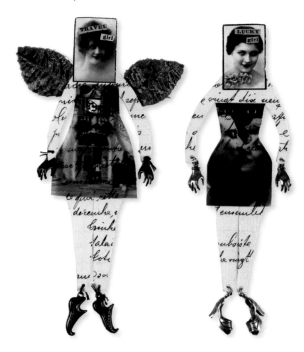

Light of Beauty: Rheba Cheek
5"x5"x5"

Kelley Cheek
Sherman Oaks, CA
Contact: CheekKR@aol.com

Print photos onto inkjet transparencies. Cut them to size and using permanent adhesive (Tombow), adhere the transparencies to hand-dyed fabric. Masking transparencies, stamp text (Hampton Art Stamps) with Plum Pearl inkpad (Palette Metallics) on a few pieces of the fabric.

To reinforce adhesion and add dimensional interest, either sew beads with ribbons, sew buttons, sew rickrack, hammer eyelets, or attach charms onto the layers of transparency and fabric. Using red line tape and permanent adhesive, attach all of this to a pre-existing box frame made of heavy gauge wire. The one I used was a wire-framed gift box that the fabric was pulled off of, leaving only the frame. (Shaping wire into the form of a box would be another alternative.) Adhere two strips of hand-dyed frayed fabric at a crisscross to cover the entire bottom of box. Cover lid with the hand-dyed fabric and line the outside rim with a fuchsia sequined and beaded trim.

Love
5"x5"

Scottie Magro
Contact: Scottiemagro@earthlink.net

Purchase a small wooden frame from a craft store and paint with red acrylic paint. Once dry, squeeze Elmer's Squeeze 'N Caulk onto the surface of the wood frame. Lay patterned paper (7 Gypsies) onto the frame, burnish, and let dry over night. To remove the paper, wet the back of the paper and rub the paper backing off. Use lots of water and do not rub hard. If a white haze appears, re-wet and rub the remainder of the paper off. (This caulking method is outlined in detail by Claudine Hellmuth in her book: Collage Discovery Workshop.) Use transparencies (ARTchix Studio) and papers to compose a collage and insert into the frame. Attach additional embellishments and fibers.

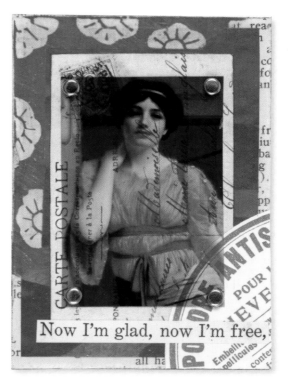

Best Friends Forever
4-1/4″x6-7/16″

Kelly Burton
Victoria, BC, Canada

Attach torn strip of light-color cardstock to card, then attach torn strip of black cardstock. Glue silver Renaissance border (ARTchix Studio) on top of torn black cardstock. Computer-generate words and print on light-color cardstock. Cut words out and attach to card as shown. Using staples, attach best friends transparency (ARTchix Studio) to card as shown. Use additional staples near top left corner and right lower corner.

Glad and Free
2-1/2″x3-1/2″

Karenann Young
Contact: karenannyoung@yahoo.com

On an ATC-sized card, create a collage composition with pieces of decorative papers and ephemera. Cut a transparency image of woman (ARTchix Studio) and attach to the card with mini brads.

Mobile House Potpourri Holder
2-3/4″x2-3/4″x6″

Heather Crossley
Australia
Contact: mkhc@powerup.com.au

Create the background color of the transparency by spreading various Piñata inks (Jacquard) and dabs of a gold leafing pen all over it. Once dry, cut out panels to construct a box. Add paper from a foreign text book to the inside panels of the box to add interest to the background. Next, stamp out Mystery image (Paperartsy) on white paper twice in black ink and trim. Cut out inner-square on both images and attach the photos of the man and woman behind each window. Attach decorative flowery paper to either side of the photos and then attach ribbon strip with the text, just below the photos. Attach the ruler image in line with the roof of the image. Glue these completed collaged pieces to each front and opposite side of the transparency box. On the opposite sides, attach a decorative plastic heart. To construct the roof, cut out a long rectangular panel, and score in the middle to divide the panel. Score a small flap at each end and attach this to the top of the box with double-sided tape. Punch a small hole at the top of the roof and thread through beads and punched-out transparency flowers to finish. Place potpourri in the completed house-shaped box and hang near a window to allow light to illuminate the piece.

Journal of a Sort of Self

4″x6″ (closed)

Tammy Kushnir
Contact: aug2199@aol.com

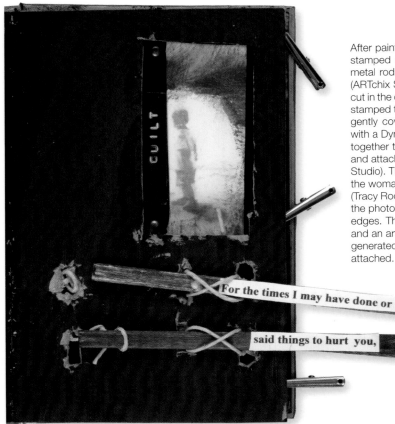

After painting every page with acrylic paints (Folk Art Plaid), the cover text was stamped (Chapel Road) onto white twill and placed through an opening in a metal rod (K & Company). In the corner is a brass filigree with a hand charm (ARTchix Studio) attached with wire. After the pages were painted, a circle was cut in the center to symbolize the womb. Inside is an artist size card with a rubber stamped transparency of a baby (Lost Angeles Rubber Works Naughty Images), gently covered with dabs of smeared paint. The word "childbirth" was made with a Dymo Label Maker and wire woven across the center. Alligator clips hold together the pages. The card is stamped (Postmodern Design-Harriet Tubman) and attached with a stick to the back of the second card with a charm (ARTchix Studio). The second section's page has portions cut out to reveal "fragments" of the woman beneath with stamped text (Catslife Press). Transparency of woman (Tracy Roos) was placed over a photo of my son's hand. The artist size card has the photos along with brads (Making Memories) and window screen around the edges. The pages for the final section were painted and then a square cut out and an artist size card placed underneath. The edges were painted and a word generated with Dymo Label Maker on black twill with brads (Making Memories) attached. Small holes were cut to put the sticks with printed text.

We Moved to New Mexico
4″x6″
Sarah Fishburn
Fort Collins, Colorado
Contact: sarah@sarahfishburn.com

Rub or paint in an irregular fashion, Quinacridone Magenta fluid acrylic (Golden) onto the incised edges of a small metal nicho. Let it dry. Attach small crystal jewels (DMD) with Diamond Glaze (JudiKins) wherever you like along the painted edges. Spray either the glass or the transparency with a very fine mist of Silver Webbing Spray (Krylon) then adhere the transparency to the glass (along the edges only) with Diamond Glaze (Judikins). Adhere a piece of light colored paper behind the transparency. For added depth, I painted & inked some light tints and highlights onto the paper I used. You could also spray the webbing onto that paper rather than the glass or the transparency itself.

Transparency Bracelets
Karenann Young

Using square- and round-shaped bases for bracelets, adhere snippets of transparency images (ARTchix Studio) into the shapes.

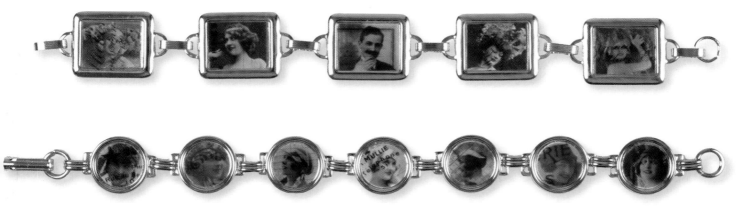

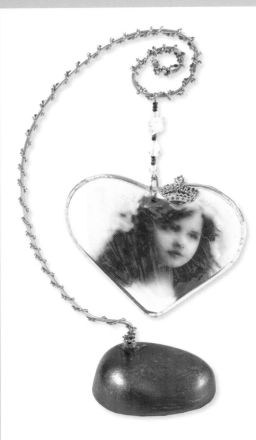

Charmed &
Little Princess

8-1/2″ (tall)

Carol Rector
Tomball, TX
Contact: mcrector@houston.rr.com

Make a plaster "rock" base using craft molds. When fully cured, paint and set aside. Cut images from transparency sheets (ARTchix Studio), use the glass ornament as a pattern. Then cut the transparency a little smaller so that the image will fit into the glass shape. Use Diamond Glaze to adhere picture to the ornament. Wrap the glass and the image with silver glass tape. Make a hanger using jewelry wire and glass beads. Attach to ornament and then to armature wire using jump rings. Adjust ornament until it hangs the way it looks the best.

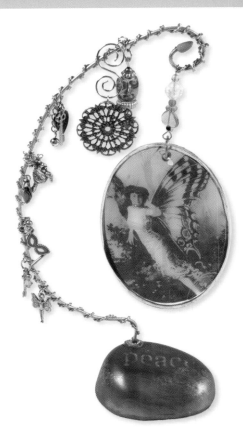

Sheer Metal
12-1/2″x3-1/2″ (open)

Kathleen Green
Auckland, New Zealand
Contact: contact@kathleengreen.com

All images by Paper Artsy. Cut transparency into six pages sized 2½″x3½″. Stamp and mask images using StazOn ink. Edge transparency pages with silver tape. Set micro eyelets into the vertical edges of the pages and link together using silver jump rings. Using matboard, cut two covers the same size as the pages. Cover with wide silver tape. Cut a separate piece of silver tape and rub with black pigment ink. Emboss with black embossing powder then while hot, dip into silver UTEE, heat then repeat for a second coat of silver. Stamp into the hot UTEE with the collage stamp pre-inked with black dye ink and allow to cool. Remove backing from stamped tape and adhere onto book cover. Set silver eyelets into the book covers and thread through two lengths of waxed linen thread. Adhere first transparency page onto the inside book cover and adhere the last transparency onto the inside of the back cover. Accordion-fold the pages between the covers and pull the thread taut to hold. Tie beads and charms to the ends of the thread and buff all silver areas with black StazOn ink.

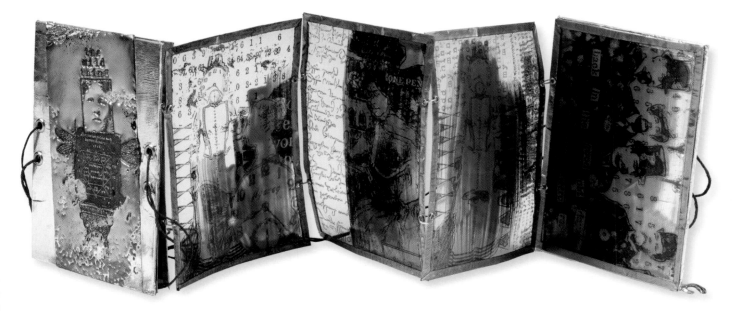

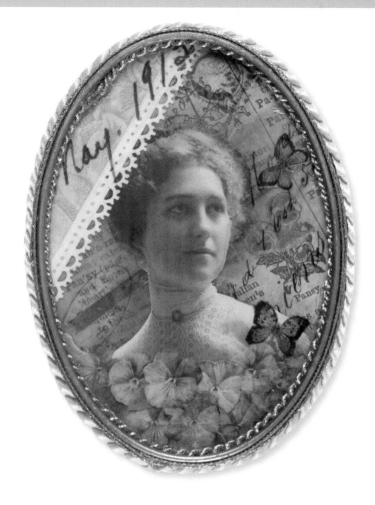

To Daydream in Blue
2-1/2″x3-1/2″
Annie Matheson
Hayden, ID

Background is from an old school dictionary. I used torn blue vellum (Paper Company), blue stripe and white lace (Mrs. Grossman's Design Line, & Art Nouveau), blue paper (Anne Griffin) and layered them in a pleasing fashion. Image of woman and transparency of envelope (ARTchix Studio) and pansies from decorative paper were cut out and placed on packing tape. I gently washed much of the backing off and then arranged them. The top layered transparency is from an old book from my grandmother. The entire collage was trimmed with assorted ribbons and encased in a gold oval box.

I Saw the Angel
21″x8″ (open)
Paula J. Dion
Mt. Vernon, Ohio
Contact: pddion@ezlinknet.com

Cut a 21″x21″ piece of canvas, prime with gesso and paint white. Fold in half and turn long edge up 2″ to form pocket, sew two short and one long edge closed, inserting antique twill tape for ties. Sew two seams to form a double-fold book as shown. Stamp text with black ink and foam alphabet set (Making Memories).

Tags were made with stamps from the following companies: River City Rubber Works, Paper Artsy, Stampington & Company, Uptown Design, and PSX. Put the white tags together by first stamping them, add white transparent papers, wings and transparency images (ARTchix). Sew around edges of all tags. Blue tags are stamped and transparencies are sewn on. Text was computer-generated, stamped, metal embossed or dymo-texted. Most embellishments are from ARTchix Studio and Silver Artbits.

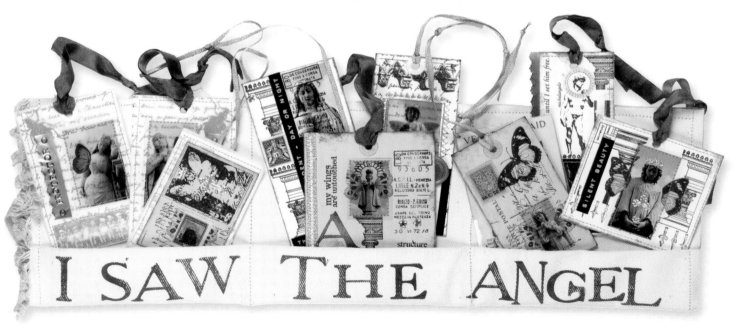

Beveled Jewel
2″x3″

Jan Harris
Vancouver, WA
Contact: purplebirdart@att.net

Sandwich a transparency between a 2″x3″ beveled glass piece (available at stained glass supply stores) and a piece of thin brass. On the opposite side of the brass, create a 2″x3″ collage. Next, back the piece with a 2″x3″ microscope slide. Holding all layers together, tape the edges with black-backed copper tape (3/8″-wide). Use a bone folder to smooth the tape on the edges and lightly buff with a piece of fine steel wool. Coat the copper tape with gel flux and cover the copper with unleaded solder using a soldering iron. Using solder, I attach two jump rings connected by a 3″-piece of chain to the top of the piece. Use solder to attach a decorative pewter angel to the top of the piece. Twist loops in a length of tinned wire with round-nosed pliers until the length of the looped wire is as wide as the bottom of the piece. Use solder to attach the loops to the bottom of the piece. Clean the piece thoroughly and then attach 4mm Swarovski crystals from the loops with eye pins.

Art Doll
Shrine
1-1/4″x2-1/4″

Caryl Hoobler
Bloomington, IL
Contact: caryl.hoobler@verizon.net

Most art supplies are by ARTchix Studio. Paint and stain a matchbox inside and out. Stamp images over both pieces of the matchbox. Trim face image and insert into frame and apply crystal lacquer let dry. Attach to outside of box with crown. Punch holes and attach hands and shoes with artistic wire. Trim out wings and apply miniature images and cover with transparency. Glue to back of box and using more crystal lacquer, attach micro beads to the front of box. Set aside. Closely trim image of lady to fit inside box. Attach to mica with brad. Punch hole in top of box and thru the hole attach beads and image of face. Using crystal lacquer, attach a few more micro beads. When dry, glue in figure with mica so that it rests dimensionally on top of the beads and attach with more crystal lacquer and micro beads. Trim transparency for door and attach with gold German scrap. Punch a hole and with wire and attach two beads to the door to serve as the handle.

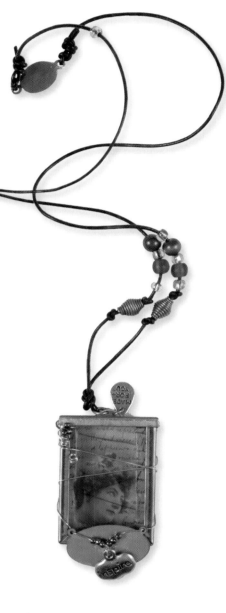

Inspire Necklace
1-1/8″x1-1/2″x1/4″

Lenna Andrews
Canton, CT
Contact: www.lennastamp.com

Cut a transparency to fit inside a box-frame pendant (ARTchix Studio). Secure the transparency by cutting strips of foamcore and fitting it into the backside of the frame. Thread beads and charms onto gold craft wire and wrap around the frame. Thread black cord with beads through pendant to complete necklace.

Wish
2-1/4"x4-1/4"
Karenann Young

For Wish, cut and fold over a piece of copper mesh over a pre-cut tag. Layer a piece of transparency over a photo image and attach to the tag with mini brads. Attach a "wish" charm and a ribbon at the bottom.

Look Within
2-1/2"x3-1/2"
Albie Smith
Jacksonville, OR
Contact: papersmith@jeffnet.org

Using a utility knife, cut four pieces of book board to a desired size in the shape of the window transparency (Angela Cartwright for Stampington & Company). The thick covers are made by gluing two board layers together. Cut an opening to create a window for the transparency in the two boards that will be the front cover. Cut a frame for this opening out of book board. Using PVA glue, attach the frame to the front cover. To create a distressed surface coat on the outside of the covers, apply an uneven coat of US Artquest 101 Heavy Artist's Cement and let dry. Paint covers with sienna color acrylic paint. When dry, sponge on a darker brown paint for an aged look. If you are using a closure for the book such as ribbons, leather or metal, attach them before you laminate the book boards together. Glue the transparency in place between the two boards that make up the front cover. Glue the two back covers together. Cut thick paper with deckle-edged scissors to create pages (12 or more) that are shaped like the book covers. Add a bit of Lumiere copper paint to a small amount of water to create a color wash and apply to the pages. When dry, fold the pages and pierce for sewing. Using an awl make corresponding holes in the book covers. Sew using a Coptic stitch.

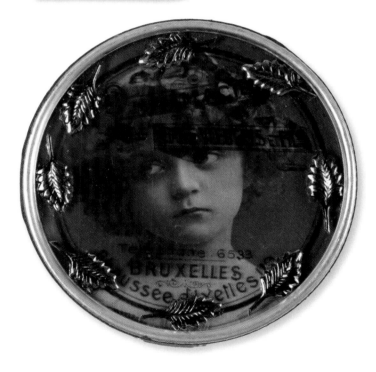

Adorned Tin Box
2" (diameter)
Karenann Young
Contact: karenannyoung@yahoo.com

Apply adhesive of choice to the top of a transparency and place to the backside of a glass lid of a round tin box. Adhere gold leaf embellishments (ARTchix Studio) to the top of the glass lid.

ABOUT THE PUBLISHER

Since 1994, Stampington & Company of Laguna Hills, Calif., has become a leading source of information and inspiration for arts and crafts lovers around the world.

Launched with a small line of rubber stamps by President/ Publisher Kellene Giloff, the company has expanded to include more than 1,000 stamp images and four best-selling publications: *Somerset Studio®, Belle Armoire®, The Stampers' Sampler®,* and *Stampington Inspirations™*. In 2002, Stampington unveiled *Legacy,* a magazine standard for paper arts publications. The bi-monthly magazine attracts a large and devoted following of readers interested in the latest innovations in paper crafts, art stamping and calligraphy.

The *Stampers' Sampler* is a bi-monthly magazine filled with hand-stamped artwork contributed by readers and accompanied by detailed instructions. Stampington Inspirations features the company's own rubber stamp images in a variety of projects, with instructions, templates, and full-color samples. Launched in 2001,

In addition, Stampington & Company produces many special publications, including: *Somerset Studio Gallery,* filled with hundreds of arts and crafts submitted by readers; *Catch Up Issue™,* showcasing stamped samples that could not fit into the regular issue of *The Stampers' Sampler,* and *Holiday Extra,* featuring hand-stamped holiday artwork. Stampington & Company has also published the popular *True Colors: A Palette of Collaborative Art Journals, Signatures: The Art Journal Collection, TakeTen, HandCrafted,*

dedicated to scrapbooking and family history art, and in 2003 it launched *Art Doll Quarterly™,* marking yet another chapter in the company's history of innovations in the crafting industry.

Known for their outstanding color photography, these publications provide a forum for readers to share their beautiful handmade creations while gaining knowledge and ideas by seeing the works of fellow artists. Since its debut in 1997, *Somerset Studio* has become the industry

Belle Armoire has become an instant hit with art-to-wear lovers by highlighting fabric arts, creative jewelry and accessories, beading projects, embroidery and handmade garments. *Legacy* showcases handmade artwork incorporating family history photographs, documents and memorabilia. Elegant scrapbook pages, home décor items, journals, paper crafts and more are presented. *Art Doll Quarterly,* brings together many art forms in contemporary doll artistry.

Material Visions: A Gallery of Mini Art Quilts, A Somerset Wedding, Artist Trading Cards: An Anthology of ATCs, Art Doll Chronicles, and *Somerset Studio's 2003 and 2004 Art Journal Calendars.*

Information about Stampington & Company publications, along with an online shop of its rubber stamps, art-related gifts and unique handcrafting essentials, can be found on the Web at www.stampington.com.